MW00560057

WHO WE ARE
AND WHY WE MIGHT WANT TO
BE SOMEONE ELSE

WHO WE ARE
AND WHY WE MIGHT WANT TO
BE SOMEONE ELSE

– or –

Catzilla at the Crossroads

SOFYA SMITH

HOHM PRESS
Prescott, Arizona

© 2009, Sofya Smith

All rights reserved. No part of this book may be reproduced in any manner without written permission from the publisher, except in the case of quotes used in critical articles and reviews.

Cover design, Layout and Interior Design: Zachary Parker, Prescott, Arizona

Library of Congress Cataloging in Publication Data:

Smith, Sophya.
 Who we are and why we might want to be someone else : Catzilla at the crossroads / Sophya Smith.
 p. cm.
 ISBN 978-1-935387-03-9 (trade pbk. : alk. paper)
 1. Spirituality. 2. Happiness--Religious aspects. 3. Psychology, Religious. I. Title.
 BL624.S59487 2009
 204'.4--dc22
 2009016088

HOHM PRESS
P.O. Box 2501
Prescott, AZ 86302
800-381-2700

www.hohmpress.com

This book was printed in the U.S.A. on recycled, acid-free paper using soy ink.

DEDICATION

To my spiritual master Lee Lozowick ... a madcap lighthouse in a landscape blanketed by fog, a veritable bastion of sanctity, sanity and good cheer in a world gone mad. It's a good thing you're here.

I'd like to thank my friend Nancy who inspired me to verbalize this roadmap out of hell ... It was her maddeningly obtuse, one-dimensional, fevered approach to life (talk about herding cats!) that provided the urgency for this framework. In addition, her pure heart, intention, and pluckiness in the face of adversity are an inspiration. Thank God.

CONTENTS

INTRODUCTION

Ten years ago, probably 15, I don't remember exactly, and more to the point, how many years ago is totally irrelevant, I sent the author of this book away, telling her that she wasn't my student and asking her, since telling her didn't seem to be very effective, to stop assuming she was and to go find another life. She didn't take either the telling or the asking with a grain of salt, as is said relative to situations exactly like this one. The reason I asked her to leave was that every one of the mental gyrations that she describes here-in (or there-in since here-in may well refer to this introduction, of which I'm not sure and furthermore couldn't care less), all of the illusions, lies, deceptions and manipulations that we live by, or rather are lived by, were so deeply rooted in her, and so blatantly evident in her behavior, that I, after many, many years of carrying it all for her, had simply run out of patience, in spite of the fact that her charming personality and infectious, if a bit unusual, sense of humor were qualities I deeply appreciated and enjoyed. Ah, but that's not a spiritual teacher's job, to rest in the temporal niceties of his or her students' mechanical manifestations, even when they are so pleasant. It is one of such a teacher's jobs to pierce the armor of the false gods that control the heaven of denial and let the light of Reality shine through, creating a resonance between the innate light of Reality within the student and the Divine Light of Reality (actually one and the same thing) so the student's light of Reality can shine outward, radiating their lives, their environment, and the lives and environments of

everyone and everything that they come in contact with, physically and subtly.

So she did go away physically but obviously stayed in quite intimate contact none-the-less, or rather it will be obvious when you read this book. And look what we have! Through diligent practice the ills that beset her were thrown into a whole new light, put in their proper place, if we can believe her words and why not? The benefit of the doubt is a wonderful option to offer someone, allowing them to prove themselves ("innocent until proven guilty," eh?). And in at least the written word, prove herself she has. In fact she's proven herself so well that I'm even a bit jealous as I pride myself on the use of creative metaphors in my own writing and howdy, she has come up with a few fistfuls here that are quite wonderful, ones that have escaped me. Well, I must offer congratulations on both the completion of this project and its utility, although clearly its utility is yet to be seen and that, of course, depends on you, the readers (or is it "youse, the readers," or "you, the reader"?). This is an unusual book and the decision to publish it does not stem from its brilliant scholarship or its literary genius but instead is a result of its potential value to a life of practice, of quality, of ease and productivity, which potential can only be realized if, once again, youse, the readers, allow the author's firsthand experience to impact or touch you to the point where you are willing to pick up her direction, her advice, make it a personal hypothesis, and go about proving this, now your, hypothesis accurate or not. And I can and will say that if you apply yourself as diligently as Ms. Smith has applied herself (remembering that her journey from the time of leaving her home here to the testimony in this book was not overnight, weeks or months), that you are, not will be, but

are, assured of success. This will take tenacity, even fierce tenacity, discipline, a soft sense of the absurd, a willingness to be blasted by things, realizations, so shocking to the rigid, crystallized mind of neurosis, that they may seem other-worldly, the ability to laugh, both gently and uproariously at yourself, and ultimately, Faith. And to end on an endearing note, I can also say that, knowing the author of this book as well as I do, if she can do it, you can!

Lee Lozowick
Prescott, Arizona
January 25, 2009

CHAPTER ONE
Hide and Seek

Life Is But a Dream

This book contains the answer to the question that's been on all of our minds since the beginning of time: What *is* the secret of happiness, the thing that won't disappoint and that will stand up to whatever underhanded hell-realm life might conjure up (including death)? I'm happy to report and to share with you, dear reader (gentle or otherwise), that against all odds, I've found the one thing, the "winning formula," that actually *will* get us all "through the night."

When I was a child, I used to have nightmares about being chased around by doctors who wanted to inject me with something that would make me forget who I was or why I had come here; that would stupefy me into a coma so I would be at the mercy of the world's seductions and distractions. (Freud would have had a field day!) As a teenager, I read something in an essay by Emerson that broke through the amnesia that was beginning to set in: He said that when we come down here, someone is standing at the top of this staircase with a sleeping potion, so that when we get here we can't remember where we came from and who we are. Then he mused (approximately), "I think whoever's in charge of making this potion is going overboard."

But what *is* this thing that I was so committed to not forgetting? I've been wondering lately if the clues to unraveling the mystery of our lives haven't been lying around in plain sight from the very beginning:

Row, row, row your boat
Gently down the stream,
Merrily, merrily, merrily, merrily
Life is but a dream.

Is it possible that we're asleep and that we're dreaming? Maybe the world around us is always pointing to the truth, and we're too sleepy to notice. Maybe it's to be found in popular songs, like Jim Morrison's "Break On Through," or Sinéad O'Connor's "All Babies." Maybe the truth is encrypted into science fiction, Sufi stories, television shows, parables, books (*Miss Piggy's Guide to Life*, to name one), fairy tales (*Sleeping Beauty, Pinocchio*, et al.), and movies (*Run, Lola Run; The Professional* and *Mary Poppins*, to name three).

The circumstances of my childhood were relatively Kafka-esque and crazy-making. At the age of twelve, I found myself wandering the halls of Belleview in paper slippers, clutching a copy of the Bhagavad-Gita. Although I was the genetic recipient of "the crazy factor" and perfectly positioned in terms of the bizarre environment I was placed in (a sure-fire recipe for disaster), the gods intervened. I was airlifted out of the scenario/fate where I would have spent the rest of my life in a madhouse and given the sanctuary and the help that I needed to do something else. Lucky me!

Here's an amusing story: Someone I know spent an afternoon at her grandmother's apartment in New York once. Upon leaving, she threw herself on the floor in front of the elevator as the full magnitude (the breadth and the depth) of her genetic inheritance hit her. The funny and interesting part, to hear her tell it, was that there was a guy washing the floors who carried on with his work, carefully

mopping around her without comment. Maybe this was a guy who'd been there, done that, and had figured out that the only thing that works is to keep working. I've just realized that my favorite quote of Henry Miller's fits in quite handily here: "On the knees of your soul? Then make yourself useful and wash the floor."

What Am I Supposed to Be Doing in a Place Like This, with People Like This?

Pockets of sanity and sanctuary have existed throughout the course of time in every corner of the world, and still do. Unbeknownst to most of us, there are schools where you can go to learn how to connect with sanity. They exist to give you the answer to the question: "What *am* I supposed to be doing in a place like this, with people like this?"

A word of caution here: The schools where you can get these answers don't advertise (they don't need to, because "when the student is ready the teacher will appear"), and the ones that do—where everyone dresses up in white robes and they promise to make you happy—are to be avoided.

The fear of gurus, spiritual masters, and cults that has been inoculated into our culture has made it more challenging for most of us to forge a connection with someone that knows more than we do about life. The idea that we might need instruction in order to become a genuine human being (*genuine*, not cooler—the phrase "looking good and going nowhere" comes to mind), has met with an avalanche of resistance throughout time. A review of the lives of anyone who has tried to interrupt the dream we're having makes this point (think Jesus, Socrates and countless others too numerous to mention who lost their lives because they told us the truth).

But here's another point of view: If we're hiring tennis instructors to improve our backhands, why *wouldn't* we want to accept instruction from someone who knows how to get our heads on straight and open our hearts?

Someone Had to Tell Us the Awful Truth

It's scary when we meet someone who's telling the truth, because this means that all of the illusions we've held about who we are, are going to have to give way in order to take in the one thing that we're afraid of hearing: "There's only God." We're not all that interested in anything that goes against our ironclad thesis: "I'm the big cheese, the master of my own destiny, and you're not."

On the other hand, if we're at the point where we suspect that "running the show" is running us into the ground, it might be fun to run into one of these characters. Despite my reservations (I sensed that this guy was going to mess with my precious reality, big-time) there was something inside me that was so thrilled by my first meeting with my teacher, Lee Lozowick, that it propelled me into a fit of uproarious and inappropriate laughter as soon as I saw him. Not the typical reaction when you meet the typical man, but then, this was not the typical man.

Jesus meant it when he said, "The kingdom of heaven is within," and "you must be born again." There *is* something inside of us that's true and eternal, despite the dream we're having that we're perishable and separate from God. Dying to who we think we are in order to be reborn can be disorienting—just like being expelled out of the womb into the bright lights of the operating room might be seen as no picnic. This explains why so few of us take the opportunity we have to do it, and why most of us that are in this process are glad we have the help of a teacher/midwife.

Here's a tip I got once: I woke up in the middle of the night, sat straight up in bed, and said out loud, "Remembrance (remembering God) is the purchase price of our souls." It's this Remembering that leads to our transformation from a caterpillar to a butterfly, and enables us to rejoice in knowing who we are and in discovering our place in creation.

Who Are You?

There are a lot of systems for producing enlightenment, for waking up, and for getting next to God. Mostly they demand sacrifice and discipline (sitting in meditation, giving up ice cream, turning our backs on the world). I don't know about you, but discipline isn't my strong suit. But here's some good news for both of us: saying the Name of God over and over inside our heads while going about the ordinary dish-washing, car-driving moments of our lives is the key to unlocking the door that separates us from the mystery of our *true* identity. Maybe we're all Supermen pretending to be mild-mannered reporters, and maybe that pair of blue tights in our hampers is trying to tell us something.

The Name of God is the thing that has the power to separate us from our fascination with the minutia of our everyday selves. If we decide to say God's Name in whatever form speaks to us, then this sets up a signal inside of us, a honing device if you will, or a magnet to attract Him to us. Here's an experiment you may wish to try at home: say "matzo balls" day and night for a few days. I can safely guarantee that sooner or later you'll wake up surrounded by matzo balls.

The tricky part about solving an equation isn't solving it, but proving that you have to others; thus the expression: "You can lead a horse to water but you can't make him drink." Maybe this is because the horse doesn't know he's thirsty. If

you're in this category—if you're satisfied with your "quality of life"; if you're not looking for a way to make sense of the madness—this book may or may not be for you.

A Rose by Any Other Name Is Still a Rose

Even though the book you're about to read suggests the use of the Name of my teacher Lee's spiritual master (Yogi Ramsuratkumar), feel free to translate this Name into the Name of God that works for you whenever you come across it, be it Yahweh, Allah, Ram, God, Jesus, etc., etc., etc. I encourage you to resist the temptation to throw the baby out with the bath water when you come across Yogi Ramsuratkumar's Name; fight the urge to get your panties in a twist and make the necessary substitutions.

The animosity between the different paths to God has always struck me as odd; the battles between Moslems and Hindus or Christians and Jews, and so on. God sends us His sons and prophets to guide us, and they're all saying the same thing: "Remember Me"—and then an evil genie infiltrates the organization that forms around this message and co-opts it, causing us to forget to Remember because we're so distracted by this schoolyard fight: "My dad is better than your dad!" I think that God, in His infinite Mercy, has responded to our great need by sending us a lot of help over the years. Even a superficial and half-hearted study of the Torah, the Bhagavad-Gita, the Bible, the Koran, and the Buddhist sutras will reveal an uncanny amount of coincidental agreement.

The Three Little Pigs

Four years ago, I came across a passage in one of the study manuals of my school about how when the Kali Yuga ("the

apocalypse," to most of you) hits, saying the Name of God is the only thing that will get us through the coming difficulties. The point here is that most of us are becoming increasingly nervous because the handwriting is on the wall: the systems that we've superimposed on top of our world (financial and resource mismanagement to name two) are coming apart at the seams. Life as we know it could (and already has for some of us) become seriously unraveled. It behooves us to put a measure in place that will help us redefine hard times and transform them into something valuable. So make hay while the sun shines; it's time to leave-off dancing and fiddling and turn our attention to building something inside of us that will remain after the dust settles, should the wolf blow down our house.

The Shortcut Through the Woods

Given the urgency of this moment in time, I hope this shortcut through the woods (the repetition of the Name of God) is useful. It cuts to the chase, it's where the rubber meets the road, and it's more than capable of making good on its promise to help us "get a life."

I'm beginning to see the time that we spend here on earth as a rare and precious opportunity to accomplish something that can't be accomplished once we leave. The kicker is that we spend most of our lives enveloped in an underlying and mostly unconscious current of dissatisfaction: "Life sucks and then I'm gonna' die". It's not until we leave that we realize that we neglected to make use of the gift we were given. Begin saying the Name of God throughout the ordinary moments of your life, in order to trigger the Remembrance of Him while you're here—or wish that you had, after it's too late and you're dead.

It's not fair to say that this book was written by me. The truth is that when I met my teacher and he began instructing me in what my real possibilities were, these teachings took root in me and leapt onto the pages of this book when the timing was right, many years later.

What Would Bruce Willis Do?

Mostly this book is about the importance of taking up the repetition of the Name of God inside of us as an antidote to our individual suffering. Because we lead our lives from the vantage point of a single, isolated perspective (our own), it may be difficult for us to wrap our minds around the fact that all life here on earth depends upon our Remembering God. But doesn't it always come down to one thing when Bruce Willis has thirty seconds to save the world—a shoestring or one last match in a matchbook or something?

Unbeknownst to us (as reported in *Ode* magazine), there's a group of people that have been running around the world for years, staging prayer interventions in our major cities; they just stand around on street corners saying God's Name, everywhere from Tokyo to Marseilles. In the summer of 1993, they turned their attention to Washington, D.C. The police chief of D. C. had stated, before the group began their work, that it would take two feet of snow in July to lower the crime rate twenty-five percent. Since they didn't produce two feet of snow, and the crime rate *did* go down twenty-five percent, and they've produced the same measurable results in countless other cities, we can be confident that any efforts that we make to say His Name while we're driving around will actually count.

All of our spiritual teachers are aware that the survival of the human race, along with its vast spiritual possibility,

is hanging by a thread at this moment in time. The forces of darkness and unconsciousness have always been with us; it's as though there's a permeable membrane that surrounds this dimension that they are able to seep through. But things change. Now the situation that we find ourselves in is unimaginably more challenging; it's as though somebody punched a giant hole in the membrane, allowing the darkness to flood into our world.

"Ah, Grow Up" — Joan Rivers

The image that I have of the human race at this point in time is that we've hit "the terrible twos." Because we've created some sacred and beautiful moments while we've been here, and because many saints and angels have been cheering us on and have high hopes for us, I hope that we're going to go on from here and grow up. No one could witness our handiwork and think of us as grownups. Things have gotten so bad that we're going to need an intervention soon, now that we're on the verge of annihilation.

Since it would be a shame if all of humanity went down the drain, it would be great if all of us took up the practice of saying the Name of God. The repetition of His Name is the only thing we have at our disposal that has enough power to pull us back from the abyss that has opened up in front of us. At *this* moment in time, the practice of saying the Name of God is our only hope.

The distortions in our psyches are such that often we're unable to lift a finger to help ourselves, but sometimes we can be moved to action for a cause that's bigger than ourselves. If you've ever wanted to do something important, to have your time here on earth count for something, now's your chance.

An Unexpected Gift

My teacher, Lee Lozowick, who started out as a nice Jewish stamp collector from New Jersey, woke up one day in another "country." He didn't even remotely resemble the person that he was when he went to bed. The dream of who he thought he was had vanished overnight; his personal identity had been subsumed by something much bigger. When someone arrives at this condition (when they're no longer living a lie), other people are drawn from near and far in order to "have what they're having" (as in *When Harry Met Sally*). When one of us wakes up, it's like we emit a high-pitched sound that only dogs (or people who are at the point where they're interested in waking up) can hear.

Unbeknownst to Lee, this "waking up" wasn't random; he found out a few years later that there had been someone—as yet unmet—behind the whole thing from the very beginning. He was inspired at one point after he began teaching to bring a group of his students to India. He met with a number of different saints and holy men before he collided with his destiny in the form of an obscure beggar-saint named Yogi Ramsuratkumar; his recognition of and gratitude for the connection to the Divine that this saint is continues to inform all of his words and deeds to this day. A reference point for the relationship that these two have is to be found in the stories about Rumi and Shams-e Tabrizi (for all you Rumi scholars out there).

Someone Must Have Called for Backup

Finding out that you're not just flying by the seat of your pants and that you have a beloved and loving friend that has your back must be the best news of all. This certainly bodes well for the rest of us—maybe none of us are lost and alone in the storm and at the mercy of an uncaring world.

Yogi Ramsuratkumar's parting gift before he died, to Lee and to Lee's students, was His Name. When Lee began asking us to take up the practice of saying Yogi Ramsuratkumar's Name consistently and persistently throughout our days, I recognized that this practice—saying the Name of God or the Name of one of His sons—is the same wise counsel we've been given over and over again from the very beginning of time. This is the countermeasure that unravels our mind's version of who and what we are. It's the best thing that we can do to jam the clockworks of our minds—like in a movie where the heroine is strapped to a conveyor belt moving inexorably to her death, and the hero picks up a board and jams it into the machinery to save her.

The Kevin Bacon Connection

We're all connected to an extraordinary possibility. This is similar to the idea that everyone's connected to Kevin Bacon by six degrees of separation. In my own case, as luck would have it, I'm only separated by one degree—fortunately for me, my daughter went to high school with a girl who became his nanny, and she recently spent a few days in Malibu with him. But I digress … the point is that we *do* have backup, whether we know it or not. Lucky for us, we're all connected to the tireless and compassionate work of countless saints.

When Yogi Ramsuratkumar began searching for the truth, he found his way to the doorstep of someone named Swami Papa Ramdas. Swami Papa Ramdas told him what he'd been telling everyone around him for years—that the trick was to say the Name of God over and over again. Papa Ramdas knew from personal experience that this would work, because this practice had landed *him* in the home-free zone. The thing that was unusual was that Yogi Ramsuratkumar

11

believed him, and actually did what he was told. I guess he figured, "This guy has what I'm looking for so, I might as well assume he knows what he's talking about."

The form of whatever Name you choose doesn't matter; it's the content, the fact that it's a Name of God that counts. In Yogi Ramsuratkumar's case, the form that he was given was *Om Shri Ram Jai Ram Jai Jai Ram* (something to the effect that God is our light, strength and virtue). If it strikes you as too weird to take up the practice of repeating the Name of some obscure saint from India, then again, don't throw the baby out with the bathwater—choose a Name of God that you have a connection to.

Whether You're a Spiritual Sophisticate or Not

This book began its life as a treatise on the territory that's familiar to students working within hidden spiritual schools. It's interesting to note that the terrain is the same in all of these schools—you can run into someone from a different school than yours in Paris, and find that they're speaking your language, even when they're speaking French. A significant amount of universal and hidden technology has been created over the centuries, to enable serious students to learn how to readjust their orientation from their personal selves to the Remembrance of God.

Somewhere in midstream, I had the idea that it might be possible to make these little-known ideas available to the public at large. Since things are heating up here, it might be the time for all of us to be let in on the esoteric secrets that are normally available to only a handful of seekers. Since this book is centered around the practice of saying the Name of God, I began to reason that this is something that anyone can do, whether they're a spiritual sophisticate or not.

I've tried to include the experiences and the pieces of information that were given to me in my school that would best communicate the urgency of this practice for everyone, everywhere—as well as the impossible things it can do—and some of the ways we can go about introducing it into our lives. Here are a few considerations that may be needed to bridge any gaps that exist between the reader and the specialized information to be found here.

We Don't Need to See the Handwriting on the Wall

A number of years ago, I found myself obsessed with the idea that it was critical at this stage for everyone in the world to be saying the Name of God internally without ceasing. This inspired me to write a letter to my teacher about how salvatory and crucial the repetition of His Name was, and how we could go about forging a connection with God by introducing His Name into our everyday lives. I said something like, "*Someone* needs to write a book about this." Since our school has a lot of very good writers, and since I had never written anything, it didn't seem likely that this someone would be me. But once again, what did I know?

It has seemed to me over the years that I'm always the last to know. Maybe this is because, as my teacher once put it in one of his published journals, "a nudge is as good as a wink to a blind bat." This may also be because if my left hand doesn't know what my right hand is doing, there's less chance that my ego will jump in and insinuate itself into the center of things.

The following essay, from another of Lee's journals, provides a thorough and madcap synopsis of this book. It also may have been the moment in time when my teacher answered my urgent concern and gave life to this project. The

blessing of his lineage seems to have been powerful enough to overcome a number of pesky details. (It seems that whether we think we can do something or whether we have a desire to do it may be irrelevant.) I've enjoyed being the last to know over the years, because it has strengthened my faith in the fact that even though I don't know what's going on, someone does—thank God for this. Finding out that it doesn't have to be me has given me a number of reasons to celebrate over the years.

12 July 2005

From a recent letter: "When all is lost and we're going down for the third time (the last time) this is the place of real refuge ... The Name is like a turtle carrying it's house on it's back—you don't have to go out to a church or monastery—the church is inside you all the time, you can be saying God's Name at the makeup counter at Macy's." And she follows up with: "So the emphasis would be spiritual practice for busy stressed people ... stuff that we can identify with (powerlessness, crushing debt, getting old, sneering husbands or wives, chaining jobs, pointless little lives, war)."

Besides the fact that this person, also, obviously doesn't indicate a clear obsession with commas, and is an excellent speller as well, this really says it, doesn't it? In the Kali Yuga we are told, by ancient sages, that the kind of rigorous sadhana engaged in in the fabulous stories of the Vedas, Upanishads, Taoist classics, Buddhist Sutras, even, and I say "even" because of the relatively recent, brand-spankin' new compared to the Vedas, history of the next in the list, the Hassidic

Jewish works, the Christian desert father lore and so on, is just not accessible in this age. True, there are notable exceptions to the rule, as there always are, but the exceptions to the rule don't define the rule, as they never do. So we practice various disciplines with as much enthusiasm, will, ease and attention as we do, and still, at the end of the day, what we're really left with is the Name, in our, or my, case, the Name being Yogi Ramsuratkumar. It could be Om Namah Shivayah, Om Shri Ram Jai Ram Jai Jai Ram, Hare Krishna Hare Krishna Krishna Krishna Hare Hare Hare Rama Hare Rama Rama Rama Hare Hare or simply Om or Ram, perhaps the Gayatri Mantra, the Guru Gita, the Hanuman Chalisa, the Durga Sapta or any number of more complex chants and/ or mantras. This is the ground upon which we walk, or could be. This is the rocket that lifts us into space to explore the "outer limits," or could be. This is, as the Indian Scriptures call it, the boat that takes us to the other shore, or could be. This is our nutrition, our deep feeding, or could be. This is the vehicle of our Blessing, the Harmonization of our lives, the peace of our minds, the balancing of our karma, or could be. Could be, of course, because we still have some truly minor responsibility in this all, which is to actually repeat the Name, perhaps at first only rote, as an act of obedience, desperation, as a "should," from a feeling of guilt, whatever, it doesn't matter how we begin, or why, but to simply begin, continue, and intensify the practice as a quantity thing. As we say the Name, which act is the spark that ignites the forest fire, turns over the engine, turns on the stove,

sets the field aflame, it begins to cultivate a more profound approach. In the beginning it is enough to say the Name and keep saying the Name, whether we can feel anything or not, whether we think something is working or happening or not, whether we are full of resistance, even recoil, or not. "Just do it" as Nike so helpfully reminds us, as Zen Masters and other forms of spiritual Instructors have done about various forms of practice for millennia. And talking about Nike co-opting this oft used phrase from the ancient traditions, how about this for a Victoria Secrets ad for racy women's panties: "God is Love." I like it, I love it in fact, but I'll let you, or V.S. have it for free, generous that I am. Back to the flow, back in the groove, back on the point, back with more straw on the camel, and more cement on the heads of the women laborers in India who carry it up to the current level of construction so the men can slap it on and work it, water it down, and go on about <u>their</u> business. Just do it. I realize that I didn't quote that, and very deliberately decided not to, so Nike, please, please, please don't sue me. We begin by just repeating the Name as often as we are willing, and no excuses about not having the time, you shameless excuse makers, as our astute letter writer says, or at least said in her letter to me, you can even do it standing at the makeup counter at Macy's (or May+Co., Dillards, Saks, Sears + Roebucks [if they're still in business as of this reading, they are as of this writing] and so on) and honeys, if you can do it at the makeup counter, which you sure as sure can, which our writer well knows, surely, from direct

personal experience, and I am equally sure, from the direct personal experiences of friends, revealed, not in the confession booth of a church, which our writer also tells us one needn't go into, but over coffee, tea or sandwiches, or, and sandwiches or brownies, possibly fruit and custard tarts, or the rare chance that it was over brown rice and tofu, Chinese food, or at Taco Bell, and why not, for any of these situation are perfectly appropriate for the revelation of the testimonies relative to the repetition of or practice of, the saying of the Name. So, to continue along the same stream, which stream's fairly lively and vigorous current is carrying us along very nicely, we begin the use of the Name for whatever reason, good, bad or indifferent (Sattvic, Tamasic or Rajasic— the orders don't align) and as we practice, even rote, empty repetition, it is the power, force, and Divine radiation of the Name Itself that subtly, and occasionally miraculously or Mercifully or dramatically alters the mood and reason and intention of the practice. We will, not we might, but we <u>will</u>, as long as we maintain some minimal continuity in the practice and use of the Name, find that our entire relationship to it changes, begins, again slowly, but in some cases with alarming speed and intensity, to take on the aura of something we not only enjoy but actually anticipate, long for, feel overwhelmed, in a most positive and even ecstatic way, by. The Name itself entices, entrances and even entitles us. It captures our hearts and makes us fall in love with It, with God, maybe even with It's creation, holy Cow, holy Smokes, holy Holy of Holies! Yes, this is the power of the Name, it begins as a mere cipher

and ends up, again, if we are even minimally diligent in It's repetition, irresistibly seducing us into It's own sweet domain, into It's own perfumed palatial, tender, intimate "love-net." So why not? There are only positive consequences, no negative implications at all, why not? Now I know that many of you are not using the Name, even many of those who have been formally introduced to it, even officially initiated into it, and this is the real question: why not? You know full well, to complete a thought and tie up a thread that I just remembered I didn't, if you can do it at the makeup counter at Macys, you can do it just about anywhere, at the tool counter at Home Depot, the chocolate counter at Godiva's, the drive-in window at the aforementioned and very convenient Taco Bell, the pants counter at K-Mart, Target, Ross or Factory-2-U, the toy counter at Toys-R-Us, anywhere, even at the video counter at Hastings, the lingerie counter at the also, well let's use a different one, Frederick's of Hollywood, the fantastic electronic gadget counter at Sharper Image, the camera counter at Wal-Mart, the little wooden chatchka counter at Cost Plus, the prescription counter at Save-On, the soy-food product counter at Whole Foods, even at the ticket counter during Christmas holidays at the airport, any airport, O'Hare, Sky Harbor, LAX, Orly, Charles de Gaulle, Heathrow, anywhere, the sexual toy store counter at any "Adult" Store, the road-rage ride to work in the morning, or even better, home from work at the end of the day, anywhere!! ANYWHERE. Even, God forbid you get this one wrong, while having sex ("Oh God" screamed at certain peak moments,

not exactly fitting into the context of the Name we're discussing here, but could serve in a pinch). So, again, the question is, if you're not using the Name of God: why not? There is no reasonable excuse (but lots of illogical and/or unreasonable excuses, lots of justifications, all absurd and ridiculous, and plenty of pretentious or pompous attempts at obscuring the answer or the question with posing, loud and obnoxious behavior, total self-referencing and just plain unconsciousness, totally lacking in even the most minimal knowledge of self, one's own self, that is, as even the most totally self-consumed egoist seems to be able to see others' with alarmingly accurate clarity). Time to meditate. Ciao[1].

We're Not Who We Think We Are

The purpose of this book is to call attention to the fact that no matter how alluring and interesting our worldly lives are, the only thing worth doing is to Remember God. But, first things first: we need to see the thing that's standing in the way of our doing this. I've come up with a number of metaphors in the following pages that point to what it is that we're up against when it comes to engaging Remembrance. All of them point to the same thing: that the part of us that we think is the real us—and that we've come to identify with by supporting and investing in it throughout the course of our lives—isn't the whole story; that there's something hidden inside of us that's attuned to serving God rather than to serving our personal identities.

1 Lee Lozowick, *The Little Book of Lies and Other Myths* (Prescott, Arizona: Hohm Press, 2005), 223-226.

The Name of God is Written Inside of Our Hearts

When we have the experience that the Name of God is written in our inner hearts, it will probably make us cry. Little do we suspect that this Name resides at the center of each one of us. I experienced it reverberating inside of me in Toronto, a long time ago. Discovering that my inner heart was saying God's Name was so unexpected and intense that it overwhelmed my outer heart, and I began sobbing in the middle of a room full of people. These were tears of joy in response to the unknown beauty of His Name.

This is what the practice of saying Yogi Ramsuratkumar's Name has in store for us: it will reveal the secret chamber in our hearts where God has written His Name. Since this is what is engraved in the very center of our being, then it's only a matter of time and diligence on our part before we discover it. Separating from the chaotic rhythm of our outer selves in order to experience the rhythm inside of our inner hearts is the only thing worth doing.

Getting to the foundation of who and what we are is the trip we don't want to miss, no matter how pretty, smart, and cool we are. It's all irrelevant when matched up against one moment of Remembrance, so go ahead and blow your unsuspecting mind by saying Yogi Ramsuratkumar's Name. Every time we do this, a piece of the forgetfulness that surrounds our hearts is dissolved. Any Name of God is a catalyst that triggers the Remembrance of who and what we are. It brings to the surface what we've always been, but were too sleepy to remember.

Hide and Seek

The problem isn't that God isn't here with us in every instant in time and in every place. We have it on the good

authority (of all of our sacred scriptures) that the problem is that we can't see Him. When you're playing a game of hide and seek and you're " it," it doesn't occur to you, when you open your eyes and you're alone, that your playmates have fallen off the face of the earth—you know that all you have to do is run around and look for them in order to find them. ("Seek and ye shall find.") When we are saying the Name of God inside of us, we're seeking Him. Because for every action there's a reaction, God responds to any effort that we make or to any measure we put into place consistently that demonstrates that we're engaged in the activity of looking for Him.

What we're missing is that our eyes are closed and God is hiding in plain sight. Saying His Name opens our eyes so that we can see Him. When it comes to finding God, it's not that His hiding place is especially tricky—He's not hiding in a cupboard or something—He's right out there in the open and we keep running past Him in a state of oblivion. When Jesus said, "Seek and ye shall find," maybe He was saying, "Tag, you're it."

Trust the Process

There's a reason my teacher keeps telling his students, "Trust the process." He wouldn't say this unless "the process" was worthy of their trust. No matter what it looks like, no matter how many lies our minds tell us, the *truth is* we're not who we think we are. We're in the process of seeing that we can stop catering to the part of us that has built up an immunity to God's presence.

At a young age, when someone yelled at us or somehow found us inadequate, we didn't reason it out and say, "This person has a bug up their ass," we assumed that *we weren't*

good enough. The assumption that followed this was, "If we're not good enough for these people, then we certainly couldn't be good enough for God." We're here to unravel the faulty conclusions in our minds that are attached to our original assumption about ourselves. We want to recognize that each thought we have is a thread that keeps the fabric of this initial faulty conclusion together. Someone, somewhere, must have been lying, since it's well-known that "God doesn't make junk."

Catzilla

Our situation is like a cat that someone dressed up in an alligator suit, and then told the cat, "You're an alligator." The cat feels a lot of dis-ease, because it's longing to meow, lick its paws, and purr, but it's forced instead to act like an alligator. That's got to create anxiety, depression, and dissatisfaction. So a spiritual teacher comes along and says, "Hey, check it out— you're not an alligator, you're a cat," but by this time we're so bamboozled—have spent so much time in the alligator outfit—that we flatly refuse to even entertain the possibility. If we stopped believing and trusting the conclusions and assumptions that our minds are perpetually selling us, the alligator costume would dissolve and the erroneous conclusions (dressed up to look like the sacred truth) would disintegrate.

Thoughts are the threads that keep the alligator costume, or personality, intact. If we started to watch and regard our thoughts with healthy suspicion, then we could begin to see the cat that we are; we could begin to lift our paw to our mouth and clean our face. The alligator pretending to be us would kick up a fuss and say, "Oh no, you're not a cat." At this point we would have built the strength to reply, "Thanks for

sharing, but I'm grooming my fur now." We may be here to learn how to penetrate the disguise.

If it were possible for a cat to achieve happiness by pretending it's an alligator—or for a swan to be happy pretending it's a duck—somebody, somewhere, would have brought back the good news to us. Therefore, until they do, let's work to uncover and animate what lives in the heart of us. The way it is, is the way it is: we're not an alligator or a duck; we're a cat or a swan. (See Hans Christian Anderson's *The Ugly Duckling* for a useful picture of our dilemma.)

Our pretend selves are afraid of the words that are written in our inner hearts. If they can make us feel like we're not good enough, then we will forget to uncover the Name of God inside of us. Here's a metaphor for the dilemma that is identified in all sacred literature: that human beings contain both a higher self and a pretend self. Maybe our condition can best be symbolized by Siamese twins: if one of the twins is playing badminton and the other one is tap-dancing, something's gotta give. This book suggests some activities that will enable us to clear up the confusion inside of us, and to allow the part of us that we think we are to give way to the part of us that knows what it's doing.

Our Last Hurrah

We really don't know who we are or what we're doing. Someone or other concluded, after many years of study and experimentation, that ninety-seven percent of the decisions we make are guided by our unconscious: the car we drive, the person we marry, the house we live in, all of it. By the time we reach adulthood, we're just going through the motions. This may have been preceded by a rocky period as a teenager,

where we tried to break from the pattern just before it closed in. In a desperate attempt to escape our fate, we ran out and got a tattoo, adopted odd hairstyles, and generally made our parents' lives a living hell. But most of us eventually settled down to the "business" of ordinary life.

The thoughts that our minds produce are a mechanism designed to keep whatever reality we've bought into intact. I remember my son, at the age of six, saying, "Mom, I'm always thinking; it's never quiet in there; there's always something going on in my head." At the time, I thought this was pretty precocious, because it had taken me until I was in my thirties to notice how unrelenting my mind was. Prior to this I was too busy to notice because I had other fish to fry—I was running through life like a scared rabbit, in the vain hope of staying one step away from disaster.

Fred Astaire Had Nothing on Ginger Rogers

The problem is that for many of us, we have only a dim memory of who we are and what we came here to do. The idea that makes the most sense to me is that we're here to build a soul, and that somehow it's necessary to take on a physical form in order to accomplish this. The challenge, of course, is that we're doing this work blindfolded.

This makes us heroes and dear to God. Angels have nothing on *us*. As Ginger Rogers once said, "I did everything Fred did, only backwards *and in high heels!*" Seeing ourselves and the nobility of our mission from this perspective, the ideal is to turn away from our pesky, low self-esteem. Admittedly, our challenge could be compared to trying to dance *Swan Lake* with a five-hundred pound gorilla on our backs—but just because this isn't easy, it doesn't mean it's not worthwhile.

Don't Cry, Be Happy

It's not that we're here to earn God's love. We already have it. We're here to make sacrifices that will result in the gift of a more active and exciting role in His ballet. We're the big losers when we get stuck imagining that the work that's required of us is a drag instead of a precious gift. If we didn't have this opportunity, then we'd *really* have something to cry about.

If we think it's torture when we're denied something in this world that we want the way we want it, that this is the ultimate bad time, then we may be surprised when we leave this world and remember a different set of priorities. The last thing we want to discover is that we've burned a bridge (our souls) to God. Waiting around for eons in an intense state of longing for Him, and for the next opportunity to approach, is a lot more agonizing than losing our luggage.

What's All This about Burning in Hell?

There probably *is* a hell, because where there's smoke there's fire. For the most part, we haven't been convinced by our spiritual elders that we need to factor hell into our accounting systems. Unfortunately, our relationship to hell has been compromised by organized religion. It has been turned into something to terrorize and control us.

The unfortunate thing about relating to hell fearfully is that it can lead us to impractical ostrich-like strategies. It's laughable when we see an ostrich with its head in the sand in response to a threat. A realistic, less-laughable, and practical relationship to hell would be to regard it as a call to action, instead of proceeding as though it's OK to keep doing whatever we're doing. Maybe we can make better use of the opportunity we have in this world if we stop catering

to the part of us that's running around looking for life in all the wrong places.

A Working Definition of Hell

So, "What is hell?" we might ask. Maybe it's the experience of watching our souls go up in flames if we forget what we came here to do. Maybe it's the slowest and most painful death that we can imagine for our bodies, only a lot worse, because we are experiencing the loss of our souls; of something infinitely precious, beautiful, and innocent that we've built over the course of eons. This experience would bring us a new and unimaginable definition of the word pain. If we could see what was at stake from where we are now, we would dedicate our lives to creating Remembrance by saying the Name of God as if our souls' lives depended on it.

Perhaps purgatory is another name for the world that we're in now. It could be the place where we've been given a golden opportunity and a shot at Remembering ourselves. Hell isn't the bad news that we need to be afraid of. The only way it *could* be bad news is if we decided to ignore it. If God had really bad news for us we wouldn't be here.

There's No Cat Fluffy Enough

When our parents behaved badly, we became consumed with this crime against us and an ironclad story constellated around this affront. From then on, every single thing we heard, saw, or touched was filtered through this all-consuming story. Our longing for God is real; the story we built to cover our loss isn't. We never get to a genuine experience of longing for Him due to the seductions and the distractions of our story, and the fact that we are caught up in the effort to fill an imaginary hole inside of us. We have spent our lives stuffing

this pretend hole by cramming donuts, cats, and baseballs into it. This won't get us anywhere, because there's no cat fluffy enough to fill up a hole that's a figment of our imagination.

The smart thing to do when we realize we're on a track that isn't going anywhere (and we can't find the real track) is to ask for directions, to ask for help. Our pain at being separated from God has been eclipsed by the neurotic suffering of our minds. Saying the Name of God is the way to separate fact from fiction.

"You Know You're Gonna Die, Don't Cha?"

Seen from the perspective of Eternity, the identities that we've taken on have a very short shelf-life. We have to keep reminding ourselves that what this temporary identity craves (non-Remembrance) doesn't have a big payoff. Seen from the standpoint of reality, believing the mind when it says, "I don't have time to Remember" is short-sighted and foolhardy. Dedicating ourselves to what's in our best interest is a very practical issue. When Jim Morrison shouted out to his audience, "You know you're all gonna die, don't cha?" maybe he was trying to remind us not to forget to pay attention to the needs of our souls. One reaction we could have to this information is that he was harshing our buzz. Another would be to open our eyes and act accordingly.

Time Marches On and Dogs Die

When we begin to feel that remaining separate from God and oblivious to Him may be short-sighted or not in our own best interest, then we may be ready to do something more amusing with our lives. The desire to break with our current strategy may arise when it begins

to fail. We may sense the need for a new strategy when our poodle becomes a pain in the ass or our ass begins to fall. Whatever strategy we've adopted to keep "the evil" at bay—the particular levee that we've designed to hold back the pain—may be based on a miscalculation. (Maybe we weren't paying attention when we were told "time marches on," and "dogs die.") When it's beginning to seem like we're running out of options, the option that's recommended in this book (saying the Name of God without ceasing) is the only one that's all-purpose and all-weather enough, and that carries an eternal guarantee.

You're Not a Balloon

Saying Yogi Ramsuratkumar's Name establishes something inside of us that we can rely upon. The experiences in the dream that we're having have no *real substance*. Our fate can be compared to that of a balloon: we can be blown up (having our own notions about ourselves inflated), or someone can stick a pin in us. (This is where the world's opinion of us reduces us to a shriveled-up piece of plastic.) Neither of these experiences is true; we're dreaming that we're being inflated and deflated.

Once Yogi Ramsuratkumar's Name takes root in us, it is the only element in this dream that we're having that *is* immutable and true. Everything else is without substance and unworthy of our attention. Since we find ourselves shipwrecked in the middle of an ocean, our best bet is to cling to the life preserver of the Name of God, instead of pinning our hopes and our dreams on the fevered mirages of the cruise ships or handsome lifeguards of our minds. Rejecting a life preserver is silly, because given our situation, it's not like this life preserver is optional.

The Beginning of the End

The secret to not being swallowed whole by the dream we're having is to resist the impulse to interpret its meaning. Yogi Ramsuratkumar's Name gives us the ability to refrain from making judgments about our experience; it stops us from offering up our opinions about what we "think" is going on. This is good news, since we don't have the ability to stop opinionating. Mercifully, the Name of God does.

These judgments and conclusions perpetuate and strengthen the flypaper we're stuck to. Conclusions are like glue: they keep us stuck to this world of our own making. The reason this activity is doomed to produce unhappiness in us is because it disconnects us from the world of our Creator. When we begin to second-guess our unfailing omnipotence and we have an inkling that we're blind, this moment is a gift. Admitting that our ideas are wrong instead of clinging to them, and refocusing our attention while waiting patiently for the truth to be revealed, is the beginning of the end of our captivity.

I Created the Leviathan!

Et viola! The entire human tragedy/dilemma has been solved in one fell swoop! The nightmare has been reduced to its *actual* size. Now we know saying the Name of God is the honing device that we need to get us home. It won't evaporate in the morning mist and it isn't here today and gone tomorrow; it won't jack us up just to let us down—after all, it *is* the Name of God.

I remember someone telling me a story from the Bible, where God is trying to impress upon a confused mortal how powerful He is by telling him, "Don't you get it? *I* created the Leviathan!" (The Leviathan is an enormous mythical

monster in the ocean.) Why *wouldn't* saying the Name of God have the power to create an entirely different landscape inside of us? If we think we've seen power and majesty in the dream we're having, we have another thing coming—because an illusion is never a match for the sacred. Maybe it's not "Thy Will be done" ("I really want His Will to be done and I hope it will be"); maybe it's "Thy Will *will* be done."

Our Minds Are on a Mission

Saying the Name of God is the alchemical ingredient that breathes life into the piece of creation that we are. Until this happens, we may not be as alive as we suppose. We have potential, but that potential needs to be activated.

The thoughts that are running our lives are actually connected to a very specific agenda: to distract us and confuse us and to keep us out of the present at all costs. These thoughts are on a mission; they have a job to do, and they do it very well. The thing that fuels their dedication is to make sure that we never bring our attention into present time, because this is the place where God is.

Jesus in the Sky with Twinkies

A little girl I knew told me once when she was three, "Guess what? I saw Jesus in the sky." I said, "Wow! That's amazing! What did you do?" She replied matter-of-factly, "I just kept going, because me and my dad were on our way to get Twinkies."

The activity of the mind is a front for the dismantling, diffusing, and encapsulating in plastic (as in shrink-wrap) of any moment of truth that inadvertently stumbles in. It regards the Divine as dangerous, and all references to it must be obscured and dismantled. Any awareness that we might

accidentally have of beauty or truth must be killed off before it can penetrate the self-absorbed dream we're having.

The Only Good Butterfly is a Dead Butterfly

A case in point: A young man went to visit his mother at her home. Her decorative approach had a definite theme: everywhere he looked, there were homages to butterflies. They were on soap dishes, kitchen towels, needlepoint pillows, and so on. It was clear that her home was a shrine to the butterfly. One day, he heard her shrieking in terror: "Get it out of here! Get it out of here!" He ran downstairs to find her in a fight for her life with a real butterfly that had accidentally flown into the house.

While our minds *will* acknowledge that butterflies are charming, what they don't confess is that they're dedicated to the proposition that "the only good butterfly is a dead butterfly." I guess this keeps the game interesting, and we develop a lot of fortitude and alacrity as we work to create a safe harbor in us for what *is* true and alive.

The Fruit Basket

Moments of objective awareness are cumulative, and lead to a field of attention that's less discombobulated. The idea is to become less numb to the ever-present existence of the Divine. This is the payoff for putting our minds on a diet and cultivating the witness part of us. The problem isn't that we've been abandoned by God and He's nowhere in sight; it's that we're too preoccupied to notice Him because our mind's agendas are eclipsing the truth in each moment.

All of the strategies and rituals that have been assembled to protect us from our childhoods need to become less pressing. It's as though we've ended up in a revolving door,

or we're circling a runway and we never land—this way we never get the Hawaiian leis and the drinks with the little umbrellas in them. When a spiritual teacher appears in our midst or when we begin to say the Name of God, this ignites something inside of us that catapults us out of the revolving door so we can recognize that there *is* life beyond our fruitless relationship to it.

The "problem" with being propelled out of the revolving door is that we might be free to go to the reception desk, get a room key, go up to the room, and get the fruit basket. This is a problem, because we'd have nothing to complain about anymore. To the chronic complainer in us, this represents death—the end of an era, the end of our conviction that God doesn't love us.

Our minds are on a trip and they're under the influence of a powerful drug. Luckily, this drug is no match for the power of God.

The Endless Hiccup

We're oblivious to the fact that we're stuck; that we have no more chance of finding freedom than an insect pinned to an entomologist's display board; that the needle is stuck in our record and we're doomed to producing a mere hiccup over and over and over again. It's gonna take something very powerful to lift that needle or to free us from the board.

Because we believe we have a life, it's difficult for help to reach us. If we don't know that we're helpless, what would inspire us to reach for help? In and of ourselves, it's impossible to escape the sure-fire and inevitable trajectory of the dream we're in—this would be like asking a cat to design a clothing line. I don't know about your cat, but I can't even get mine to pick up a copy of *Vogue* for inspiration.

No Way, No How

We can appear to be leading our lives with enthusiasm, but we may only be mimicking genuine involvement. This could be because we decided that, at all costs, we'd stick to a conclusion we made about life. We may have struck a secret pact with life to never do anything new, to never see anything new, and to spend our lives re-hashing one particular moment in time. Our participation in life may be limited to nourishing our initial decision: "No way, no how, you mother f*****s!" more than we realize. Our creativity and spontaneity may have been sacrificed to the important task of accepting and colluding with every problematical and defeatist little thought that appears in our heads.

In a business negotiation, if the person is moving in the opposite direction we want to go, we don't just lie down in the road and invite them to run us over. By the same token, we don't have to buy all of the pessimistic and life-negative thoughts that appear in our heads. We can recognize that these thoughts are rooted in a conclusion we made decades ago, and we can begin to question their validity. We can look underneath them and begin to suspect that they are disconnected from our well-being.

Changing the Course of History

Yogi Ramsuratkumar's Name is a powerful elixir that He carried down from heaven. It is able to thaw segments of the frozen time-space continuum that we're in, in order to allow revelatory and creative responses while we're in this dimension. Sixty days from now, you'll yell at your child and make his bones hurt—this has been preordained since the beginning of time. The only way to avert this disaster and create a different outcome is to pull out Yogi Ramsuratkumar's

Name. In and of ourselves, we *can't* rewrite history. This being a given, it's a good thing that Yogi Ramsuratkumar's Name *can*.

Since we lack the ability to change the program, let's regard His Name as the miraculous Advent that it is. Let's keep it handy, dust it off, remove it from the inaccessible shelf that it's been sitting on, and keep it close to us at all times. The Name of God is the remedy for all our sorrows, real and imaginary…but only if we use it.

Never Trust a Winged Monkey

Draconian: A designation, law or code of extreme severity; exceedingly rigorous or harsh; draconic or relating to a dragon.

The dragon that's actually behind the scenes pulling our strings doesn't usually show itself, it sends little minions dressed up in cute costumes to control us by suggesting that we don't need to work to Remember ourselves in this moment. They recommend that we continue to bask in a false sense of security by convincing us that the forces that are governing our lives aren't all that bad. In the fairy tales, the evil queen always has soldiers to keep us in line. She doesn't have to personally attend to each of her captives; she has wolves and flying monkeys to do this work.

Don't be fooled when the mind tells you, "It's too much trouble to say Yogi Ramsuratkumar's Name and to watch my mind." Just because the voice is charming or cute doesn't mean it's benign. If we're not following the instructions of our spiritual teachers and we're choosing to do it *our way*—if we're taking our direction from winged monkeys—then we won't be able to see who's sending us our thoughts.

Because we're in a frozen time-space continuum (a Narnia-esque endless winter), the practices our teachers give

us are designed to thaw us out so that we can move into a continuum that's alive.

"Lord, Make Me Pure—But Not Yet"

If we brought objective intelligence to the process of examining the false imperative that informs all of our days and all of our nights, it would be impossible to avoid the conclusion that this isn't a winning formula. Maintaining a relationship to life that's exclusive and independent from our Creator (the very ground of our being) is hilarious at best. Talk about cutting off your nose to spite your face! It only appears as though we have two choices: to be used or to be useful. Since the fundamental intentions, or qualities, that back all of the created and uncreated worlds are Praise and Worship, sooner or later "Thy Will" is going to be done. Sidestepping who and what we are by giving ourselves over to a seemingly endless array of loopholes has a limited shelf-life. A loophole is a delaying tactic that we're employing to fend reality off with. I think it was St. Augustine who said, "Lord, make me pure—but not yet."

Sleeping at the Wheel Isn't a Plan of Action—It's an Accident Waiting to Happen

We're either going to build strength and resilience and consciousness in order to navigate in the demanding dimension that we find ourselves in—another way to put this is, we're either going to make space for our real selves to guide our activities—or we're going to crash and burn. Sleeping at the wheel isn't a plan of action—it's an accident waiting to happen. It only *appears* to be viable.

The guidance and the help we receive from a spiritual teacher who's been around the clock and knows what time it

is, is pointing us in the direction of waking up for a reason. All of the activity of a person that's sound asleep is backed by one single and counterproductive imperative: *Don't let God in no matter what.* Scripture, the words of a qualified spiritual teacher, and the repetition of the Name of God are here to remind us of a new and more delightful imperative.

Chapter Two

The Bowling Ball,
the Alligator and the Rose

Swimming Against the Undertow

All religions suggest that we contain two selves: a higher self and a lower self. Someone who has been in the company of a spiritual teacher for a long time has made a whole bunch of decisions over days and years that were about giving it up to the higher Self. What we want to do is benefit from their example and begin to take up the welcome mat that's been in front of our door for the lower self, while engraving an invitation to the real self. This requires us to switch our allegiance from one part of us to another.

This process could be compared to building a house: it has to be built brick by brick. We can't be off in the distance saying, "I'd like to have a house over there." We have to pick up the first brick and add another one to it. Surrender to God is constructed from lots and lots of tiny sacrifices/bricks. Spiritual training teaches us to swim away from the subhuman undertow of things like pride, jealousy, and retribution.

It occurs to me that we may be here to earn a point of view. Maybe the point of view that we think is ours (that was superimposed on top of us as children) is so unworkable because it hasn't been earned by forging it with consciousness in the light of day.

Looking Good and Going Nowhere

Up until I met my teacher, I thought things were going well and that I was having a relatively good time. I spent

my twenties traveling around the world, living and working in a number of exotic places. In my thirties, I parlayed an unusual amount of inability (the fact that I didn't know how to draw didn't seem to be a stumbling block) and a complete lack of education into a successful career in the art world. Everything was going pretty well—possibly due to my natural disposition towards optimism, cheerfulness and denial—but I had yet to get to the bottom of the questions that had driven me nearly out of my mind in adolescence: "Who am I? What about God? What is this place, and what am I supposed to be doing here?" Somewhere inside of me I knew that I was here to do more than shop, and that even though my life had the appearance of working, something was seriously out of sync.

I'm grateful to my teacher for helping me unravel the mystery of my existence, for setting me on the right road, and for allowing me to see a new set of priorities and possibilities. The first order of business in this process was to divest me of some of the illusions that I had about who I was (separate from the rest of humanity) and about just how workable the relationship that I had built to life *really* was. When I met him, I was spectacularly unclear about where my impulses to say things and do things were coming from, who or what was running my life, and how much conscious participation was true of me. At this point, unbeknownst to me, I wasn't on very good terms with life. All I'd managed to do was carve out a very shaky replica of the thing itself. This was a classic case of "looking good and going nowhere."

The Unbearable Heaviness of Being

We carry an enormous amount of unconscious fear and tension inside of us. Somewhere in the depths, there's a

terrified little child waiting for the axe to fall. I had a bizarre experience a long time ago: I walked outside one night after one of my teacher's talks and found myself in a different state than I'd ever been in before: all of the fear and the tension inside of me had mysteriously disappeared. The contrast between the lightness of being that I was experiencing and my usual state was so great that I remember remarking to myself, "It's as though I've been carrying around a giant bowling ball all my life without even knowing it was there." Since this burden was unconscious, the experience of having it lifted from me was the only way I could have identified its mass and weight.

I think the reason we assume that it's impossible and not advisable to part with all of the energy of resistance and tension that's driving us is because, for most of us, we haven't had the experience of a "free moment" like this one. Without the experience of having the bowling ball lifted, we can't imagine—from where we're standing now—that it would be possible to continue to exist without tension and resistance. We assume that if we don't keep feeding a life-negative relationship to life (if we don't keep sustaining and nourishing our bowling balls by giving admittance to and following thoughts that add additional substance to these bowling balls) that we will die. But, as it turns out, the opposite is true.

Our situation is similar to that of a person who was introduced to Cheese Whiz (one of the most disturbing inventions of modern man and possibly an indicator that we are in the end times) at a young age and has grown up to believe that real cheese is dangerous and incapable of sustaining life. The trick here would be to wean oneself away from Cheese Whiz (from problematical and prejudicial

thoughts and states), in order to create the necessity and the space inside of oneself for real food. Little do we suspect that we are trading our possibilities for a way of being that is insubstantial, and that we are addicted—unbeknownst to us—to a form of nourishment that's depleting us rather than strengthening us. Putting our minds on a diet is necessary so that we can wake up one day and see the Cheese Whiz for what it is. Until we do this, we will be too bloated to notice. The next time that we feel tempted to fly into a rage, we need to see this impulse for what it is: just another Cheese Whiz craving. I think this is worth doing, because the people that I've met that aren't in a Cheese-Whiz-induced trance seem to be the ones that are having the most fun. Perhaps these ideas are connected to Christ's instruction that we need to die to who we are in order to be born again.

When I was parted from my bowling ball, not only didn't I die, but the value of being separated from this bowling ball was soon to become apparent: My three- and six-year-old children came running down the path to greet me, in the midst of a sibling-rivalry hell-realm that had something to do with a Star Wars toy. When they got within three feet of me, they mysteriously and abruptly abandoned their contentious and fevered states. Since they were able to intuit that I wasn't the same person that I was the last time they saw me, the necessity to act out and express my tension no longer had a point. Because harmony had been restored within my being, I was able to see that my bowling ball had been seriously messing with them, that they had had no choice but to take on my tension and act it out in the desperate hope of driving me into the present. When they were "behaving badly," they were merely reflecting and expressing all of the tension inside of me.

40

Our children are very open and susceptible to the states of the people around them. Even when we're trying very hard to be patient with them and to be nice to them, they always produce an accurate reading of what's *really* going on inside of us. We're all reacting against the state of fear and tension that we inherited from our parents. This is the black hole that our parents took in when *they* were faced with the unexpressed and hidden pain around *them*. I remember surprising myself one day when I was writing about my childhood with this phrase: "It was as though my grandmother hooked up a garden hose from her mouth to mine, and pumped all this black sludge inside of me."

Since the chain of pain extends back farther than recorded history, it's unlikely that we're going to be able to run the initial troublemaker to ground. What's more likely is that we will misspend our lives in an effort to exact retribution upon those that come after us. Perhaps the acts of terrorism of today are the expression of our unconscious habit of holding the people in our lives hostage because of the love we missed. This activity (projecting our anger from the past on top of whoever is in our line of sight) could be considered a bizarre and aberrant form of "paying it forward." But blaming our dense parents for the pain we're in is like blaming a blind person for not noticing that we're in the room. If our parents are up to their asses in denial, or if they're dead, it's a fair bet that they're not coming any time soon to clean up the mess we've inherited. The only thing we can do at this point is to serve the child that's in front of us by unraveling our own blindfolds.

The Rose and the Bowling Ball

The interesting thing about these hidden masses of pain inside of us is that they have a purpose: when treated properly,

they can be turned into fertilizer and be a wonderful source of nutrition for a rose to develop inside of us. I think what we're supposed to do once this rose is established is to offer it to God.

The important thing is to not go back to where we came from with our rose still buried inside of us. Should we fail to accomplish our mission, maybe the sadness that we feel will strengthen our resolve to do something for God the next time we have the chance. Maybe this time, our yearning to help will outstrip our fear. But why not do what we've come here to do now?

But, first things first: we're going to need to do something more creative with our bowling balls than add more weight and mass to them. It's never a good idea to elevate them above their station; treating fertilizer like it's the main event leads to a messy situation. We do this by protecting the bowling ball/manure and making excuses for its skewed behaviors. This approach has never worked in the past; ergo, it won't work now. Catering to this neurotic mass by insisting that it has another nature than it does, and defending it and making excuses for it while refusing to see it for what it is, doesn't get the job done—deferring to and remembering the Divine when our fertilizer tries to subsume our lives does.

What we want to do is to separate out from it instead of feeding it and engorging it any further. Separating from this mass allows it to be broken up into useful components that can fertilize the innocence inside of us. This is a far better-case scenario than spending the rest of our lives being ordered around by a bowling ball or a pile of manure. When we starve and break down our neurotic selves and begin to fuel and nourish the innocent and the Divine part of us, this is where we get to exercise the creative genius we're capable

of. This act of creativity could be seen as additional support for the maxim that all genuine art is preceded by an act of anarchy that breaks with the way things have always been.

The High Price of Low Thoughts

Another thing to factor in about the impact of our bowling balls is the effect that they have on our teachers and saints. Since the ones that have come here to remind us of God can only do this if they're in an open and vulnerable state of Remembrance, it must be agonizing for them to be surrounded by people like us, who are silently shrieking in terror all the time. We can't hear ourselves, but they can—it must be like being locked in a cage full of howler monkeys.

For this reason, I sometimes find myself involuntarily making efforts to turn down the volume when I'm around my teacher. This involves cutting off ungenerous and prideful thoughts at the pass with Yogi Ramsuratkumar's Name. Something inside of me knows that my teacher's hearing is painfully acute. When I get around him, I'm sometimes moved to spontaneously part immediate company with the crazy and mean thoughts that are drifting through my mind, even if they're fairly innocuous, like: "I don't care for her shoes." The part of me that wants to refrain from doing harm leaps to counteract a thought like this with Yogi Ramsuratkumar's Name. It can also see that a thought like this is connected to my bowling ball's fear, and is designed to cut me off from communion with someone by pronouncing them fashion-challenged.

The likelihood that Yogi Ramsuratkumar's Name will arise inside of us in response to a critical thought when we're around a saint increases exponentially if we're practicing the repetition of His Name during the off-season (in a saint-free

zone). Of course this is tricky, because sometimes saints are hiding in plain sight in the middle of K-Mart, and it would be nice—since they probably have their hands full taking on all of the pain around them—if we could be one less turkey to baste or one less terrified voice to listen to. "Attention K-Mart shoppers: Are you saying Yogi Ramsuratkumar's Name?"

The Offer We Couldn't Refuse

When we arrived here as babies, we were functioning from a place of benign, agenda-less purity. Because our caregivers had, somewhere along the line, misplaced their own connection to innocence, their unconscious and insensitive treatment of us—at a stage when we were very vulnerable and defenseless—made it necessary for the alligator to appear and protect us from further harm.

Its strategy went like this: It convinced us that the only way to not be destroyed (by the pain and shock that the innocent always experience when they're treated to the disregard of the world) was to put ourselves under the guidance and protection of a false self in order to cushion us from the blows of an uncaring and heartless world. ("Here's what we're going to do: we're going to approach our experience in this vale of tears by buying into the tacit assumption that life has it in for us—this way we'll never experience this pain again. From here on in I'm in charge, and I will continue to send you an overabundance of thoughts that will prove conclusively that this thesis is true. This idea must be upheld no matter what. Should there be any deviation in the pattern we're setting up here today—should any new information try to intrude upon the way we're wiring up your experience at this moment in time—these intrusions and the intruders that carry them will be dealt with swiftly and ruthlessly.")

When we were a baby, the offer that was made to us was one that we were in no position to refuse. Continuing to allow the love that we are to shine would have been too scary for the alligators that were running our caregivers; *their* alligators would have been so rattled by this bright blip of innocence that they might have convinced them to skip a few of our feedings. When we connected up the alligator's strategy to protect us with the true piece of information that our lives were at stake here, this created a powerful bond between us and the life position we're continuing to play from.

Welcome to the Nightmare

Here's an example from the world of TV of what tangled webs our minds are capable of weaving. There's an episode of the show *Samantha Who?* that illustrates just how deadly the conclusions in our minds can be. At one point, Samantha's boyfriend is inspired to create a gift for her in order to bridge the fear and suspicion gap that separates them. He paints a beautiful mural of Paris to delight her heart, and pins it up in her bedroom. When he wakes up in the middle of the night and looks across the hall and realizes that she hasn't come home, he jumps up and rips the mural down because he's propelled by a conclusion ("she's in bed with another guy") that's connected to some childhood conclusion that's running his life instead of reality.

Someone that had a different take on life might have extrapolated differently: "Oh my God, she's been run over by a bus!" (In reality, she had spent the night in jail.) Her boyfriend didn't know he was at the mercy of another knee-jerk reaction—based on a subjective and short-sighted relationship to his life—and nor do we. Had he developed the habit of relying upon countering the conclusions in his

head by clinging steadfastly to the repetition of the Name of God, while he lay in bed he might have found it easier to resist the temptation to destroy a genuine act of love. Welcome to the nightmare—the one where we don't get to do the thing we were born to do: to give and receive love.

The Trade-Off

We all made a decision to forego an ecstatic relationship with life in order to protect ourselves from the unbearable tension around us. We concluded that it was impossible to enjoy life and stay safe at the same time. This was a trade-off that we were forced to make, and one that seemed like a good idea at the time—it was kind of like trading in a Mercedes for a Nash Rambler. (Now that I think of it, my first car *was* a Nash Rambler. It only ran for three days because I neglected to look under the hood. I was blinded by the fact that it was a convertible, the radio played, and it was turquoise.) We don't realize—when we decide to trade in our joie de vivre for the full-time job of protecting ourselves from the painful distortions in the world around us—that we're making a bad bargain; that we're going to spend the rest of our lives in a state of quiet (or noisy) desperation; that keeping these Nash Ramblers on the road will be more expensive and time-consuming than we imagined.

This puts a different spin on the "terrible twos.'" Maybe this phase is merely the death rattle that ensues as we begin to see that we're being asked to sacrifice our perfect and innocent relationship to life.

Having Our Cake and Eating It Too

If this book is about anything, it's about the fact that saying God's Name allows us to "come as we are" to the party

of this world. We're here to find out that we don't need a fancy outfit and that we're perfectly presentable as we are.

Our distracted and confused egos don't have the ability to separate from the bowling ball of terror, but His Name does. When we become sick and tired of the "I can never get to have my cake and eat it too" scenario, the yearning inside of us for freedom reaches a fevered pitch. At this point, it becomes clear to us that His Name is the way into, out of, and through all of our pain. This pain is rooted in the unconscious feeling (somewhere inside of us) that we've been sold a bill of goods and that we're driving around in a Nash Rambler. What hurts so badly inside of us is that we've been cut off from our innocence; at some forgotten level this is agonizing.

The Name of God drives a wedge between who we've come to think of ourselves as and the innocent one that we are. It's necessary to create some separation between the real and the pretend in order to begin to Remember ourselves. Our neurotic and anxious dispositions are just the tip of the iceberg. This iceberg/bowling ball that's under the surface isn't just anxious; it's in a state of abject terror. The real part of us is cut off, lost and alone, and it knows that it doesn't have the power to make it to the surface.

The Lilies of the Field

It's interesting to note that pushing and shoving in order to get our needs met isn't a very effective wealth-accumulating strategy. Luckily for us, there *is* a way to have your cake and eat it too: when your attention is fixed on God, on being of service to something higher than yourself, you'll be given everything you need in this world. Maybe this is why Jesus said, "Seek ye first the Kingdom of God ... and all these things

shall be added unto you," and why we were encouraged to model ourselves after the lilies of the field. ("They toil not, nor do they spin.")

What we think we know will kill us. Getting a life (an eternal one) requires forgetting everything we ever thought we knew. Becoming a "real" bunny requires us to let go of the idea that we're a stuffed bunny. (See the children's book *The Velveteen Rabbit* by Margery Williams for further clarification.)

The Big No

Rather than deal with and accept the obvious (that we're going to die), we banish this catastrophic truth to a place below our conscious awareness. We may profess to an awareness of our fate and we may even hear ourselves say, "*I'm* not afraid to die!" But I wonder if we know what we're talking about? I wonder if the tension and anxiety that we carry throughout our lives isn't connected to the "big no" that we've banished to the furthest regions of our awareness. Every time we counter whatever life is offering us with the "Oh shit" response, every time we give a circumstance or a person the power to unmake our day, maybe we're giving expression to this fundamental fear. The only reason we have something left to lose (never an ideal position to play from, as evidenced by the fact that in Vegas "the house always wins") is because we haven't made our peace with the inevitable. This puts a serious damper on our capacity to serve and to enjoy life, green grass, and the good company of others. When we're always on guard, micro-managing the moments of our lives in order to stave off the uneasiness in our gut, where would we find the *time* to worship God?

The Alligator and the Alarm Clock

Why trust the planting of a rose to an alligator, our egos, or a bowling ball? This part of us will just roll over it or tear it up. Our job is to separate from these inelegant forces. God is in charge of planting the rose and we're in charge of cleaning up and fertilizing the planting bed. (I guess this is terrible news for some of us if we see it this way. Another perspective would be: This is nice work if we can get it.)

There's value in knowing our alligators and what they're capable of; in becoming familiar with the time-honored strategies that they have used so far to keep us out of the present and to distance us from our job. This is analogous to Captain Hook throwing an alarm clock into his alligator adversary's mouth, so that he'd hear the clock ticking and have a heads up when his nemesis tried to sneak up on him. Getting to know the ways your particular alligator shows up is useful, because you can observe the agenda of your thoughts more clearly as these thoughts are taking form. Knowledge is power; we want to see the particular bias of these thoughts. If being at the mercy of time is your psychology's bias, then you can regard any thought or attitude connected to this bias with skepticism (i.e., "I don't have enough *time* to do this job properly; I don't have *time* to meditate today," and so on). We can become suspicious of any thought that's connected to a particular aspect of neurosis that we've identified (tick-tock, tick-tock).

Life becomes more fun once we know our alligator. When it tries to creep up on us and trick us (like the wolf wearing grandma's nightgown and shawl), we can clap our hands with glee and say: "I see you, Mr. Alligator!"

Isn't This More Fun Than Being Eaten?

Isn't this more fun than being eaten? Yes! But we need to identify with the one that's excited about seeing through the game. The alligator is in a babushka, out in the cold, pressing its nose against a window, looking in at a warm room with a family enjoying a turkey dinner, and it's whispering in our ear, "I can never get what I want or need." Get a clue—it's just that silly old alligator again. It's only these madcap alligators dressed up in costumes that are standing between us and the planting of our roses. It's worth noting that these alligators are insomniacs—they never sleep. If you think you're doing a good job of noticing your alligator's nefarious input then it has you in the dark, just where it wants you. When you've begun to see some of the tricks in its bag, what you want to remember is that its bag is really big (not worthy of your attention, just big).

The Game

Here's how it works: Any time someone or some element in the dream we're protecting presses the button that's connected to our decision about what life has in store for us (based on a conclusion that arose in order to protect us from an initial traumatic experience), this button-pressing creates an uproar from the one that's in charge of making sure that we don't stray from this decision. If our decision was "I can never get what I need," nothing will rile our alligators up more than someone pointing out—while we're in the midst of listing all the evidence that we're being "denied the goods"—that we're lucky and fortunate. It's at this point that the alligator marshals its considerable force and brings its artillery to bear, taking direct aim at whomever or whatever has dared to introduce a new point of view.

50

This is war. Our job at this point (once we've seen how tedious it is to stick to our script), is to unleash an opposing army by saying Yogi Ramsuratkumar's Name. We don't want to lie down in the middle of the road and allow the alligator army to run us over or, worse yet, allow ourselves to be captured and duped into fighting alongside it against the truth.

The Light of Day

At some point, enough of the truth that endangers our pretend worldview sneaks in, and we've got enough evidence of an opposing viewpoint to begin to side with God, our inner selves, or a spiritual teacher (if we're lucky enough to have one) and take a few risks with our attention. Paying attention to the survival strategy that's been running our lives is the equivalent of paying protection to the Mafia. When we stop paying attention to what our minds tell us and we neglect to pay out protection money (attention), we're nourishing the part of us that's still in there that wants the truth and that wants the Will of God to be done in us and through us. When the goon that the Mafia has sent to collect from us at our candy store arrives, we may be surprised to notice that he's less powerful than we imagined. When we see that all hell *doesn't* break out (just a little—and that our kneecaps are still intact) we can say, "No, I'm not going to be paying you protection money today. I'm going to use my money/ attention to contribute to a better cause." Any sincere efforts that we make to cooperate with the truth over and against the lie will be rewarded.

No Alligators Allowed

Every time we don't pay out for protection, and we take our money/attention and use it to contribute to the freedom-

fighter fund (i.e., Saying Yogi Ramsuratkumar's Name every time we wash a dish, if this is the practice that we've committed to; reading a sacred book that reminds us of a higher perspective; asking God for help; or saying our prayers at night as we fall asleep), we are making a contribution to it. Activities like these are designed to help the alligator begin to cut his losses and start packing it in. Every time that we say the Name of God, he throws another piece of underwear or something into his suitcase. The handwriting is on the wall, and he knows it. Provided that we're consistent, he will continue to pack, because he knows his days are numbered and that the day (the happy day for us) is coming when he will no longer have a home inside of us and he'll have to look elsewhere for a place to live. Every time that we see through a thought connected to complaint and dissatisfaction with the way things are, and refuse to allow it to take root inside of us, we're adding another brushstroke to our "No Alligators Allowed" sign.

Serving the one that's serving us by telling us the truth, instead of routinely following our alligator's agenda ("What we need to do here is to move from the place of me first, and the hell with the rest of you!") is a great step forward. Asking ourselves "What can I do for the one who is tirelessly and painfully serving my awakening?" will liberate us. In other words, "Ask not what your country can do for you, rather, ask what *you* can do for your country." This is a whole other way to go. If we can begin to do this, this leads to a veritable packing flurry. The minute we begin to serve someone who's serving God, this signals the alligator that we've discovered a more fun master and its days are numbered. ("How you going to keep them down on the farm, after they've seen Paree?") Once we figure out that serving God results in, and

is connected to, an infinitely more fabulous reward system than serving some messy, scaly and clammy old alligator, the tables will turn.

How to Help an Alligator Pack

Demonstrating to the universe that we can follow directions will always lead to a promotion. Mastering the fine art of moving in the opposite direction of our ideas and our personal preferences has a definite payoff.

When we find ourselves in a spiritual school or in a marriage or at the mercy of the workplace, we have an opportunity to learn to follow instructions without improving upon them. This is the ideal way to learn to serve someone or something besides our minds. It's a challenge if the person you're working for is too f****d up to live, but what we want is to master the skill of serving without complaint and without insisting that we know better, because learning to follow something, *anything*, other than our nihilistic and petty alligator, will catapult us to freedom. The only way to get the alligator to pack is to start doing what someone outside of us is telling us to do; to defer to someone else instead of our superior minds. Wherever you're placed in a lineup of those that are serving something besides their own version of reality, say yes to whatever is asked of you "until it hurts." In the real world (God's world), people never receive a promotion until they've learned to do the job they've been given cheerfully and gratefully.

If you end up in the middle of the Black Forest with only a rock and a pine cone, do something with what you *do* have. Be creative and don't waste time whining. Resenting what we've been given is a sucker's game.

Of course, we've been given a lot of examples of people behaving badly in this world; we've seen people stabbing

other people in the back in order to get ahead. If we follow the model that the world is demonstrating, we may regret it. We need to resist the continual pressure from our outer selves to do things how and when they want to, without grace and kindness.

One reason that continuing to move from self-absorption is flawed is that serving others is the only way to get *our* needs met. Ironic, isn't it?

The Game At Hand

At some point, each of us has to begin to work against the decision that we made to stop contributing because it was too painful. (This is what big people *do* to little people: they invalidate their possibilities and their contributions.) The only way we can reverse this decision is by calling into question the thought that we're having *right now*. This is because the thought we're having right now is always attached to the decision we made to go unconscious and allow the gift that God gave us to remain dormant.

A spiritual teacher is like a quarterback running down a field, and what he needs are teammates that are open and receptive to passing the ball; teammates that have become more interested in the game at hand than in recreating a game that was played thirty or forty or fifty years ago when they were children.

The Invisible Giant Ears

When we were babies, and someone was changing our diapers and they said, "You stink," (playfully or otherwise), the information that we were less than perfect was so shocking that we grew a pair of invisible giant ears in order to take in data for the rest of our lives that matched up with

this assessment of us. The implications of a remark like this were so catastrophic that we couldn't hear anything else for the rest of our lives.

My teacher has said that we keep replicating an original horrific moment because we become addicted to the experience of surviving the worst over and over again. In whatever environment or circumstance we're placed in, our giant ears are hell-bent on filtering out anything that doesn't support the initial bad news. We're like pianos where all the keys are broken except one. If, when we grow up, we can't get somebody to criticize us, then we'll spin their words, and "mis-hear" and distort what is being said to us.

Our real ears that are waiting inside of our crazy big ears have become dormant from lack of use. Our real ears have the capacity to interact with and experience the full spectrum of life *as it is here and now*. Questioning the data that comes in from the aberrant ears, discovering that this information isn't reliable and genuine, interrupting the phony feedback loop by not letting more false information penetrate us and take up lodging in us, results in waking up the real ears. Because the real ears can hear the music of the spheres, it might be refreshing to defer to them. The problem isn't that we're not in the Garden of Eden; the problem is that we don't *know* that we are. Every time we allow the big ears to reinterpret reality for us, it sets up a cacophonous environment that drowns out our ability to hear the truth.

There's an expression in Italian: *non me prende en giro*, which means "Don't take me for a ride in circles; don't take me the long way around." Being guided by the input of the big ears is the equivalent of being taken for a ride by a nefarious taxi driver. We're also behaving like spinning tops that are spinning *against* life. This is probably why whirling dervishes

counter anti-life circling with circling that brings us into relationship with Worship and Praise.

One of the gifts of a spiritual teacher is that he explodes the myth that the miraculous *can't* show up any time, anywhere. In the moment when our assumptions are pierced—intruded upon by the sacred—he can be seen jumping out of the bushes with a giant cake and a huge smile, exclaiming, "Surprise!"

The Alpo Effect

Our minds have an infinite capacity, when presented with something true, to clamp down on it and make us think that we know what's happening in order to guarantee that we never experience anything inside of our hearts, and to make sure that they're never exposed to the truth. Maybe they say "Gather ye rosebuds while ye may" because we're here to gather rosebuds, not to walk through our lives like zombies.

Any time we're paying attention to the words of a spiritual teacher—and we're attending to the words they're saying with our inner ears instead of our outer ears—we're gathering a rosebud that we will be able to take with us as part of our eternal being after we leave here. When we listen to something sacred with our outer ears, these ears have this knack of dissecting and disarming anything true and turning it into something to be used as worm food, along with the rest of the corpse that we will leave behind. When we listen to a spiritual teacher's words with our outer ears, we are turning his words into dog food that can only nourish our mortal and imaginary selves. This is why it's so important to listen to a teacher's words with the part of us that not only welcomes these words, but is depending on them for its very life.

All We Need Is a Screw Gun

The presumptions we've superimposed on top of life are like a stage set and our thoughts are the screws that hold it together. It's a relatively quick and painless process to disassemble the set—the ego doesn't tell you that all you need is a screw gun (saying Yogi Ramsuratkumar's Name). The truth is, if you *didn't* have a screw gun (if you *didn't* have Yogi Ramsuratkumar's Name), *then* you'd be screwed.

The Little Gene That Couldn't

The picture spiritual students have of what they're up against (their psychological self and their egos) is inaccurate. It turns out that the neurotic imperative that's been putting a damper on our inner lives isn't as powerful as we have been imagining. If the point is to stop being moved from a place inside of us that's immune to the charms of life—and even more than this, resents it—then here is a way to see this part of us that's been holding up the show for what it is: The resentment gene is only one gene out of thousands of genes that make up our being; we also have worship genes, celebratory genes, music-of-the-spheres genes, and many, many others. Just because this one gene is always saying that life is unfair and devoid of benediction, it would be a mistake to be too trusting of this particular opinion, once we begin to see that only one gene has been speaking for our entire being. Just because it has maneuvered itself into a place of dominance doesn't mean that we need to keep encouraging it by listening to it.

What we need to do is to drown out its loud and obnoxious voice with the Name of God in order to hear the voices of some of the other genes in the gene pool. Perhaps if we viewed the part of us that's neurotic as only one crazy

gene—instead of seeing it as having a really big life and being really powerful—this new perspective would enable us to be less responsive to its insistence. Then we could say, "Pipe down little gene; we've heard quite enough from you. I now know that my genetic inheritance is vast and fabulous and I'm on a quest to meet up with all of these other exciting and interesting places inside of me. You've had your day, and succeeded quite nicely in convincing me that your voice—the voice of fear and anger—was the only one worth listening to." In this way we could take hold of our states, our moods, and our thought patterns, and refuse to be at the mercy of this part of us because it's not the whole ball of wax. This one part doesn't have the authority to speak for the full spectrum of who and what we are. It never even got a permission slip; it just took over and it pretended to represent all of us.

The game of complaint and dissatisfaction that's been running us ragged isn't the giant and heavy boulder standing between us and the light that it's cracked up to be; it's only the voice of one aberrant and clueless little faction of our being. Seeing this part of us in all of its insignificance (matching up its relative importance with the information that we contain tens of thousands of other genes) should make it a lot easier not to trust it, confirm it, nor to follow it around. Not only doesn't this gene own us, it isn't even who and what we are— its importance in the relative scheme of things has been blown way out of proportion. Making our lives an effigy or a testimony to one aberrant gene defies the law of reality. Since it's never in our best interest to do this, this would be a good time to stop paying attention to it and to give our energy over to more inspiring and fascinating parts of our being.

When we discover that our lives have been co-opted by one cranky little gene, the desire to blow it away may arise.

In the movie *Tremors*, when the giant worm breaks into the survivalists' bomb shelter, it's greeted by a couple in army fatigues, holding giant elephant guns. The wife says, "Well, I guess you just broke into the wrong damn rec room now, didn't you?!" just before blowing it to kingdom come. In our situation, elephant guns lack the required finesse and subtlety. Quietly and persistently denying the aberrant gene our attention and support is a more elegant and dignified approach; reducing it to a state of emaciation by walking in the opposite direction of where it's telling us to go while remembering God is more artful.

Come to think of it, this strategy might be worth trying on cancer cells: instead of blasting them with radiation and chemotherapy, we could simply alter the acidic environment that they thrive in and flood them with oxygen, which they don't like.

Chapter Three

The Mind:
The Twilight Zone of Half-Truths

The Curse of the Merry Pranksters

Life is about making bad bargains and good bargains. Neal Cassady (Dean Moriarty in *On the Road*) had an unusual amount of energy. Ken Kesey and "the merry pranksters" (merry pranksters *indeed*) were devouring him. This unhappy situation remained in place for a long time because Ken was Neal's drug supplier. It struck me at the time that Neal had made a bad bargain. If they don't say "Addiction makes for bad bedfellows," they should. The end of Neal's road was *not pretty*.

It's been said that drugs show us the map of where we want to go, but the joke is we can't get there on drugs! The opinions in our minds are like drugs. Since we're prone to being led astray, to being distracted by the *appearance of truth*, we need to develop a place in us that's prone to the truth. The way to do this is by looking at and questioning our minds instead of going along with their hair-brained schemes. Problematical thinking that goes unnoticed is not unlike methamphetamines—it's a hard way to go.

Throughout the day, bringing some needed perspective to all the things we "think" are problems (like getting our hands dirty, or losing our favorite belt, or the cellulite on our thighs), enables us to withdraw from the twilight zone of dissatisfaction and complaint. The Name of God is the answer to all of the "Oh shit" thoughts in our heads. As the father of a friend of mine used to tell him: "If you had

a real problem, it'd f***ing kill you!" (Out of the mouths of tyrants …)

The Bad Guest

Remembering God is the remedy for all of our fears. We're free to the extent that we don't prefer one thing over another—could there be anything here that's *not a gift* from God? One way to view the climate of our minds is that we've been invited to a classy dinner party and we're nitpicking about the food ("I'm ever so fond of this, but I don't care for that"). Why not just reach across the table and slap the Hostess across the face? Demanding special foods that conform to our dietary "needs" and leaving food on our plates are the hallmarks of the bad guest—it's rude.

Whenever We're Thinking, We're Behind Enemy Lines

The forces that are less than human that inspire most of our words and deeds employ the same strategy that we see played out in wars. When Hitler began his march across Europe, the idea—the point—was to capture, dominate and control one village at a time. When the forces of destruction began their occupation of us, they headed straight for our minds. They set up camp there and they've been holding sway over them ever since.

The objective of capturing our minds is to keep us from discovering the still, quiet place inside of us that's capable of hearing and moving from the truth—the France in us that's more innately disposed to celebrating a fine wine and an extraordinary piece of cheese than it is to colluding with the agenda of world domination. Just because our minds are the place where the anti-truth forces have infiltrated and set up camp, the solution isn't to engage in a war with the

propaganda machine that's controlling our thoughts; the solution is to build upon the Remembrance of the truth that continues to live untouched inside of us, to support and nourish the territory that remains free and unoccupied. The repetition of the Name of God is the most powerful ally that we have at our disposal.

With Minds Like These, Who Needs Enemies?

The work of a genuine spiritual teacher begins with a realistic appraisal of the situation. They will always remind us not to pay attention to the distracting information in our heads, so we can Remember the essential truth (that "the kingdom of heaven is within"). When we succeed in becoming quiet and still enough inside to locate this "kingdom," this will result in a mass exodus of the forces that have been occupying our minds. Anything that you've ever thought or that you're thinking right now is a lie dressed up to *look like* the truth. D-day is approaching when we arrive at a conscientious and healthy mistrust of the false intelligence that we're receiving. This must be why a friend of mine told me once: "Any time I'm thinking, I'm behind enemy lines."

It's a complicated situation, given the fact that we've been hoodwinked into believing that our mind's views are a fair and accurate representation of the truth. Little do we suspect that they don't have the right to speak for us and for who we are (croissant-loving Frenchmen) and that they're actually speaking out against us. With minds like these, who needs enemies?

His Name Really Is All That

We need to see that being taken over by these dark, angry, despairing states costs others and ourselves dearly;

that when we're possessed by something other than who we really are, the fur will fly and we'll wake up the next day to a bald cat. We're in the process of learning, by tragic example, that falling asleep on the job and ignoring the knock at our door is not the way to go. Best not to let the evil in in the first place by enticing this energy with bread crumbs (thoughts connected to ingratitude and complaint) at our doorsteps. This is its preferred food. It finds thoughts connected to gratitude very unappetizing—the way we avoid becoming this kind of energy's next meal is to become something that its system can't digest.

Yogi Ramsuratkumar's Name is more powerful than any lie we could tell ourselves. Any time the lie is on the move and telling us stories, the option that works (not just sometimes but always) is to counter our bizarre thoughts with Yogi Ramsuratkumar's Name. It's the paddle when we're up the creek; it's our license to exist; and more than this, it's the bridge between life and death. Disregard the blessing force that it is and we will die to see what it is that we've been warned about. Assume that His name really *is* "all that" and we will prosper in ways that we can't imagine from where we're standing now.

Our Almighty Minds

All of our unhappiness can be traced back to the fact that our minds are lying to us. Unfortunately, the impulse to march to the drummer of our separate personal selves has become ironclad over time. Even if it were true that we can't trust our minds, we would need to exhaust any and every "get out of pain quick" strategy that our psychologies can come up with or ever could come up with in order to break their spell. Because most of us have no way of knowing at

this point that we're not "the decider," the masters of our own destiny, and the captains of our ships, then the best advice I can give anyone (and by the way, I went to hell and back to find this out) is to say the Name of God without ceasing, because over time, when the dust settles, what will be left standing is something that's not a lie.

The Alligator Never Has a Senior Moment

The way this works—the way our alligators manage to keep us away from the truth—is by sending us their interpretation of the words that are coming out of the mouths of anyone who's telling us the truth, in order to distract us from what is actually being said. The alligator is always in control. Our span of attention may be limited, but the alligator never has a "senior moment." Its *purpose* is to find something that's going on *right now* that it can rewire into a complaint related to our past, and plug it into the anger that we're repressing from our childhood. If it can make this connection and get some serious high voltage going by provoking the anger and the fear that lives inside of us, we will be too distracted to take in the truth. The beauty of the situation (from our ego's point of view) is that it owes no allegiance to, and feels no responsibility to, the truth. It has carte blanche to twist whatever is happening to us, whatever words are spoken to us, into whatever suits its purpose.

You Can Have My Mercedes, but Stay Away from My Self-Loathing

Interestingly enough, the thing that's the most difficult for us to part with isn't our Mercedes, but our low self-esteem and self-hatred. The part of us that isn't a fan of our true selves knows that once our low opinion of ourselves goes,

it will lose the connecting point in our psychologies that it has been using for years to jump in and safeguard us against God. Reminding ourselves that we're not the ill-kempt and undesirable bags of trouble that we've been pretending to be—and that the thing that *is* true of us, that the place where we *really* live is our inner heart, where God has written His Name—is the solution.

Be That Which Nothing Can Take Root In

I had an experience soon after meeting my teacher where I was catapulted into a unique state of consciousness: I suddenly found myself in a place where I was immune to the thoughts and opinions in my head. I was standing in a field at night, and I had the clear perception that thoughts were coming towards my head, but they were glancing off of me and not taking root inside of me. I hardly know how to describe how delightfully spacious this condition was, but it had a lot in common with the way someone might feel if they'd been in a prison cell for thirty years and they suddenly found themselves in the Alps, under a brilliant blue sky.

I wasn't able to connect this sudden moment of freedom with an activity or an effort on my part. It was just an unexpected gift that I was given, an experience of a whole other way to go: "So this is what it feels like to be separate from the constant barrage of misinformation in my head!" I guess you would have had to have been there, because it's a serious challenge to describe the indescribable.

What the mind doesn't want us to know is that the bars of the prison we're in are actually very flimsy; that a thin veil held together by the thoughts (threads) in our heads is all that separates us from freedom. Busting out of jail is simpler than we've been led to believe; the veil that separates us from

the truth of who we are and our true relationship to life isn't made of steel, it's just pretending to be. In *The Wizard of Oz*, Toto pulls away the curtain and reveals the wizard hiding behind it. When the wizard says, "Pay no attention to that man behind the curtain," he's trying to throw us off track.

The Helicopters of Hell

The information in our minds is designed to connect with a misunderstanding we're having about who we are. The way to "be that which nothing can take root in," as my teacher suggests, is to call the thoughts we're having into question *before* they can connect to the place inside of us that's dreaming that it isn't good enough. This creates the necessary space inside of us to connect to Remembering ourselves. Maybe this opinion that we're not good enough is the landing pad for the helicopters of hell—no wonder we receive so much encouragement from the cheap seats to stick to the "you're no good" story line. Remember yourself, and pay no attention to the next downer thought in your mind.

The Pretender to the Throne

Continuing to lead our lives from the vantage point of our low self-esteem and unworthiness does take its toll. This mistaken idea that's taken root inside of us—that we're no good—is having profound and unhappy repercussions throughout our entire being. To continue to cater to and substantiate our psychological hang-ups is making us sick of mind, heart, body, psyche and soul. This idea that we're no good is poisonous, deadly, and vicious.

It's as though we're in a throne room where the king has been replaced by a pretender. Because we've set our neurosis on the throne and we keep scraping and bowing

and deferring everything in our lives to it, the king (our true selves) has been reduced to scrubbing the palace floors. This is an unhappy situation. God must be unhappy when he sees us giving up all of His gifts to a part of us that can never receive them because it's completely engrossed in playing the victim. We're here to get over our imagined woebegone selves and to restore harmony and nobility to our kingdom. We're here to dethrone the part of us that is spreading sickness throughout our kingdom and to reinstate the wise, reverential, and compassionate king. I've discovered that the only way to restore some order to my kingdom is to say the Name of God.

The thing about a beloved and wise ruler is that, unlike a cheesy pretender to the throne, they have more on their minds than entertaining themselves with lavish dinners and dancing girls. The true king cares for each and every one of those in his kingdom, and works tirelessly to bring about prosperity and happiness throughout the land.

How to Get Lucky

Let's say that you and everyone else on an airplane were exposed to a deadly virus, and that the people who were responsible for making sure that this deadly virus didn't spread throughout the population and ruthlessly maim and kill a whole bunch more people put everyone on the plane into quarantine. Would you be the person who couldn't see beyond your own busy life; the one who treated all of the health workers with disdain and irritation because you were forced to miss your connecting flight to Pittsburgh? Or would it be possible for you to graciously sacrifice the disruption of your urgent plans in order to serve a more noble cause?

How we would show up would depend almost entirely on how diligently we had been working up until this crisis to unseat the pretender and to make way for the king. It's possible that we could get lucky and find ourselves showing up in relation to the greater good because an angel or God or something liberated our king for us; because all of the people around us needed to see an example of somebody functioning from a less self-serving place. This would mean we got lucky; it wouldn't mean that we didn't need to work tirelessly to produce a stable environment inside of ourselves so that we can get lucky a lot.

The way to go about this is by attending to our state, in order to make sure that we haven't left a welcome mat out in front of our house for the pretender. Greek housewives in villages haven't lost the ancient art of how to do this: each day they participate in a ritual that involves sweeping their doorstep and the sidewalk in front of their homes and then cleansing this space with water.

Only the Power We Give Them

Fairy tales *are* true. You know how in fairy tales there's an evil sorcerer or queen who's spiteful, and turns the prince or princess into a beast or makes them fall asleep or something? This is an accurate metaphor. The spell that we're under is strengthened every time we have a thought that we don't question and then say Yogi Ramsuratkumar's Name to. Once the evil sorcerer has set up camp in our minds, it can send us thousands of thoughts every day to keep us asleep and cement the belief that we are something other than who and what we really are. It's actually quite simple to step into reality; all we have to do is stop trusting the lie and break off our apprenticeship to the sorcerer. We can ask if a thought is true and notice that it may be part of the sorcerer's agenda. If

we persist in this, our enchantment will end and we'll wake up one day and say, "I'm not a frog!"

The illusion of who we thought we were can't stand in the face of a conscientious program of dismantling the projections that appear in our minds. It's like throwing water on the Wicked Witch of the West. Who would have thought such an innocuous substance would reduce her to an object of pity ("I'm melting!")? How much power does the witch or the sorcerer *really* have? Only the power we give them.

Did He Just Flip Me Off?

Here's an example from the world of reality TV (this really happened), of just how "off" the information in our minds can be. One of the episodes of Morgan Spurlock's show *Thirty Days* (where people get to spend thirty days hanging out with people whose worldview is dramatically opposed to their own) involved inserting a fundamentalist Christian guy into the heart of Islam. It was wonderful to see that he approached the experience of living with a Muslim family and spending time in their mosque with sincerity and vulnerability, despite the fact that he was disoriented and frightened.

On the other hand, the head of the household where he was staying may have been less flexible, based on the following exquisite moment that was caught on tape: When it was time for the Christian to depart, he walked down the hall, calling out his goodbyes and thanks. The camera was situated behind the Muslim husband and wife, and captured the husband turning to his wife and saying, "Did he just flip me off?!" "No," she responded, "he just gave you the peace sign." Doesn't this say it all? If we think that our eyes and our ears aren't deceiving us, that we've cornered the market on the truth, we may need to think again.

The Pause That Refreshes

Another moment in the Morgan Spurlock show that I especially enjoyed because it supports the thesis of this book, (aren't we all thrilled when our version of reality is confirmed?) was when the two guys fell into an angry and heated argument over dinner, and the wife reminded the husband that it was time to say the prayer. (I point out somewhere in here that the five-times-a-day prayer ritual in Islam has something to recommend it; that connecting with inner quiet and Remembrance on a regular basis throughout the day is useful.) So they all get up and roll out their prayer mats and pray. After this, the Christian guy is musing in the kitchen that even though he was pretty stirred up before the prayer, he felt much better afterwards.

Can't We All Just Get Along?

If we think we're above misreading the signs (confusing a peace sign with a middle finger) then this is only because we haven't begun to notice that we're not always right. The stalemate that's enacted over and over whenever a man and a woman engage is: "I get it and you don't." It never occurs to us that it's our *interpretation* of our experience that's the fly in the ointment. Our assumption that we're the only one in the room that knows what's going on is the missing piece to the "Can't we all just get along?" puzzle. Our insistence that our conclusions about his/her motives, behaviors, and communications are correct doesn't make them true. We're all running our own tidy, independent little fiefdoms, where the truth is unwelcome and irrelevant.

When we're killing the sacred it's very hard to see that we're doing it, since it's being done *through us* and our field of awareness has been captured by it. The good news is that

there *is* a way to stop these takeovers and relinquish our role as accomplices. Saying the Name of God consistently and persistently clears up the confusion inside of us so that we can see and separate from our part in the devastation. Even more miraculously, it creates the desire in us to part ways with destruction.

Pay No Attention to That Toaster in Your Kitchen

Our minds have more in common with our toasters than we may imagine: they're machines. I don't make a habit of going to my toaster for guidance and counsel. The smart thing to do seems to be to make efforts not to cater to what it wants me to do or where it wants me to place my attention. I'm in the process of becoming less reliant on my toaster's counsel.

Our minds aren't alive and they're in the same realm (they contain the same amount of life force) as a toaster. Once we begin to suspect that our minds are clueless, thoroughly predictable, and mechanical, and we begin to question their authority, we will never be the same. Every time they voice their opinions and tell us what to do or what not to do, we can choose not to "activate" them by turning them on. This is where we walk out of the kitchen while declaring, "I'll be back should I need a piece of toast, but until then I won't be needing your services." For most of us, the composition—the molecular structure—of a toaster and our minds are identical.

A mind that's subservient to the truth (instead of engaged in the activity of killing it) emits an energetic field that's radiant with life. Because we're in this world, the material world, the thoughts that we're having that are directing our lives have the creative energy or structure of a rock, a sidewalk, or a car.

We were created for more than this. Resenting our lives and wishing that we had something other than whatever we have is an invitation to forces that are less than human to direct our activities. If we're not resenting the way things are, then it's impossible for these forces to make a home inside of us.

Why, You're Nothing but a Pack of Cards!

All of life is about developing faith and trust in God. In order to do this, we have to break faith with the beliefs, opinions and moods that have lodged inside our minds and emotions. Noticing our thoughts and questioning them is the beginning of breaking faith with the world of illusion. This is where we start to unravel the misunderstanding. This is the critical piece.

It's not like, "Oh dear me, I'm at the mercy of *maya* ... oh well!" The secret is to do what it is that we actually *can* do, which is to question the validity of the thought we're having right now and respond to it with Yogi Ramsuratkumar's Name. It's as though we're looking out at a bleak landscape and we're fascinated and under the spell of its bleakness, while never realizing that if we work with the ground that's right in front of us, this will transform it from bleak to beautiful. Any time we notice a moment of discontent and complaint, the trick is to counter this moment by saying Yogi Ramsuratkumar's Name. Any no that we identify inside of us needs to be noticed and neutralized with the Name of God *before* it's too late.

The forces that inspire us with thoughts and feelings of discontent, complaint, and hostility can only survive in darkness and obscurity. For this reason, it occurred to me at one point to carry around a little notebook and write down the thoughts that were appearing in my head, while

detoxifying them by writing "Yogi Ramsuratkumar, Yogi Ramsuratkumar, Yogi Ramsuratkumar, Jaya Guru Raya" next to them—that this would be the equivalent of shining a flashlight on the situation. It's hard to turn a blind eye to the unremitting commercials of our minds when reviewing a sampling of their handiwork over the course of a few days: "Aha! So this is what's really going on in there! There's someone in there that loves complaining."

Remembering God is the only thing worth doing. When we begin to see the quantity and quality of our thoughts and how pervasive and perverse they are, then we can see that there's quite a bit of competition for our attention. How could we remember God when there's so much neurotic "necessity" driving us in every moment? The only way to deal with this is one thought at a time. This is the solution to the sacred task of unraveling our delusions—it's either this or a lobotomy. The fabric of our forgetfulness is held together by the stray thought in *this* moment. Approaching each thought with suspicion rather than blind faith—"this thought may or may not be true"—is the beginning of the end of the veil that separates us from who we really are and who we thought we were.

It's like the moment in *Alice in Wonderland*, when Alice is being threatened by the queen's soldiers and she exclaims, "Why, you're nothing but a pack of cards!" Just because the "reality" we've been living in keeps telling us that it's formidable, powerful, and impenetrable doesn't make it *true*. Our job is to notice that we have a trickster in our minds whose aim is to send us thoughts that inspire fear, despondency, and anger in order to convert our life force into a form of food that it can digest. Noticing that this is the agenda of all of the mind's activities and that it's not our friend—refusing to be its bitch—is the beginning of *getting a life*.

Saying Yes

The mind likes to convince us that if we fall off the practice wagon, there's no getting back on. Meditation shows us this isn't true—every second is an opportunity to switch gears. The mind goes off during meditation and then we come back; the mind was out there, but now I'm back. This is proof-positive that something new and different *can* happen. Among other things, meditation can be an arena to experience the fallacy of the mind's insistence that we can't switch gears. This sets up a pattern of information inside of us that's antithetical to the mind's agenda ("The way it is is the way it is, and there's nothing you can do about it").

The mind also has a vested interest in demonstrating irrefutably that we can't possibly accept or say yes to things that aren't what *it* wants them to be; that we have no choice but to position ourselves in opposition to life. It doesn't want us to see that doing what we don't want to do and putting ourselves out results in reinvigoration rather than death; that moving in the opposite direction of our personal preference and making small sacrifices of what we want will have the effect of a revitalizing B-12 shot. Rather than investing our energy in changing our circumstances, we need to invest it in learning to change our "opinion" of our circumstances. Dedicating ourselves to making things and people more suitable to our imagined needs is unprofitable, and leaves no time to revolutionize our relationship to life.

We've spent our whole lives barking up the wrong tree. My Aunt Geraldine tried to impress the possibility of an alternate route through life by telling me, "When rape is inevitable, relax and enjoy it." I've shared this with different people over the years, hoping to find someone who sees

the essential wisdom it points to. Mostly people think I'm tasteless. (You'll get no argument from me here.)

The opportunity we have is to turn all the little no's inside us (that are based on a veneer of supposed personal preferences) into yeses and into Praise. The fallout from giving our attention away to what we like or what we don't like is that we don't have enough attention left over to do what God would like. When we lack the ability to move through life in a reverential way—creating moments and monuments to God—we can't see what's wanted and needed, because years and years of focusing on what we *wished* we had or on what we *don't* have has produced a kind of dullness that makes it impossible to respond in the moment to whatever life is asking for.

This is a silly strategy, because providing something useful is the only way we can generate what *we* need. We think that bitching about what we don't have and scheming to get it—based on the common denominator of our thoughts ("I don't have what I need")—will actually create happiness for us, and it never does. Rumi had some interesting advice on this topic. In one of his poems he said something like, if you don't *have* bread, *be* bread for someone else.

We can't produce something new by reshaping the past (that boat has sailed) or by projecting our neurotic life-view on top of the future. The arena that's open to us is *this* moment in time. The only way to create something new and alive is to hold up our thoughts and expose them to the light so that we can see that they're not true.

Wishing for a different life and a different circumstance won't make us happy. The lottery winners in this country are a cautionary tale. A series of documentaries have been made recently entitled, "The Curse of the Lottery," where

all of these poorer people who win millions of dollars have their lives painfully devolve when they get what they *thought* they wanted. When they find out that money didn't make them happy, they go nuts and self-destruct. Up until their wildest dreams came true, they at least had some shred of hope. Pinning our happiness on the things of this world is like expecting a squirrel to take you out to lunch.

What Your Mind Doesn't Want You To Know

The conclusions and opinions about the significance of the experiences we're having in this world is the glue that holds the dream we're having together. My teacher has a little saying: "Draw no conclusions mind." I had no idea what it meant when I heard it years ago ("Oh, that Zen-like stuff. It's so obscure and esoteric"), but after spending some time noticing the rat holes that my mind's conclusions lead me into, I've concluded that this phrase is useful.

I don't know about you, but from the moment I wake up, my mind starts in offering its opinions about everything. It spreads a dense fog over all the possibilities that this day might offer, so that before I can even get out of bed "the die is cast." You know, "Different day, same old shit." When a child wakes up, he doesn't know what's going to happen and he's free to have tiny little adventures. This is because his conclusion about what life has to offer, based on years of having the deck stacked by his mind, hasn't been hardened into cement yet. He's free to have more fun than we are.

It's unbelievably tempting to stick to a single point of view about what we can expect from life, based on our initial experiences in childhood ("I can never get what I need"; "People will always leave me"; "My Jell-O mold doesn't wish me well") because we feel safer when we know what we

can expect. At least it's a recognizable pattern. The tiniest interruption in this pattern sends shock waves through our systems. Change sucks. Our dedication to prejudicing the outcome of each moment of our lives when we're forty-six— by attracting experiences that confirm the conclusion that we drew when we were two—is awe inspiring.

Can't We Just Get a Little Peace in Here?

Having a free moment—the space to just be, without the unremitting and distracting input of our minds—seems to be the focus of a lot of spiritual endeavors. Yoga, tai chi, meditation, etc., are some of the ways that we gravitate towards because we are desperate to create a little breathing space. ("Can't we just get a little peace and quiet in here?") My answer to this would be "No, we can't," because the sheer volume and intensity of these thoughts invites a comparison with a Category-5 hurricane. Meditation is designed to produce the awareness of what we're up against that my son had when he was six. When we're running around doing whatever we do all day long, it's harder to notice the flurry of activity in there. There's a method to this madness: the busier we are, the more freedom our limiting thoughts have to operate under the radar.

It's interesting to note that when we start looking at the messages in these thoughts, they're almost always connected to dissatisfaction and an assumption that if we're not careful something bad will happen. They have a very specific agenda (to harsh our buzz). Even when these thoughts are of the happy variety ("I just *know* he's the one and we're going to end up together forever") they're a drag, because when things don't pan out we *really* crash. The mind likes to inspire us with an attitude *about* and a relationship *to* whatever we're

doing. It's not interested in allowing us to get up out of bed and just see what happens: "I wonder what will happen today?!" As a result, our lives are not a delightful excursion; they're a forgone conclusion.

If we begin to suspect that our life isn't as much fun as it could be, the place to start is to shine a light on the thought we're having right now; to not take it at face value, but to turn it over and enquire about its hidden agenda.

It's OK Not to Know Stuff

We're the prisoners of our need to know what will happen next. This makes it difficult for life to surprise us. When given the bare facts of our situation: we don't know where we came from and we won't be given any advanced notice about when we'll die—given that we don't know if we'll be taken out by a bus or a lawn mower [note from typist: I would rather be taken out by a very large bus]—the sensible thing to do is to separate from our chronic need to know and turn our attention elsewhere. We may as well practice jettisoning our need to know throughout our lives, in order to prepare ourselves to approach the unknown finale with ease, good humor, and grace.

Don't You Want Any Surprises?

Separating from our addiction to mapping out what's going to happen next and slavishly adhering to whatever program we've set up, is necessary if we're going to have an encounter with God. The Divine is no lover of the routine; it's delightfully unscripted and unpredictable. Just when you think you have it figured out and that it's about to leap in one direction, it will do something uniquely unexpected. The extent to which we perpetuate and support the mind's love

of knowing what's coming next is the extent to which we will be unable to experience the life of our souls, which are also not known for being stagnant or regimented. Our minds will tell us that it's in our best interest to plot out what's going to happen next, that this will guarantee us a measure of safety. But what they're not telling us is that this chronic habit is engineered to strip us of delight, laughter, and joy.

A friend of mine once had an odd experience when she was pregnant: she found herself, out of the blue, in a conversation with the child she was carrying. (Maybe the Day-Planner part of her had fallen asleep or something.) She asked the child, "Are you a boy or a girl?" To this he responded, "Of course I'm a boy!" Next she wanted to know (probably so that she could schedule her labor), "What day are you coming?" To which he responded, "Don't you want *any* surprises?"

The part of us that rules over our lives with an iron fist, that is constantly and feverishly organizing all of the moments of our lives, takes a dim view of the unexpected because from its point of view, the unexpected is a threat to its dominion. If we were less afraid of not getting our needs met, and of things going wrong, we would be less dependent on it for guidance. As long as it can continue to overlay our lives with its prescribed agenda, we will never suspect that it's not the boss of us. So when we wake up and we begin to anticipate what our day will consist of, two things are happening: The first thing is that we're saying to God that whatever moment we're in isn't valuable in and of itself and worthy of our attention and celebration (that this is just a throwaway moment that we don't have to show up for), and that we have better things to do with our time than appreciate this moment and that it's "not good enough." The second thing that's happening is that we're indulging the part of us that secretly believes that

life is a hassle that needs to be dominated and manipulated to its own ends.

Guaranteeing That the Milk Will Spill

Once we've placed our day into a straightjacket, the fallout from having "decided" what can and what can't happen to us will perforce be extreme and unsettling. This is because no matter how dedicated our minds are in their compulsion to know what's going to happen next ("the best laid plans of mice and men" … and all), some aberrant element is bound to intrude and disturb our plans, and this will result in a mood of irritation, complaint, and dissatisfaction. When this happens, we become the prey of a form of energy that revels in negativity. Also, the false thesis that life isn't trustworthy and safe becomes further engraved into our psyches, and our attention to mapping out a more ironclad plan for the next day becomes more imperative than ever.

Noticing each morning that we're engaged in the chronic activity of figuring out what's going to happen and backing off in midstream, is the way to interrupt the less-than-benign habit of setting ourselves up for failure and perpetuating the myth that we don't have what we need. Silencing the militant Day Planner in our heads demands, initially, an act of faith and a leap into the great unknown. But as sure as day follows night, our reward for separating from the desire to control our days will lead to more immediate and less tedious encounters with life.

Crying Before the Milk Spills

Don't you just hate those people who come along when we're up to our asses in alligators and say, "Everything happens for a reason; God has a plan."? Maybe this is annoying because

we know that waxing philosophical and mouthing platitudes can't help us. What can help is stockpiling anti-frenzy data as we go along and experience life. If we can recall all of the times that our mind told us that we needed to be afraid because a bad thing was barreling towards us, and the bad thing never even materialized, then we can begin to call into question the validity of the next doomsday, kill-joy prediction from our mind about how bad things are going to get.

Let's say our elderly mom's caregiver quits, and the mind starts in: "Oh no, this is a disaster!" If it turns out that someone even more splendid than the last caregiver shows up to do the job (and this is usually what happens), then we can add this episode to a growing stockpile of evidence that our minds aren't always right. It's a good idea to eliminate as much unnecessary worrying as we can in relationship to life. This is because when we're worrying, we're asleep. Crying before the milk spills is even less productive (if such a thing were possible) than wasting our life force crying about it after it spills.

The Infamous Towel Incident

Questioning the ideas, opinions and attachments that govern us is analogous to clearing out our hard drive to make room for something new. Yogi Ramsuratkumar's Name is the delete button. It's not that the Divine doesn't exist; it's that we're too busy to notice it. The emptier we become, the more evident its presence will be.

Any moment in time and space that we bring presence and awareness to becomes a signpost in our landscape. It's a wonderful thing to have these signposts in place, so that as we go along and get swept up in the video game that is our lives, a warning pops up and we can say, "Now wait a minute … this

is familiar. This moment reminds me of the time when my panties were in a twist because the tide washed over my towel and it got wet, and I laughed for a change because I saw how over the top my reaction was to this 'disaster.'" So when we're in a similar relationship to something that intrudes upon us as an idea of what a bad thing looks like, then the warning message will come up and alert us to the resemblance of our current reaction to the "infamous towel incident." The more we contribute to the stockpile of experiences we've had where our minds blew something out of proportion, the freer we'll be to participate in our lives instead of being herded around by them.

Pay No Attention to Woody Allen's Mom

Our minds are never the bearers of glad tidings. This reminds me of a Woody Allen movie. (This will be even funnier if you read the quotes from Woody's mom with a Jewish/Brooklyn accent.) Woody brings a girl home to meet his mom, and his mom begins to muse, while they're sitting around the dinner table: "Your Father was bald ... you're bald." Woody says, "Ma! I'm not bald!" to which she replies, nodding her head sagely, "You will be!" This story becomes funnier still when we begin to realize that Woody Allen's mom is in charge of *our* thoughts.

Not Crying after the Milk Spills

It's possible to parlay an ability to separate from our mind's activity that's calculated to take us on a bad trip into even more stunning and fabulous feats of separation. This would be when we're not just faced with the mind pretending all is lost, but when our circumstances are truly horrific. The ability to not be at the mercy of and graciously give way to

the worst news that we could ever hear is what separates the boys from the men. I suppose the way that we could rise to such an occasion would be if we had put in some persistent and consistent efforts laboring in the minefields of the mind. This work would reveal to us that no matter what happens to us, the only thing that matters is God. This way we would be able to cling to Him in the middle of a gale-force wind and Remember: "There's only you, God."

The Bad News and the Good News

Life is here to take away and wash out to sea everything that washes up on our shore; it gives us things and then it takes them away. ("The Lord giveth, and the Lord taketh away.") The closer we get to God, the worse it's going to get. This reminds me of St. Teresa, shaking her tiny little fist up at the heavens after falling in the mud, saying, "Lord, no wonder you have so few friends—look at how you treat them!" The point seems to be to create Remembrance whether the good times or the bad times are rolling; not to contract and imagine that whatever our pain is, it's more important or bigger than the Divine. (See the Book of Job for a detailed accounting of this point.)

If we lean into loss instead of clawing our way away from it, we'll be given something more valuable than we could ever imagine to replace it with. The movement of the ocean is a picture-perfect frame of reference for what we're here to do: the tide never puts its foot down in midstream and says, "I refuse to keep going in this direction." The natural world is filled with many examples of the way to participate in and to be a part of God's creation, but surely the ocean provides us with a reminding factor that can't be missed.

The other thing that the movement of the tides is showing us is how to say the Name of God. The movement of the ocean is pointing to the same rhythm that is going on inside of us: in the same way that our inner hearts are always saying the Name of God, the tides are the heartbeat for this world and they are engaged in the same act of breathing the Name of God. Maybe the ocean is saying over and over again, "Yes God, yes God, yes God."

An Accident Waiting to Happen

Here's another way to forfeit our happiness. This is where the accident-waiting-to-happen part of us, that's immune to the charms of the good, distracts our attention when we're setting a glass of water down in the grass. This way, when the water inevitably runs out of the glass, it can say, "Aha! I told you so! Your glass is half empty!" Somehow we have to learn that being present in each moment actually makes us less accident-prone, not more; that if we bring focused attention to our lives (and we're not off dreaming about what's going to happen next), we'll receive less flack from life.

We're on a Very Short Leash

The militant organizer in us has us on a very short leash. I was in a department store once and came across a little boy who was tied to his mother with a leash. When she was distracted by a pile of sweaters, I leaned down and looked into his eyes and said, "How do you feel about being on a leash?" He replied sorrowfully, "I hate it." I said, "I know it's hard, but hold on— because I promise you, a day will come when you'll be free of the leash." The same can be said for us when we separate from the Day-Planner voice with persistence: there will come a day when we find ourselves free to romp around leashless.

In addition to giving up our energy by pre-planning and then falling into moods of dissatisfaction because the day didn't go according to plan, we can outfox fun-loving life in other ways. Whether our minds are trying to determine what a future outcome will be or they're layering a prejudicial opinion on top of a particular moment in time, the result is always the same: the collar attached to our leash gets a little tighter around our necks.

Mr. Clean

There are two things that we need to address in order to up the radiance factor in ourselves: One is our habitual state or mood, the one that's been built from giving admittance to billions of downer thoughts throughout the course of our lives. This is the fertile ground that today's dissatisfied thought is attracted to—the cushy nest, the comfortable home—that exists inside of us. So at the same time that we're fending off the new thought before it can lodge inside of us and contribute another bit of fluff to the nest, we need to be engaged in cleaning out the nest. This involves noticing the quality of our moods, and dismantling them by reminding ourselves that it *is* possible to be cutting up this avocado happily. Interjecting moods of lightheartedness by remembering that they exist makes it harder for the next fun-less thought to get in.

It must be like cleaning out a house that rats live in. In addition to setting traps so that more rats don't get in, we have to clean up the nest and droppings that are sending a signal to the rats outside our house that it is a "rat safe house." Whether we're working on the established nest/mood or denying entrance to a new thought/rat, saying the Name of God is the all-purpose solution for both jobs. It's the Mr. Clean of the spiritual world.

Can't We Get Somebody Else to Have the Baby?

There's great value to determining what our goal is, committing to it, and then achieving it, because follow-through creates a foundation to support Remembrance. We're like a country that has borders that aren't well maintained: there are lots of interlopers crossing over the borders because we're not patrolling them. Our inattention can be compared to guards playing dice at the side of the road who are distracted from their job.

Just because we're maintaining a relationship to life that's haphazard doesn't mean that we can't stop at any time—like now, for instance. Not working to see our illusory thoughts for what they are is the same thing as saying, "Come on in, invade my borders; I don't care who lives here."

Since it *is* our country and *we're* not taking care of it, then who will? It's no good saying, "This is too much work. I don't want to be on border patrol," because *we're* the only ones that can do this. We're fond of saying, "I want to take a nap. I don't know why I should have to take care of this flea-bag country anyway. Can't we get somebody else in here to deal with all this?" Like in the movie where Meryl Streep is being driven to the hospital in labor, and she says to her husband, "I don't want to have the baby. Can't we get somebody *else* to have the baby?!"

If it's too much trouble to put a fence around our gardens, then rabbits will sneak in and eat all our vegetables. This is a similar fate to when a wolf comes along, and huffs and puffs and blows our house down because we thought it would be too much trouble to build a good house.

Essentially, we're learning the fine art of saying yes to our job. As human beings, we have a very specific job: to cultivate and create a space for the Divine and to move in

concert with where God is moving. If we're not doing the job of a human being, and if we're moving in concert with our alligator's preferences, then somewhere inside of us we know something is terribly wrong because we're not expressing our grand design and purpose—no wonder we sometimes entertain thoughts of offing ourselves! This is because we've become severed from the delightful experience of giving expression to *who we are*, and the song we're stuck producing isn't beautiful and harmonious. It's the song of a crazy person lost in the unremitting horror of illusion and discord.

Rumpelstiltskin Isn't Coming

Our task is to give ourselves over, in every given moment, to the work that's in front of us. This is the hay that's been placed in the room for us to spin into gold. The more we delay sitting down at the spinning wheel, the more we end up buried in hay. The only way out is to recognize that Rumpelstiltskin—or our mommies—aren't coming, and it's up to us to get spinning. Just because the mind keeps saying, "We need to get someone in here to deal with this mess," or "You can't possibly turn hay into gold," or "Don't pay attention to that spinning wheel in the corner," or "God, there's a hell of a lot of hay in here!" doesn't alter our situation. The answer to all of the mind's ideas, the proof that's always to be found inside the pudding, is to sit down and begin spinning. The truth is that we contain something inside of us that's capable of doing extraordinary things. It's only our minds that beg to differ.

Cease and Desist

Over the years, I've managed to embrace a policy of cease and desist when my mind begins to supply me with thoughts

that are fated to land me and other people in hot, slimy water; I've come to a place where I'm somewhat vigilant. The first sign that I'm being led down a rat hole is that these thoughts are invariably connected to how I have a problem, and they're disconnected from feeling like life is good. If *you think* you're having a problem, *you are*. This is a huge waste of time.

When we begin this process of patrolling the borders of our minds, we're out of practice and a lot of shady thoughts sneak in. Saying the Name of God when the tape starts playing in our heads—answering our mind's version of what's going on in this moment with the Name of God—clears enough space and breathing room in our heads so we can actually Remember that we're on guard duty. Once we have the knack of paying attention to the distortions in our thinking, we're not so easily had. At this point, our response to whatever the mind is selling can be: "I'm not buying."

Keeping an Eye on Our Minds

I've noticed that my mind has the quality of a ticker tape: it's just ticking away in there, producing an endless stream of worst-case and best-case scenarios that are disconnected from reality. It's as though these scenarios and plotlines, sourced by my unconscious fears, exist in order to make sure that the next thing that happens to me is predetermined instead of miraculous. Sometimes I get lucky, and a part of me (which I'm calling "the eye"), glances over at the thought that I'm having and sees (after all, it is an eye) that this thought isn't real. It can see that the majority of my thoughts fit into two major categories: self-aggrandizement or catastrophe. Once this eye has noticed an unreal thought (dressed up to scare me or to feed my flimsy ego), I'm able to remind myself that this thought is a product of the ticker tape; that it's just

"business as usual," and that it's not in the same league with the truth—the truth being, *there is only God.*

I was at a talk once when a friend of mine said, "If you're feeling depressed, this may not mean that God has bad news for you. It may just be that you're at the mercy of bad chemistry." While wending my way through menopause, I've noticed a definite and untrustworthy trend: it has become clear to me that the despairing thoughts and moods I'm having just before a hot flash aren't all that credible. I've been grateful when I've managed to discount the accuracy of these thoughts and moods over the years—from PMS through menopause—and link them to chemistry. What a relief! When we finally figure out that our mental and emotional television stations are producing distortions in their reportage, this eases a lot of pressure.

In addition to the influence on our emotions of hormones and brain chemistry (low blood sugar, etc.), we want to be aware that our unremembered dreams of the night before, the state of despair of the check-out counter clerk at the supermarket, our genetic inheritance, and a whole host of unfactored influences may be contouring how we feel. The important thing to know at all times is that just because we're thinking or feeling about things in a certain way doesn't mean that we're having a credible experience, and it doesn't mean that the point of our thoughts and moods are well or truthfully taken.

Quality Control

Sometimes I find myself reviewing what I've just been thinking. The moment before I hit the rewind button, the thoughts are just humming along, skipping along from one to another. I examine their content for lead. (This is the

opposite of panning for gold.) I'm sifting through them for lies, pride, and anything that smacks of delusion, attachment and the stories of all sizes and shapes that I'm telling myself. When I discover lead in the stream, I call a spade a spade and acknowledge its uselessness and heaviness.

This process also reminds me of being in a minefield, where I'm putting pins in the mines that I come across in order to keep them from going off inside of me. It's difficult to realize that the majority of the thoughts that we're having are "having us"; that they're having a dramatic and toxic impact on our lives and moods and that most of them have more in common with poison darts than maypoles.

The Dead Zone

Sometimes in this process of reviewing what just happened, something in me concludes that the train of thought wasn't "dangerous" (making a case for world domination), but that even though it was "benign," it wasn't worthy of one of the moments of my life … that I could have been saying the Name of God instead of ruminating pointlessly. These are the moments where another viewpoint arises inside of me that's always asking, "What's the best use of my time right now?" This part of me seems to prefer a conscious connection to the present rather than unconsciously coasting and spacing out. It knows that this is "the dead zone," where inspiration can't reach me.

Scheherazade

Maybe we've spent most of our lives with the accent on the wrong syllable. The story of Scheherazade, who manages to buy her life, one night at a time, by telling interesting stories to her husband, (her predecessors had their heads cut off, due

to an unfortunate misanthropic kink in his psyche), could point us in a different direction. Maybe our focus should be to not bore God instead of entertaining the thing that's pretending to be us. Entertaining God by making sincere efforts to Remember Him may be more essential than we can see at this point. It worked for Scheherazade.

The question is: What can we bring to the table that's entertaining and useful? We think that we have a real problem if we (our outer selves) are bored, and that we must see a movie immediately. Our amusement level is actually the least of our worries. Cows are boring; they just stand around chewing grass. So when we're driving down the street in our cars in a state of unconscious mental mastication, we're probably not providing a lot of entertainment value for the Universe. In these moments we're not doing our part, and we're not contributing. If someone is sound asleep at a party, how much fun can they be?

I imagine the trick is to notice that we're in our cars, rather than being carried away by a stream of random thoughts, opinions, conclusions, and pointless musings. This would mean stepping outside of the space inside of our heads and linking up with life at large. What if we suddenly discovered we'd been barking up the wrong tree all this time; that being amusing was the point, rather than being amused?

The Growing Landfill

There are two ways to approach our supposed dilemma: the easy way and the hard way. Focusing on "our problem" (represented by years and years of slugging it out with our presumed situation); or practicing inner quiet and Remembrance in every moment. Separating from our imaginary robotic trance, becoming still and at ease inside

of ourselves, and saying the Name of Yogi Ramsuratkumar is the superhighway. None of the moments in our lives are throwaway moments—we can never afford to walk out of our front doors and get in our cars without knowing that we're doing it. Each moment in time and space is precious and will never come again. Taking a "well-earned, well-deserved" vacation from being attentive to this moment in time will always bite us in the ass. It's not worth it. This is bad stewardship and bad energy management. If we recognize the value of not adding yet another plastic bottle into the growing landfill that surrounds our souls, then we'll choose to not chuck the bottle in there in the first place. (An ounce of prevention is worth a pound of cure.)

Oh! I Was Just Thinking about You

I was advised once—by a demure little Indonesian lady who knew some things, being the daughter of a sheik—that thinking about other people carried a penalty that most of us are unaware of. She said that as we reach out with our minds to others, we run the risk of picking up extra debris and taking into our being whatever state they happened to be in at this moment. She said that you wouldn't know, when you were thinking of someone, if they were doing something "naughty," and in this way, having your attention on them at the wrong time could lead to trouble. Given that I have my hands full dealing with my own naughtiness, I've made a few efforts to take this advice to heart.

An exception to this rule must be thinking about one's spiritual teacher, as they are never having *any* thoughts, naughty or nice. In the beginning of my apprenticeship, my teacher called me up and I blurted out excitedly, "Oh! I was just thinking about you." Never one to skip a beat or

miss an opportunity to make the truth available, he shot back cheerfully, "That's what makes a good teacher/student relationship!" If we've been blessed to have a spiritual teacher that has been surrendered to God and has come here to provide a doorway to the Divine, thinking about him would be a good way to activate his help.

Fair Journalism

Sometimes a news station will pride itself on presenting a balanced point of view when it comes to liberal and conservative politics. Spiritual students need to cultivate balance in their minds so they don't keep running into brick walls. If our minds are telling us that our life is shit because we don't have "X," then we want to balance this message with the "Y" perspective: "Yes, you're right! In a fairer world, you *would* be elected Queen of the May, and your brilliance would be recognized by your teacher, and you wouldn't be stuck doing some menial job around here—but on the other hand, you're a lucky duck to be in the game at all." This is fair journalism and balanced news. "On the other hand" keeps us from getting into *big* trouble.

It should be fairly obvious to us that we don't get to move on to greener pastures until we've eaten and appreciated the grass in whatever field we're in. God runs a tidy universe. Waste isn't part of the program, and we're here to *get with the program*, not invent and substantiate our own. The advice to curb unbalanced thoughts of complaint and comparison as if our soul's life depended on our doing this is designed to lead us to sanity.

If you're like me and you need something to get you through your imagined nights, then here's something that might be helpful: One of my alligator's first costumes

involved black tights and a beret, and an attitude picked up as a teenager in the coffee houses of Greenwich Village: "What's the point? Being here is stupid, stultifying and horrifying!" I heard something a few years ago that balanced the news: I talked to a woman who'd actually seen the purpose of our lives. She told me, "I can't put it into words, but I *can* say that it's *glorious!*" Even though this was cold comfort to my alligator's beatnik impersonation at the time, over the years, someplace has been liberated inside of me that now knows good news when it hears it. It's almost as though something that was never supposed to happen did.

> *Amazing Grace! How sweet it is*
> *That saved a nihilist like me*
> *That turned nihilism to faith ...*

Theory and Reality Are Two Different Animals

Ulysses stopped up his ears when passing the island where the sirens were singing their song; he put a measure of protection in place because he knew that listening to their song would lead to his death. Yogi Ramsuratkumar's Name is our protection against the insidious song of the mind.

We're not bad or wrong; we're at the mercy of a misunderstanding. The women who've been hoodwinked into taking YAZ in order to avoid the inconvenience of a monthly cycle aren't bad; they're the victims of a lack of education. Also, the people taking Allī to lose weight could only be doing this because they missed the fine print, warning about "rectal leakage."

We're being held hostage by a conclusion that our minds drew decades ago. Just because our mind produces a thought *doesn't make it true*—or, theory and *reality* are two different animals.

The Magic Decoder Ring

What's the point of following our mind's big ideas around if they're going to end up smashed on the rocks of reality? We need to forget all of our big ideas. The language that the mind uses is a language designed to lead us in the opposite direction and away from what our souls need. It would be helpful to approach the information that our minds are supplying us as though we're dealing with someone that is speaking a foreign language—this would lead us to reinterpret what they're saying. The chances are high that if our mind is telling us to go left, life would be better served by going right.

Saying Yogi Ramsuratkumar's Name is the way to decode what our minds are telling us. I think there used to be this thing advertised in comic books in the forties that kids could send away for, called a "magic decoder ring." I wonder if they're still available? Oh, wait a minute—I guess I don't need one, since saying God's Name will crack the code of my thoughts.

There's a fine line between Remembrance and giving life the finger, and we're usually the last to know when we've crossed it. Yogi Ramsuratkumar's Name activates our early-warning system. It's better for us if we know *before* we're about to cross this line rather than after, when it's too late.

The Theatre of the Absurd

If we've convinced ourselves over the years that we're awkward in social situations, then we're on a runaway train. The way to slow this train down is to counter the thoughts in our minds that fuel it with skepticism: "This may be an opinion, a story I've been telling myself for years. It may not actually be true ... Yogi Ramsuratkumar." It's actually possible to break a train of thought: "'I'm awkward' is a role

that I've taken on, a part that I'm playing. This is one of many ways I can see myself and one of many roles I am capable of playing." When we begin to not take our role personally and to see that we're not married to it, this creates the necessary space for our authentic self (the one that's not mired in one particular role) to arise.

The forces that inspire thoughts that are rooted in scarcity don't wish us well; they don't want us to become aware of more exciting possibilities. They want to fix our attention on, and they want us to be at the mercy of, a single neurotic perspective. They neglect to tell us that there's a connection that can be forged between our outer self and our authentic self, and that this would give rise to a chameleon-like spontaneity that would allow us to show up as lots of different characters, depending on what would serve the people around us.

Saying Yogi Ramsuratkumar's Name is the beginning of our freedom from the stranglehold that's been pinning the doomsday character to center stage. The truth is, the one that thinks that it's awkward and lonely doesn't *have* to take center stage. Self-observation is learning to listen to what's going on in our minds and to counter *all* thoughts sweetly with: "Not necessarily." *"Your life is in the toilet; it would be best if someone flushed."* "Not necessarily ... Yogi Ramsuratkumar." *"You're the next Jesus Christ."* "Not necessarily ... Yogi Ramsuratkumar."

The Tennis Game in Our Heads

For the most part, we're frozen inside of a chronic debate. There's a continual tennis match in our heads going back and forth, back and forth: "I'm fabulous; I'm f****d up." This is a silly activity because we're neither, and God is all there is.

Chapter 4

It's a Miracle

Slowing Down in Order to Speed Up

Have you ever wondered if your thoughts are friendly? I don't hate my mind, but I *do* wonder if the thoughts running around in there wish me well, if they're not attached to something that has a vested interest in confusing me and distracting me from more interesting and elevating moments. When working with our minds, the first step is to slow down, take our cars out of cruise control, move out of the fast lane, and pull over to the side of the road. The next step is to turn off our engines and wait patiently and quietly for assistance. This makes it possible to notice which direction our authentic selves are recommending. Sacrificing our need for speed allows us to be moved to action in response to the Will of God. Repeating the name of God gives rise to a desire to follow only the best GPS system, and to separate from the enticing notions running through our hell-bent-for-leather minds.

Timing Is Everything

Once we're connected to our inner GPS systems, the challenge becomes acting without delay or interruption when we are genuinely inspired to do something that's worth doing. Hesitating—being out of step with God's timing—can ruin a really good idea. It also demonstrates to the Divine that we're unreliable and it can't count on us to get the job done. Timing really is everything—it does matter when we pull a cake out of the oven. Whenever we're genuinely inspired and we hesitate,

this is the consequence of spending many years moving in the wrong direction. Something inside of us has known all along that a lot of mistakes were being made. There's a period when we're not quite on board with the fact that our inner selves are reliable. Also, our hesitance as we learn the art of "call and response" has to do with traces of misleading energy that aren't quite gone yet. But this too will pass.

As time goes on we will become more—but hopefully, not overly—confident. The more we practice just being, just standing, just driving, just walking, the more we'll be able to relax into the present and discover that it's not such a scary place after all. We'll find out that the present is actually more hilarious, free-wheeling, creative, and delightful than our misbegotten and relentless relationship to the past and to the future. Surprise! Another untrue belief bites the dust! Endlessly agonizing over whether you tied up your camel properly in the past, or where you're going to tie him up in the future, stops being as much fun as moving along and following the Will of God as it arises in each moment.

Maybe the place to start is to notice that there's a *major theme* weaving through our thoughts. The purpose of these thoughts is to propel us into what's going to happen next or to keep us stuck in what just happened. Their agenda is to keep us away from this moment in time and from God at all costs. In addition to this major theme, there are a number of recognizable (once we look) minor themes that arise consistently in order to seduce us out of Remembrance. As we begin to notice some of the minor themes these thoughts contain ("I can never get what I need," "People will always betray me," "I'm better or worse than someone else," etc.), it's worth noting that these themes are merely variations on the major theme: "Avoid God no matter what." Our minds want

us to believe that their efforts are aimed at protecting us from the chaos in us and around us, but—true to form—they're lying. Their secret agenda is to maintain control *over us* rather than *for us*. Ironic, isn't it?

Less Is More

The foundation practice for all endeavors that are dedicated to Remembering God is establishing a domain inside of us—a place of stillness and inner quiet—that we can visit again and again as we are working to reduce the volume of the voices that are working to create forgetfulness in us. Connecting to our essential selves may be somewhat fragile at first, and could be compared to a connection to the Internet that keeps getting lost. Over time, if we begin to show this part of ourselves that we mean business and that we're serious about disconnecting from our egos and connecting with our essential selves, the connection will become less fragile. In terms of establishing a connection to the part of us that's trustworthy, we might say, "Seek ye first inner stillness, and all else will be added to you," or, even more accurately, subtracted from us. On the spiritual path, it's not that we need more, given that our bodies, minds, and emotions are teeming with activity. What we need is *passivity*. When it comes to our spiritual lives, less is more. Inner stillness is the ultimate hedge when it comes to ego inflation.

Positive Thinking Is Evil, and Negative Thinking Is Just Stupid

Chasing after the truth has its comical side—it's as funny as a cat chasing its own tail. It turns out that what you *don't* need is another workshop, self-help book, or a really cool yoga teacher. Jesus said, "The kingdom of heaven is within."

Even though we didn't believe him, truer words were never spoken. You can accomplish a lot more by sitting at home in your closet saying the Name of God than you can by searching for the truth out in the world. It turns out you've already got "the secret" (and it's not the one where you get to improve upon the dream you're having. It doesn't matter how *nice* the dream is—a dream is a dream is a dream). As a mentor of mine once said, "Positive thinking is evil (it drives you deeper into the servitude of your illusions, while minimizing the possibility that you will ever live up to your potential), and negative thinking is just stupid." Speaking of what we already have right under our noses, I like to think of saying the Name of God as yeast, because it activates the still place inside of us where we can hear God's voice.

A State-of-the-Art Kitchen

We're here to create conditions inside of us that are habitable and attractive for our true selves. The way to do this is by accepting life as it is. Our task is to reverse a trend that got started early on in our lives: At the moment when we shut down to life because the shit hit the fan in whatever situation we'd been placed in, our true selves distanced themselves from this unworkable climate in the same way that a chef might walk out of a kitchen that's filled with dirty dishes and rats. We've come here to prepare a state-of-the-art and functional kitchen for a gourmet chef to create exquisite meals in.

Any lack of acceptance, resistance, or tension (and this is what informs every moment of our lives) is an environment that exiles us from the blessing of being guided by our true selves. These selves need a particular environment to function in; inner quiet is the preface and the prelude that enables

us to connect our words and our actions to the present moment. An activity that's preceded by inner quiet and Yogi Ramsuratkumar's Name will be informed by the benediction of reality. Catching ourselves in reputation-enhancing lies and noticing and separating from things pretending to be us, will arise easefully when we're quietly saying the Name of God. This is what we can do to restore order to our kitchens, and create a safe haven for reality to function in.

Getting Off the Grid

Separating from the imagined self (getting quiet and saying Yogi Ramsuratkumar's Name) gives us the experience of running on solar power instead of on electricity. We could just pull the plug a few times a day in order to experience being "off the grid" now and then, and see little by little that it's more peaceful that way. This is the way to discover that this is a delightful break from the insanity. It might be interesting to find out what connecting to another power source would produce. I don't see how this could be any less interesting than our current habitual and redundant experience.

We may want to try unplugging when approaching important things like making a sandwich, or when we first wake up in the morning and when we go to sleep at night, or before we pick up the phone to talk with someone. Our real selves are capable of all kinds of odd things; we never know what they're going to do next. When making a sandwich, we might be stopped in our tracks and flooded with love, and find ourselves crying with gratitude for the avocado.

The very best thing we can do to help ourselves and others is to be saying the Name of Yogi Ramsuratkumar in every moment. When our words and actions are aligned to our egos, we are similar to puppets or ventriloquist's dummies.

What we want to discover is what would happen if we stopped moving our mouths or raising our arms when our strings were pulled. Maybe the ventriloquist would conclude that our dummy is defective, and move on.

Hit the Deck

In the Muslim world, when the *muezzin* climbs to the top of the minaret and calls out the Name of God, the whole world comes to a halt. Everyone hangs up their cell phones, drops their hairbrushes, stops whatever transaction they're engaged in, and whips out their prayer mats, in order to hit the deck and bow down before God. As far as systems go, this seems like a good one for reminding ourselves that God comes first.

I don't know about you, but my ability to focus on "the main thing" is fragile. This is evidenced by the fact that after morning meditation, I can't make it to the bathroom without downshifting into the nether world of unconsciousness. Maybe it would help to maintain a more easeful relationship to the present if I set up specific times throughout the day to up-shift. These mini-vacations from the runaway train that we're on don't have to be limited to the number of times and the time of day that we decide to do this. Once we become accustomed to pulling the brake and stopping the train, it might occur to us to become quiet inside when we're about to bite someone's head off, or when we find ourselves languishing in and stewing in our own juices.

Stand Down

We don't *have* to have our emotions sitting on top of us telling us what to do; we can be the ones that call the shots. The gift of Remembering ourselves is quite the paradox, since

freedom is achieved by sacrificing our personal preferences and moving in the opposite direction that they want to go in. The resistance we feel to the loss of control of our outer selves isn't trustworthy. The outer self tells us, "When you don't do things my way, and you give up my point of view and stop striving to get what you think you want, then you're going to get into trouble." The part it leaves out is that subjugation to the outer self always leads to a bad time. Have you ever noticed that following what "you" want results in sorrow, and that someone around you always ends up getting hurt? It requires courage to give up something when we're not sure if something will show up to replace it. But, as they say: "No guts, no glory."

The demand that life is always making of us is to "stand down" (to become quiet inside) and to say the Name of God. This is similar to the situation a soldier faces when he is ready to engage in battle and he gets the command to stand down. Because it's difficult to pull back from an emotional takeover once it's in full swing, what we want to do is practice standing down in the ordinary moments of our days by checking our state and separating out from any insistence and tension in it. This will make it easier to stop right there when things heat up. If we routinely find ourselves at the mercy of our emotions, then this is because we haven't seen that we are the commander and that it's our job to interrupt our mechanical responses and issue the command: "Stand down."

One way we can be kept from the practice of separating from a mood of insistence is by believing our minds when they say, "That sounds great, but you won't be able to remember to do it." This voice will present our inability to remember as an insurmountable hurdle. Our minds aren't *solution-oriented*, they're *problem-oriented*. They won't tell us that separating

from the madness is as simple as deciding how often and at what time of day we're going to do it, and then doing it come hell or high water.

Maybe we could experiment with this approach. We could determine that each day at an appointed hour we'll sit down, take a few deep breaths, become quiet inside, and drop God's Name into the stillness that we've prepared to receive it. This would lead to a new idea—to the discovery that we possess a gearshift and that all we needed to do was practice locating it. This way we'd discover that it's possible to shift gears and separate from whatever trip our emotions are on. This would set up a different pattern inside of us, a new reference point for what's possible when we're experiencing a massive takeover by the forces of destruction.

The Chalice

It seems to me that my teacher is here to help his students move in accordance with something beyond their personal worldview. A spiritual teacher's work is to create a chalice, or a Holy Grail, to contain the Divine here on earth. This chalice is constructed from and by a group of students that become fused together by turning their attention from their personal preferences to the service of something more interesting and sacred. At some point, we're able to see that the only way we can contribute to this cause is if our real selves are calling the shots.

Even though our personalities can mimic what's real, and make us say the "right" thing or sing the "right" song in the "right" way, a song that doesn't come from our true selves will be devoid of life. If we're invited to be warmer and more generous with others and if we mimic the way our mind thinks warmth and generosity looks—without first issuing

an invitation for our inner selves to take over by saying the Name of God—then there won't be a useful result.

We all know about food out in the world that's pretending to be real but that has no actual nutritional value. It's the same thing with us: when our words are disconnected from our inner selves, we're just passing out processed cheese slices. Getting quiet inside and saying Yogi Ramsuratkumar's Name is a way of acculturating ourselves to what it's like to disconnect from the personality that mimics rather than creates. So a few times a day we can become still inside and stick our toes in the water in order to get used to another way of being. This is worth doing, since there's a world of difference between processed Kraft Singles and raw cheese from a dairy in France.

Abracadabra

The imperative, the place that we're all stuck at, is "avoid love." Since we haven't managed so far to switch to another imperative on our own, it should be obvious that we're going to need some help to do this. It's as though a long time ago somebody pressed a button inside of us, marked "I can't get love and if I could it would kill me." But what we don't know is that there is another button inside us that would open us to another experience. Because the other button is hidden, we're going to need a flashlight or something in order to find it. Saying Yogi Ramsuratkumar's Name to the thoughts that we're having in this moment not only interrupts the program, but it illuminates the other button.

Sometimes we feel so much distress about the program that's guiding us that we superimpose a nicer veneer on top of it, and we pretend that our adaptation to the loveless program is more fabulous than it is. We figure that the best

we can do is to mimic and create a facsimile of a freer and more elegant response to our situation. I guess we do this because we know something's not right here, and we know we don't have the key, the magic words, or the incantation that will unlock a different response to life. What we've all been looking for all of our lives is this secret abracadabra word or incantation.

The Name of God is the incantation that will shift our reality and catapult us into a uniquely sane relationship with life. This is extremely good news for those of us who have begun to suspect that we're a mess (psychologically speaking), because now we know that we don't have to go to our graves this way.

Switching Our Allegiance

When we begin to travel a spiritual path, we haven't connected yet to the place inside of us that's real. For this reason, our response to life is produced from the place of how to get through life in a way that avoids as much pain as possible. Because our spiritual selves are still cocooned and dormant inside of us, it can't occur to us to ask, "Is this thing that I want to do or say going to be beneficial and profitable for my spiritual growth and development?" How can we approach our decisions from the highest point of view when we're unaware that we have a place in us that *is* objective and infallible? It takes awhile on a genuine spiritual path for our attachment to what we think is in our best interest to weaken. It takes time for spiritual guidance and practice to clear enough space inside of us so that we can connect with the place in us that knows what it's doing. It takes the time that it takes to leave off supporting the part of us that's fated to die and to begin to support the place inside of us that's eternal.

The quickest and easiest way to accomplish this is to say the Name of God without ceasing. The Name of God, if it's said consistently and persistently, will rapidly clear up the confusion inside of us that inhibits us from acting on the behalf of our true selves. It will allow us to swiftly and easefully switch our allegiance from our pretend selves to our as-yet-undiscovered genuine selves. We can't go to work for some unknown thing. First things first: we need to become aware that we contain something more fabulous than fear in order to align ourselves with it.

Where We Live Matters More than Where We Think We Live

We're all capable of being quite mean. If someone said just the right words to us in just the right way, we'd be willing to throw our own grandmothers under a bus. We're all, every one of us, unconsciously or not, grenades and loose cannons. The only difference between someone who's destructive and someone who's not is the intention they're connected to underneath the surface. A knife can be used to create a cheese plate or to kill someone—the intention of the person wielding it makes the difference. If self-interest is ruling our minds and our behaviors, then the people around us shouldn't be afraid, they should be terrified. If, on the other hand, protecting the sacred is where we live (at least fifty-one percent of ourselves), then it's this intention that will find expression consistently in our lives.

It's not where we say we live, or where we wish we lived, that counts. What counts is what matters most to us. If we're still playing sneaky games of one-upmanship with the people around us, then it's time to redouble our efforts to connect to the sacred. It's time to get down on our knees and beg God to

keep us from harming people. It's also time to say the Name of God with incredible diligence.

Because we can't see what's inside of us, we don't know if what's moving us is benign or destructive. The way we can begin to suspect that "there's trouble right here in River City" is if we're getting feedback from the people around us that we're being aggressive (passively or otherwise). If this is the case, then please take this as the evidence that it is and allow yourself to feel the sadness of this. This sadness could propel us to offer up a sincere and humble plea for help.

And if this prayer were to be answered and we found ourselves being kinder, would this be so bad? It wouldn't be, but we think it would be—and unfortunately this is all that matters. If we did decide to counter our secret life-negativity with the practice of saying God's Name, the balance of power would shift and we would no longer be at the mercy of self-interest. Again, would this be so bad?

"We Have Met the Enemy and He Is Us"—Pogo

Everything we see enacted out in the world—the cruelty, the greed, and the violence—is the face of what it is that runs us night and day. It's not that the personal self can be unpleasant—the personal, by its very definition, is an agent for pain. The personal self is a ruthless killer of all that's innocent and sacred. Spiritual teachers come here to create space for the sacred by uprooting our personal selves from the seat of power. If only we knew that the ugliness we see on TV (child soldiers, for instance) is the expression of the personal self that dominates our own landscape. The horror within us will destroy anything that becomes a threat to its sovereignty.

The sight of what we've been sustaining and placing between God and ourselves can act as a catalyst for making

efforts in another direction. As long as we think we're hunky-dory and we're not that bad, then we'll remain as co-conspirators to the destruction of innocence in ourselves and everyone else, and we'll continue to "neuroticize" everything and everyone that comes within six or seven feet of us.

Tag, You're It

Our true selves are *never* emotional. *They* know there's never a problem. They're clear about who and what they are: that they were created by God and that God loves them. Any time we're having a problem, the reality is that we're manufacturing it and it's *our* job to get off it. When we project a limbic/alligator lapse on top of another person and try to convince them that *they're* at fault and that *they're* responsible for our problem, this is similar to throwing-up in someone's lap and walking away, convinced that in a just world *they* should be the ones to clean it up. As long as we're being tyrannized by our psyches, we'll continue to live our lives unconsciously from this perspective: "Somebody, somewhere, screwed up big-time, and if it's the last thing I do, whoever they are (and frequently whoever they're not) are gonna pay!" Is this any way to live?

The Rubber-Band Effect

Until we begin to work with whatever thought we're having now, we can't create anything new—we're like rubber bands that keep snapping back to the same place over and over again. We have the experience of being caught in a downward spiral down pat; we've had a lot of practice buying into and believing each of our thoughts and ending up in the same place we've always been. This is because something inside of us is working overtime to make sure that our lives resonate

endlessly with the way things have always been. Since a deviation from the "party line" inside of us is unacceptable, we don't have very much experience spiraling up. In order to spiral up, we'd need someone or something new (like saying the Name of God) to interrupt the program.

Tap Dancing While Chewing Gum

Getting from A to B while accomplishing our daily tasks is far less important than we think. The real issue is which part of us is running the show as we go about them. The pertinent question is: Who's in the driver's seat? We can't expect a pig to drive us to market; it's our job to drive him. Any activity that's connected to Remembrance instead of the manic suppositions of the mind will always proceed smoothly; we will always end up at the right place, at the right time, with the right words, when we're not being driven by these assumptions.

Hedging our bets and exerting our will over the events of our lives strips us of the capacity to connect with life. We can't be in a state of tension while striving to make things happen and enjoy Divine inspiration at the same time. This is even harder than tap dancing while chewing gum.

It's Not What We're Doing That Counts, It's Who We're Doing It For

When we reflexively meet the demands of our pretend selves, we don't understand that every time we meet one of these demands we're hammering another nail into our coffins; that every word and every action that's connected to our survival—over and above serving God—is a ballot that we cast to strengthen the part of us that's turned away from life. Saying yes to what the mind wants is the way that we

get to vote against the Sacred. Neurosis wins and becomes stronger; our true selves lose and become weaker.

The way to get around this horrifying situation is to up the frequency of saying Yogi Ramsuratkumar's Name, in order to have the wherewithal to question ourselves when we're about to do something: "Now, what is it that this action will result in? Will it end up strengthening my neurotic life, or my soul's life?" This is always the question: "Which part of me will be served if I do this thing, and what exactly is the purpose behind this thing that I'm moving towards?"

The Talisman

Every time we're at the affect of an entity (mood, state) takeover, every time these forces set up residence in our minds and hearts, we incur karmic repercussions. Every time we banish them at the first sign that they're drawing near, we create a space inside of us that Divine inspiration can live in. I'm assuming that at other stages, Yogi Ramsuratkumar's Name will connect us to other possibilities—but first things first. In the beginning, Yogi Ramsuratkumar's Name may be used as a talisman to ward off these takeovers. It's the garlic that keeps us safe from vampires.

The problem with the garlic remedy is that we might run into a vampire when skipping through the woods, and be unprepared for the encounter because we left our garlic at home. The way to ensure our protection is to apply the garlic so rigorously (to say Yogi Ramsuratkumar's Name in the innocuous dishwashing, car-driving moments of our lives) that we'll reek of garlic wherever we are, in whatever moment we find ourselves, in or out of time.

We may not realize what this practice is actually doing— how much pointless pain and suffering we're sidestepping,

and how much benediction is infiltrating us. But just because we haven't been shown a profit-and-loss statement doesn't mean that the Name of God *isn't* performing miracles inside of us. Remember, there's very little that we *can* see at this stage. We have it on good authority that saying the Name of God is the correct medicine for what ails us, because it's the prescription that has been handed down by all spiritual lineages. For those of us in Lee's school, it is the all-purpose prescription that's been handed down from Grandfather to Father to Son and to us.

It's a Numbers Game

How much Remembrance needs to be in us so that we can have a *real thought*, versus one contaminated by the voices that are pretending to be us? If we realize it's just a numbers game, then we're not going to be duped by the voices that want us to believe there's no way out. My teacher Lee once said that Remembering and moving out of the force field of illusion is about accumulating moments of practice throughout the course of a day. He likened it once to building up a savings account: if we meditate in the morning, resist the impulse to "let someone have it," say Yogi Ramsuratkumar's Name, etc., all these moments of practice add up—like deposits in a bank account. Once enough of these deposits are made, the balance of power will shift.

The mind doesn't want us to know this. It considers this idea to be dangerous. It is. It will ultimately lead to a coup d'état and the end of our captivity. Hopelessness, anger and despair are the moods that the mind uses to keep its regime in place. We may have a moment of Faith and optimism on a good day, when our practice has been strong, but if we don't notice the very next thought in our heads—the one that's

connected to discontent—then we can lose what we've built. It's our job to safeguard the treasure.

Is My Ass Fat?

Everything we're presented with in life can be used to fuel our insanity or to fuel Remembrance. In and of itself, nothing that we're encountering is good or bad—whether we turn a scarf into a noose or a fashion accessory is up to us. When we begin to cultivate the place in us that lives to discover what's useful in each moment in order to trigger Remembrance, then this is what we get: Remembrance.

When an artist is working on a project, their attention is narrowly focused. If they're driving down the street and see an old screen door, they immediately see how they can use it for their project. They're not like, "Hmm, there's an old screen door … wonder if my ass is fat?"—they're scanning their environment while asking, "Can I create art with this?" This is the perpetual and overriding question inside of them. They're Remembering "the main thing."

God's Cherished Children

Life doesn't have it in for us and it isn't unfair; our neglect of our soul's welfare is unfair. We're here to do something else beyond coddling and catering to our neuroses. When all else fails—and it all will—we can always ask for help. It's always a big shock when we ask God for help and He gives it to us; no one's more surprised than we are at this bizarre turn of events. All of our neurotic and psychological "problems" exist to bring us to our knees, to the point where we *have* to ask for help because we've created such a tangled, knotted-up mess. When we're ready to stop banging our heads against the wall, we'll realize that we have no idea how

we got here and that we are incapable of rationalizing our way out. When all the arguments that we have about what life is and what we think it should be are *not working*, we'll see that no matter what situation we're in, and whatever asshole is treating us so "unfairly," the remedy is always the same: resist the temptation to make others the author of our misery, and ask God for help.

Many years ago, when I was in the thick of it and my mind's machinations completely dominated my emotional landscape (this was before I knew that I could say Yogi Ramsuratkumar's Name in order to shift my relationship to the hell-realms that I was frequenting), I was desperate for help. Not believing that God would answer a prayer of mine, I called a friend and asked her to intercede with Him for me. She put down the phone and ran into the bathroom in order to have a private chat with Him. (This was a woman who had five children.) She picked up the phone again and announced gaily: "God gave me a message for you. He said, 'Tell her that she is my cherished child, and that if she needs anything just ask me—I'll give it to her!'" I burst into tears at the words "cherished child," because nothing in my experience in this world had given me the impression that I was anyone's cherished child, let alone God's.

A Plunger and a Prayer

What does "calcified" mean? Calcium deposits restrict movement. We need look no further than our own toilets to appreciate the sorry state of our perceptions. According to my dictionary, recalcitrance is "being disobedient and stubbornly resistant to authority or guidance; to become stone." The thing about being recalcitrant is that when it comes to human beings, calcium deposits interfere with

moving things out of us that interfere with the flow of the Divine in and through us.

It couldn't hurt to address the situation with a plunger (the Name of God) and a prayer: "God I need your help here. Please help me to have clarity about the thoughts that are running through my mind. Help me to see them and to question whether they're actually true. Help me to see them for what they are instead of what they're pretending to be. I want to see who sent them, and the agenda behind them. I'm willing to see the truth." If we do this, if we ask for help, we will get help (stranger things have happened). Anything we're having trouble with can be met with an appeal for help. God, or our teacher, is waiting for someone to turn and say, "I could use some help here." After all, we all like to feel useful.

One day a friend of mine was having a mini nervous breakdown. His four-year-old son arrived home to discover him lying on the floor in the fetal position, crying. The boy said, "What's up, Dad?" His father tried to reassure him by saying, "Oh, I'm OK; I'm just having a hard time, that's all." The boy responded, "Have you asked God for help?" "No," his father admitted. The boy ran outside and called out to the night sky: "God! My dad needs some help here!"

Speaking of Recalcitrance

Speaking of recalcitrance: If we're going to be a conduit for the Divine, there can be no resistance to its movement inside of us. It would seem, according to all of the spiritual traditions, that spiritual teachers arrive here equipped with a jackhammer in order to break up our concretized personalities. They seem to be adept at putting us into states that magnify our unconscious view, in order to provoke an experience of the mood and the energy of the place where

we got stuck, built a dam, and refused to let the good times roll. This experience of being provoked is very strenuous for the programmed, mechanical self we're identified with. It's so threatening that the claws come out, and we literally feel that if this concretized space in us is broken up to create more room for the Divine, we're gonna die. We pull out all the stops to protect our imaginary selves, because we sincerely believe that the blocks inside of us and all the no's inside of us *are us.*

Our capacity to insist that we are right when a teacher calls attention to the irrational and shameful world we're living in knows no limits. Our basic stance could be summed up as "I am right and the entire universe is wrong." We will stop at nothing, literally, in order to prove in every situation that we're right. We'll stand in the middle of a funeral pyre of our own making, shrieking, "I was right!" That's the charge, the force, and the energy of dominance contained in the separate self. It won't occur to us, ever, to lean into the pain of being wrong. *Nothing* is ever our fault.

If we're going to save our souls, we may have to rush into the fire of our denial in order to retrieve something of value. Maybe a teacher's task is to get us to the point where we're willing to go into the burning house of our hidden pain, because our own safety means less to us than God does.

In the meantime, we have our hands full defending who we imagine ourselves to be. This activity becomes less and less meaningful as we gradually see that being wrong isn't the end of the world; it's the beginning of a wonderful new creation. It's actually a relief when some of that concrete is broken up, and we're delivered from the exhausting task of holding our imaginary identities together. It's as though we've been standing on guard, protecting a pig trough with

the utmost vigilance—standing in the rain and snow—ready to defend it against all the "evil-doers." Then a teacher points out that not only is this task unnecessary, but we're missing the warmth of the fire and the delicious turkey dinner that we came here to enjoy. When we see our folly, we won't be able to help laughing.

What About God?

Sometimes spiritual teachers will give their students exercises or jobs to do that will lead them to drop whatever winning formula they had set up in their lives to keep them from exploring the "What about God?" piece of the puzzle. My teacher gave an exercise to one of his students that I wouldn't have minded getting. This was a woman who was wired to believe that eating comfort foods would keep her safe from the abyss. The exercise consisted of eating twelve donuts every day without fail (even to the point of "If I eat another donut, I just know I'm gonna throw up").

At the time, the only thought I had about the exercise was, "How come I'm not getting any donuts?" Upon reflection many years later, I wonder if the point was to give her an experience that made it clear that donuts weren't the be-all-and-end-all answer to all of her fears and resistance to life. This experience might have prompted to her ask, "If the secret to the puzzle of my life isn't donuts, then I wonder what is?"

Sometimes a neurotic habit gets built into our psyches based on an irrational "crib conclusion," and we continue to animate this habit throughout our lives, never realizing that not only isn't it keeping us safe, but it's superfluous. I was working with someone once who had a bizarre relationship to time; she was incapable of showing up at her workplace

any sooner than two hours past the designated time. No matter what she did, and how much self talk she engaged in, it was as though the urgency of not meeting a timeline was too powerful for a mere mortal to overcome. One day, I looked out the window into the parking lot at nine a.m., and saw her sitting in her car, sobbing. When I went down to find out what was wrong, she said through her tears, "I had an alarm clock malfunction and I ended up here at the right time, and I'm terrified and paralyzed."

Sometimes the fear connected to a habit we've built is pretty powerful, and a teacher will go out of their way to come between us and one of these overwhelming and irrational adaptations. The experience of not going along with the things our psyches are telling us to do can be both terrifying and liberating. When we discover that disobeying a segment of our psyche's storyline doesn't kill us, the relief can be considerable. The value of this experience is that we can then pose the question: "If my mind has been lying to me about the omnipotence of donuts or tardiness, what else has it been lying to me about?" Maybe this is like putting together a jigsaw puzzle, and it's a process of elimination: we have to keep on picking up pieces to see if they fit, and eliminating them when they don't. At some point, the question becomes: "If donuts aren't my Lord and savior, then what is?"

One Hundred Years of Psychotherapy and We're Sicker than Ever

Once we realize that we lack flexibility because our responses to life are redundant, the desire to escape our reflexive and neurotic selves will certainly arise. We're all looking for a go-to-guy, a winning formula or a system, that will make the pain go away. I'm not saying that there

aren't some extraordinary therapists out there who can help us enjoy a less painful relationship to life, but I do think that finding someone who has what we need (a relaxed and fearless state of being) is improbable. The odds are high that we will choose a therapist who is stuck at the identical space of denial that we are, because our fear of change inevitably outstrips our desire for it. The book *We've Had A Hundred Years of Psychotherapy—And the World's Getting Worse* (James Hillman and Michael Ventura; NY: HarperOne, 1993) says it all.

Sometimes we become distracted by the creative and fascinating particulars of our program, and we invest our energy and our attention in studying its machinations. If we understood that our programmed responses to life were all connected to the same objective as everyone else's, we might not find our individual neuroses all that fascinating.

The mental projections of today are held in place by our decisions of the past. We are stuck in agendas that can never produce new and different tomorrows. If we could go back in time where all this got started, and have a moment of clarity about whatever life position we bought into while in our cribs, then we would have what we need to spring forward. But this isn't possible. At some level, we all realize that sifting endlessly through the embers of our past won't produce change—we keep hitting this same space and we can't figure out why. It turns out that the only arena that will produce change is whatever moment in time we're in right now.

A Moving Target Is Harder to Hit

We're all stuck at the same place: "I don't care for this game and I'm not going to play." Not playing is not a viable option, even though we believe it is. We think the goal is to

dig a trench, climb in, and stay in there as long as we can. The idea is to not get stuck and become rigid, no matter what. Regardless of whether we're having psychological disturbances or blissful encounters, the idea is to *move on*. Dead things have stopped moving; one of the ways we can tell that something's dead is if it doesn't move. Also, "a moving target is harder to hit," if you prefer.

Once when I was in a foreign country, I had my first encounter with death: I came across a dead dog in the road. When I touched it, I was struck by how rigid it was. (What with rigor mortis and all, it was as hard as a rock.) I extrapolated further: This is a major dividing line between life and death. When something's alive, it's pliable, flexible, and in motion.

The Worst Is Over

We're hiding, but nobody is coming to look for us. If hiding in the shadows and in the darkness isn't working, try something new. When someone gets in the trench with us and tries to lead us out, don't hit them over the head. Our parents already shocked the shit out of us, and it's too late to stop it from happening. Continuing to defend ourselves as though it's still happening is crazy; protecting ourselves for the rest of our lives against a fait accompli is silly. Maintaining an attitude of distrust won't get us out of the trench. Einstein said, somewhere, that sooner or later each one of us has to decide if the universe is for us or against us. Rejecting help from a teacher or from our real friends is like shooting ourselves in the foot. Doing something new looks like picking up our marbles and resuming the game, even when we don't want to; going in the opposite direction of what feels comfortable is doing something *new*. Trusting that the person that comes

into the trench is there to help unearth us would be a novel response. Just because the experience of being unearthed is uncomfortable doesn't mean it's bad.

Through Good Hair Days and Bad Hair Days

The response of our true self to the jaded and distorted assumptions that guide us in this world is: *There is only God.* No matter what comes up, no matter how real our fantasies appear, the answer is always the same: *There is only God.* This is our lifeline. This is the reality that we must hold onto— through thick and thin, fair weather or foul, PMS or pudding, accolades or criticism, apple pie or Brussels sprouts, good hair days or bad hair days, porridge or pestilence, Brahma or Kali—*there is only God.*

How to Refrain from Jumping the Gun

I wonder if sometimes God or our teachers cry when they give us what we want, knowing that what we want isn't the best that life has to offer. Perhaps we leave life no choice when we dig in our heels and refuse to serve *at all* if our cherished desires aren't fulfilled. What if getting our way not only compromises *our* possibilities, but also the possibilities for others and for the Divine? So to ask for something to make our lives easier or nicer may not be in our own best interest. Maybe it lightens a teacher's task if he doesn't have to keep tossing carrots to us to keep us moving. We may need to be more careful about what we're asking for. Since we don't know what we need and we can't distinguish between a bad fate and a good destiny, trusting a trustworthy teacher is the most practical advice we could ever hope to hear.

In order to refrain from jumping the gun and sending urgent distress signals, we would need to be ruthless with any

thought that's trying to convince us that where we are now is not good enough, or "If only I had just this one thing, then I'd stop being a pain in the ass." Saying Yogi Ramsuratkumar's Name illuminates (completely wipes off the slate) the necessity to be a pain in the ass.

In and of ourselves, we are incapable of animating anything else. When Yogi Ramsuratkumar said, "This beggar begs of you: please don't forget the Divine Name," we weren't out of the room—we couldn't hear him. We're not helpless, we're just deaf. The Name increases our ability to hear frequencies that escape us at this point. This being the case, saying the Name of God is the one recommendation from our spiritual advisers we need to hear for everything else to fall into place.

It's a Miracle!

It's rare (but not impossible) to find something out there in the marketplace that does what it says it will. I was in a store a couple of months back when a cosmetic representative put a "miracle" cream on my face. A small child in the crowd exclaimed, "Wow! That stuff really *does* work." I was unprepared for the face I saw in the mirror when I sprinted to the bathroom: I now looked and continue to look ten years younger. This blew the doors of my mind off—for once, a product did what it said it would. Naming it, "The Eighth Wonder (yeah, right!) Revitalizing Serum" wasn't an exaggeration after all![1]

Saying the Name of God—in my case, Yogi Ramsurat-kumar's Name—is such a "product." It's a tonic that actually

1 Based on my extraordinary results, this beauty tip alone is worth the purchase price of this book. Hopefully, this will help me neatly sidestep any liability issues that might come up if you decide that I haven't made good on my promise to share "the secret of happiness" with you. WARNING: This remedy may be hazardous to who you think you are, and may make everything you ever thought you knew look silly.

works for every malady known to man: it wipes out character defects, soul blemishes, cataracts, and the pesky weirdness of our psyches. If they can put a man on the moon and transform me from an old hag into a glowing middle-aged woman, then why *wouldn't* His name work? Here's a partial list of the conditions that His Name remedies:

- selfishness
- anxiety
- righteous indignation
- gluttony
- dressing your cat up in costumes
- cruelty
- cellulite[2]
- poor judgment
- low self-esteem
- boredom
- lack of kindness
- arrogance
- insomnia
- blame-shifting

- dull-wittedness
- apathy
- tardiness
- rigidity
- self-pity
- megalomania
- memory loss
- jaundice
- irresponsibility
- bad manners
- agoraphobia
- depression
- callousness
- arachnophobia
- toxic anger

2 In an effort to take a stand for truth in advertising, I need to tell you that even if you don't ever wake up free of cellulite, your thighs will lose their grip on your psyche. You'll be released from their power to cripple your spirit and cause you to curse the gods for their cruelty.

Chapter Five

If You're Having Trouble Getting God or Your Inner Teacher on the Line

Practice as if Your Hair's On Fire

Here's a story that illustrates just how far a spiritual teacher is willing to go in order to relieve his students of their crazy, mixed-up ideas about themselves: Many years ago my teacher was in a Mexican restaurant in LA. He was working to interrupt the happy flow of one of his student's denial festivals. In order to make his point clear, he picked up the plate of nachos in front of him and smashed it into his face right then and there, in broad daylight and in public. The bizarreness of this act stopped her cold and in her tracks. She later reflected that it was at this moment that she realized her teacher would stop at nothing to save her from herself. We all need saving from ourselves, whether we know it or not. (Lee likes to sing the old classic, "Nobody Knows the Trouble I've Seen.")

When we find ourselves, one fine day, in the company of a genuine teacher, it's as though our hair's on fire—but he's the only one that can see it. The truth of this was brought home to me when I was standing in a field one day, talking to my ex-husband. I looked up after lighting a cigarette and noticed an odd expression on his face. This was followed by some important news when he said, "Your hair's on fire!" A few minutes later, I rejoined a talk that my teacher was giving. When I walked into the room, the first words out of my teacher's mouth were: "You must practice (make heroic efforts to move in the opposite direction of what your mind is telling

you) like your hair's on fire, because it is." The synchronicity of this didn't only make me laugh, but hopefully it served as a necessary heads up about just how urgent it *really* was for me to apply myself.

The Unfairness of Life

Helping us to turn around and face life (because our backs are turned away from it) is the sacred work of a spiritual teacher. They come here to help us develop our capacity to take in the gift that life is, instead of rejecting it and finding fault with it and the gift-giver. This is a rare and priceless opportunity.

I think what happens is that in order to put a dent in our unnatural relationship to *the way things are*, a spiritual teacher has to provoke a healing crisis in us. He has to confront us in outrageous ways that really stun us with how exaggerated, all-consuming, and childish our thesis ("Life is unfair") is. At this point, when we're whipped up into a state of incredulous indignation and we've ended up in a place where all the exits are blocked, we will have no choice but to give up our cherished dream of getting our due, our fair share, or whatever we've been holding out for. Once we give up this ludicrous position (as if our Father could ever deny us, His cherished children, anything), then we become able to see the blessing encoded in every shocking and crazy manifestation of life.

We're either serving our *idea* about life (that we're a victim) or life itself. When life hands us an opportunity and we respond with a complaint, this is because we're standing behind a glass wall that's limiting how much we can serve and contribute to life. One of the functions of a spiritual teacher is to break the glass. They don't do this because

they're mean, but because we're isolated and cut off from life. As the glass begins to shatter we assume that this is a bad thing, because the assumption we've built over time is that life isn't our friend. Spiritual teachers are victimless crimes, because they're not at the mercy of their psychologies like we are. This is one occasion where our assumption about life is really wrong. Anyone who has the great fortune of being in the presence of a real teacher can never be victimized.

Diminishing Options

Our attachment to our convenience is the hobgoblin of spiritual life. Until we find a teacher, we think we're supposed to change the things and the people around us to better suit our preferences and purposes. Once he enters our lives, "the system" breaks down and we start getting glimpses of the ineffectualness of our efforts. Getting *what* we want, *when* we want it and *how* we want it, becomes more difficult than usual around him. Every time we start running towards the goal, he throws up a roadblock. When this happens enough times, you could say "he's run us to ground"—a term borrowed from the world of fox hunting. At this point we've exhausted all *our* options, and there's the possibility that we can begin to consider a new one. How else would you get someone to give up the ghost of who they're pretending to be?

The Red Shoes

Hans Christian Anderson's story *The Red Shoes* is an allegory of our situation before help arrives: A little girl sees these extraordinary red shoes in a store window that she absolutely must have; she becomes obsessed with the desire to possess them. As soon as she does she becomes a slave to them—she can't stop dancing and she can't get them off.

This is the current situation for most of us: we're under a spell that demands relentless twirling. There's no way out. We're incapable of producing thoughts, words, and behaviors that are disconnected from this enchantment. Once we understand that our lives aren't our own and that we can do nothing about our knee-jerk reactions, (this might have been what Gurdjeiff referred to as "the horror of the situation") it's important to take note of the fact that the cavalry *has* arrived if we have a teacher, and that he's here to tell us what to do to get these cursed shoes off. If we don't have a teacher, then saying God's Name without ceasing will do the trick. Saying the Name is equally useful when we have a teacher, because this enables us to hear his instructions.

All Through the Night

People who have found real teachers (not to be confused with a discarnate entity; or a member of the White Brotherhood; or someone who thinks they are because they say they are, mind you) who are helping them to Remember God, end up feeling grateful and devoted to them. This is because they have received a priceless gift from their teacher: knowing themselves as they are.

After a teacher has ignited the spark that lives inside of each one of us (it seems to me that until this moment we're straw men, inflatable dolls, insentient puppets) he sees the job through. He never abandons us, and he stands ready to protect us and lead us out of harm's way as we make the transition from stuffed bunny to real bunny. Because he's faithful, loyal, and vigilant, it would be nice if we would make some small efforts on our own behalf.

A teacher's vigilance could be portrayed as staying up through the night with a candle, watching over us as

we sleep, and dream, and pretend. (I like to think of him wearing striped pajamas and a stocking cap as he attends our bedside.) This surely is an example of someone being devoted to us in a way that we never could imagine, based on our experiences here in this world. Surely the example that a teacher sets (being riveted unselfishly to our cause) is nothing short of unheard of and unseen in this world. Why would anyone go *this far* out of their way to care for us? The whole notion is completely foreign to us since we don't care for ourselves. The thing that sets a teacher apart from all others is that his concern, dedication, and compassion have *no limits*. He's Infinity, holding back the tide of the finite from engulfing us. So don't be disheartened or dismayed—he has your back.

Is It Hot in Here, or Is It Just Me?

Most of our anger at life is hidden from us and percolating along somewhere below the surface. This slow-burn condition is infused with a mood of unwillingness to serve life. It's shot through with a million tiny no's. Because we can't begin to do anything about something that is out of our line of sight, sometimes a spiritual teacher will turn up the heat in order to save us from ourselves and from all of the no's that are separating us from life.

It's well known that the way to cook a frog is to put it in a pot of water and gradually turn up the heat, so that it won't freak out as the water is getting warmer and warmer—it will just be lulled into sleep and wake up dead. The other way to cook a frog would be to throw it into a pot of boiling water, but here the chef would run the risk that the frog would use the considerable propulsion power of its little legs to leap out of the pot.

Spiritual teachers know that the best way to get us to participate in the salvation of our souls is to turn up the heat way past our comfort level, in order to motivate us to make the leap and to catapult us out of our lethargy and self-forgetfulness.

Feedback

Just because our relationship to life has been adversarial and we've been unconsciously giving it the finger doesn't mean things have to stay this way. Just because the energy that enjoys inhabiting an angry little psyche keeps telling us we're trapped doesn't make this true. If we have someone around us like a teacher or a senior student of a genuine teaching, all we have to do is listen to them when they're saying, "Stop!" or, "Shut up!" They're yelling at us to get our attention because we're on the wrong train. We need to pay attention to them in order to learn that it's not that hard to get off the train to nowhere, even if it has started to leave the station. They're giving us the gift of showing us that we have more freedom than we've been led to believe—all we have to do is listen to them.

It's *our* job to stop feeding the anger of our psyches by excusing it, justifying it, condoning it, and generally pretending that it's a good thing. It's their job to interrupt the nightmare we're having, in order to show us that it's not substantial. It's their job to say, "Stand down" when we're being carried away by forces that are less than human, and it's our job to stand down and become quiet inside when we're getting urgent feedback. We need to learn to trust a voice other than our own when it's telling us that it's time to get quiet and separate from anger. This is how we will have the experience for ourselves of seeing that our anger is transitory and that it's possible to stop feeding it. We need to see that,

not only isn't it our friend, but we can walk away from this fair-weather friend at any time of our choosing.

Don't Leave the Room

Spiritual teachers will often take us to a place where there's no way out. When we're backed into a corner, we can't help but see how silly our ideas about life are. The energy that's unleashed from that sighting can be used to catalyze a leap into a new relationship with life. But if we take the pot off the stove just as it's coming to a boil and say, "I'm done" and flounce out of the room, then the heat is wasted and this energy doesn't get to be used to propel us forward. This is why, when a student is receiving pressure from his teacher, it's poor form to leave the room.

We want to do the opposite of what's comforting and let the teacher do his work. Even though the mind is saying, "I don't have to take this," etc., we may want to experience the thrill of going in the opposite direction of where we think our safety lies for a change. Every time we do, we'll discover that having one of the barriers removed (the ones we've been holding in place between ourselves and life) feels better than we could have imagined—that feeling more alive than dead isn't so bad after all.

The Dictator Within

Our condition (being run by lower forces or energies that have attached to our wounded egos) appears to be an OK situation. The thoughts in our heads appear to be useful and benign. All the coaching and cheerleading from the sidelines that infiltrate our heads appear credible. It's not apparent at first glance that we're in bed with something vicious rather than kind.

It seems that a spiritual teacher quickens the process of revealing how destructive these forces are. Without his help, it might take eons for us to notice that we're not free and that the dictator within isn't benevolent. With his help, our true situation is brought into focus. Maybe it's helpful to see our situation as one of subjugation by less-than-human forces, in order to break the misidentification that helps to keep the status quo intact. The idea that "my" psychology is defective and that "my" ego is bad strengthens our ties with the misidentification myth. There's nothing wrong with us that ousting the maniacal dictator in our heads wouldn't fix.

A teacher's call to action needs to be connected to a decision to end our collaboration with the enemy. It's like when there's a mess at the supermarket and you hear "Clean-up on aisle three." The clean-up guy doesn't sit down on the floor and say, "This is a mess." His job is to clean it up.

Biting the Hand that Feeds You

Ignorance isn't a legitimate defense of indefensible behavior. Just because we're pretending that we're not screwing Christ to the cross doesn't protect him or anyone else from harm when they get in the way of the self-absorbed and violent dream that we're having. The alligator that I've been comparing our mind/ego complex to is always patrolling our waters in order to shred the least little bit of awakened and reverential consciousness.

Spiritual teachers literally take their lives in their hands when they come here to give us the truth. This act of generosity and kindness is met with swift and brutal repercussions. Speaking of alligators here, one thing I could say is, "Talk about biting the hand that feeds you!" When we begin to see how much we're costing the person who dares to love us

and lend us a hand, then this inspires us to do some alligator wrangling.

A long time ago, a friend of mine visited me at my teacher's school. She attended a talk he was giving, and sobbed all the way through it. The reason she gave for her odd behavior was that she was crying because of how much he was suffering. Whether we know it or not, our psychology's position ("This is my world and don't anyone dare f**k with it"), is painful for others.

"Best Not to Let the Evil In"

A depression, fear, or anger takeover doesn't mean God has bad news for us and that other people are screwing with us (there we go again, drawing conclusions)— it means that we've temporarily forgotten that *there's only God*. Once we've gone around the mulberry bush a few times and seen the inevitable wreckage, after the dust or the snowstorm settles we're ready to decide to work on shortening these lapses by remembering sanity sooner rather than later. It might be helpful to realize how much we have in common with a snow globe: when it's snowing, we're not doomed to an eternal winter; we've just been turned upside down.

Since we've had amnesia our whole lives, when we begin to wake up and Remember that there's only God, we will continue to have lapses of forgetfulness. Our task is to shorten our recovery time and to begin to identify what precipitates these lapses; to notice the quality of the thoughts that precede an emotional takeover of our consciousness. We could become like Henry David Thoreau, who built a retreat from the madness of the comfort-possessed world at Walden Pond. I remember hearing a story that when a friend tried to give him the gift of a doormat for a housewarming present,

he rejected it saying, as I recall, "Best not to let the evil in!"

A teacher's job is to save us from ourselves, not from the big bad world. His efforts to protect us from the irrational imbalances and contaminants inside of us are prone to misinterpretation. We can't help viewing the remedies and corrections that he applies from the standpoint of what we want, not what we need. A teacher's stand (to go against the grain of our wishes, hopes, and dreams) is susceptible to misinterpretation. We might as well assume that he knows what he's doing, based on all of the evidence that we've been amassing that *we* sure as hell don't.

We've Got Bigger Fish to Fry

When we question the aberrant thoughts in our minds, we clear out our illegitimate suffering in order to get down to the real job we've been called to do here. The story that we've latched onto is irrelevant in terms of our job. We've got bigger fish to fry than grumbling about how "unfair" life is; we're actually here to turn to God and to stop frittering away all our energy by whining. We've been barking up the wrong tree, pole-vaulting over mouse turds, and our lives have been consumed by a grand irrelevancy. Life is about God, not us—so *deal with it.*

On the other hand, (there's always another hand, as the truth is multi-faceted), there can be great value in exploring the places inside of us that are wounded. Because the pain that we experienced as children happened when we were very raw and still reeling from the pain of being separated from God, some of the arteries to our hearts became shut down. If we could connect with the pain that preceded the formation of our manufactured existences, we could use this experience as a conduit to opening these arteries in order to

Remember God. This isn't something that we have to effort or make happen; it will get done "accidentally" when we say the Name of God. If a profitable experience inside of us needs to be retrieved, it will arise spontaneously and naturally once we clear away some of the flotsam and jetsam that's always drifting through our minds.

Over the River and Through the Firewall

We have more important things to be concerned about than whether we're wearing sun block (now there's a preposterous product, given that the sun is responsible for all life on this planet. What will we think of next?[1]), or whether our pants are getting wet when we're sitting in the grass. We want to begin to give our attention to important things—like figuring out how to get through the firewall between us and love.

Outwitting Love

Here's a good word—*petulant*: "unreasonably ill-tempered, irritable, or peevish; contemptuous in speech or behavior." Petulance is one of the first lines of defense when the personality's authority is challenged. If a teacher is "lucky," when he starts to hack away at our ill-begotten assumptions

1 By the way, it turns out that the sun isn't our enemy (despite the fact that there's actually a newsletter out there called *The Sun Is Your Enemy*), and that once again we're the enemy. It's been discovered recently that our fat-free diets are responsible for turning yet another beneficial source of health and energy (the life-giving sun) into something harmful. The sun block manufacturers are making out like bandits here!

Given that our eyes contain sixty million receptors that are designed to take in sunlight, in order to catalyze the correct functioning of every system in our bodies (think photosynthesis), sunglasses would seem to be another foolhardy invention, because they inhibit the production of serotonin in our brains. Of course if we knew this, sunglass and antidepressant sales would suffer.

When I think about all of the ways that we're killing ourselves with our cleverness, I could just plotz.

about life, then he's treated to petulance and peevishness. If it's true that all true teachers are transmitting love from every cell in their bodies at all times (that this is a gas that they emit), then it would be great if we were open and receptive to this love. There are a lot of strategies we can use to ensure that this doesn't happen.

Here's one way to outwit love: Imagine that we're baby birds that won't open their mouths when their mother tries to feed them a worm. One strategy we could use to not take in love and nourishment would be to tape a cardboard baby bird's mouth that's drawn to look open onto our closed mouths—by pretending our mouths are open instead of actually opening them, we think we won't be held responsible for passing on love. The first step in the process of taking in the worm is to take off the cardboard replica of an open mouth that's stuck to our faces and admit that we're pushing love away every chance we get.

The more we're protecting ourselves from life (or love) while running around saying that we're not, the less likely it is that we'll be able to receive anything. Admitting that we're trapped in an insubstantial and lonely world helps us to be more permeable to the influence of the Divine. Knowing that we need help and that we don't "have it covered" could be the start of something big.

You Must Become Like a Little Child

My teacher's devotion toward and love of children is noteworthy; the tenderness and care that he brings to his interactions with small children is really something. Because his love knows no limits, it extends to the children that are trapped inside each one of us—even the naughty children who are behaving badly. Jesus didn't draw the line at healing lepers. In keeping with this

tradition, a real spiritual teacher doesn't flinch when presented with the worst in us. He knows that there's a prince or a princess trapped inside the frog suit that we're wearing.

A number of years ago, Lee wrote a song for his band Liars, Gods and Beggars called, "Angel Still." I remember the line "What is it about this world that turns innocents to whores?" very well, because it was etched into my being one night at an outdoor concert that his band was giving. I was chatting merrily with my friends, when out of nowhere this line in the song catapulted me into an unearthly awareness of the innocent and remarkable being I was before a series of strategic cover-ups obscured my true self. I abruptly found myself grieving and crying uncontrollably for the loss of the one that had existed prior to what I had become.

Angel Still

She sashays up and smiles at
Each man in the band
She oozes with flirtatiousness
Though she can hardly stand
The remnants of her beauty
Still captivate your mind
But looking deep into her eyes
You know she's not your kind

Oh what is it about this world
That turns innocents to whores
She's a drunk and lonely goddess
Who no one will adore

The sorrow of her painfulness
Tempts you for a moment

But you always have second thoughts
It's not worth the torment
You think you want her in your bed
You want to fix her heart
But it's cracked in so many places
She's crumbling all apart

You look at her used body
That for a few beers can be bought
It's not this tramp you're feeling
It's the one you've always sought
For though it's sex she's selling
It's love that she still seeks
Beneath the mask she's woman
Though she rarely dares to peek[2]

What Have You Done for Me Lately?

Many spiritual students arrive at a spiritual teacher's doorstep more dead than alive, and some of them actually need to be resuscitated and/or resurrected. I wonder if Lazarus' resurrection (he'd been dead for four days by the time Jesus got to him) isn't a play from the spiritual teacher playbook.

Generally speaking, spiritual students get to be spiritual students because they've built something in their inner being. Before finding a spiritual guide—someone that's been sent here to rescue us—the inner radiance of a potential student doesn't go unnoticed by forces that are unsupportive of the truth. Maybe a true teacher comes here equipped with a machete, in order to hack away the tentacles of the "denying force" that are wrapped around our hearts and minds, in

2 "Angel Still" Lee Lozowick and Stan Hitson; LGB Music, ©1993.

order to give us a break and some breathing room so that we can live to fight another day. Most spiritual students have some awareness—when they make it across the threshold—that the hounds of hell were nipping at their heels (that these were *not* the poodles of paradise).

But maybe it's possible to underestimate the kindness and generosity of the one who saved us from a fate worse than death (this would be spiritual death). If we don't know just how close we cut it—that we owe a debt of immense gratitude to our rescuer—then of course we will respond to the next phase of a spiritual teacher's work (learning to do our part in separating ourselves from any vestiges that remain of the tentacles) with churlishness or apathy. Perhaps we're reluctant to do our part because we're blind to what's been done for us. We never knew how much trouble we were in in the first place, so how could we know now that the only correct response to God's mercy is to make efforts on our own behalf that are inspired by gratitude?

The story of Rapunzel leads us to conclude that we *do* have a part to play in all of this. If she hadn't grown her hair, then the prince wouldn't have been able to climb up to the tower and rescue her. Our response (because we're blind) is to approach the one that saved us with the bizarre question: "What have you done for me lately?"

Where We Come In

The way we get to say thanks is by pitching in and cutting any residual threads once we're relieved of the tentacles that have us in their grip. This is what self-observation (noticing and separating from treacherous thoughts) is for. The most expedient tool to get this job done is saying Yogi Ramsuratkumar's Name to every one of our thoughts that are masquerading as real.

138

These thoughts are the precursors of bad things to come, and the way that destructive energy knocks at our door in order to gain entry. If we go to the door and open it (if we buy into the very next thought in our mind that's connected to ingratitude and complaint) without asking, "Who's there?" then this unfriendly energy will possess us before we even know it's happened. This is why they say, "The only good thought is a Yogi Ramsuratkumar thought." The energy that's working night and day to gain admittance needs to have the experience of being turned away a few times when it knocks at our door, in order to get the point. Once it's figured out that we're not the food source that we used to be, it will turn its attention elsewhere and we'll begin to enjoy a little freedom from being ordered around night and day.

Even Better Than an Alarm Clock

Any response other than yes to life is the equivalent of slapping God in the face. This is the literal activity of saying no, not an over-dramatization. An alligator is a good choice to represent the personality because it has a big mouth with dangerous teeth that will tear anything apart that gets in its way. The value of having a teacher is that he can show us how violent and cruel this outer self is; that when cornered it *will* pull out all the stops and attack. This is actually what we need to see, because if we think who we're in bed with is benign and innocent enough then we will believe it's OK to stay in bed with them.

We've been lulled into a false sense of security by the poison/sleeping-potion dripping into our minds thought by thought. It's not until a teacher—or the practice of saying the Name of God—arouses us that any alarm bells

go off; that we notice who we've been sleeping with. Then we can say, "Oh s**t, I better get out of here!" We begin to see we're in bed with a dangerous bedfellow when a teacher is standing in front of us triggering the rage that lives inside of us. It's worth noting with gratitude that a teacher is even better than an alarm clock, because he is also here to take on the forces we've been associating with and identifying with, in order to lighten our loads and give us an essential break.

Thank You

One of my children turned to me one day a couple of years after I found myself in my teacher's company and said, "Mom, if it weren't for Lee, you'd be dead by now!" This matter-of-fact appraisal of the situation was obvious to a six year old.

Another moment that comes to mind was when my teacher turned to me and said, "I got you out clean from all of your entanglements and enmeshments, and you never even said *thank you!*" Sometimes even if we only dimly suspect that something really great was done for us, we can make a beginning by clinging to our etiquette books and mouthing the words "thank you" until the full import of our teacher's sacrifice hits us.

The third reference point I have is a story from many years ago of someone who made it into the sanctuary of a genuine spiritual school just in the nick of time. A friend of mine had a dream that illustrated the reality of this person's collision with help. She saw him as a beautiful, shiny, silver fish that was swimming around in a very murky tank that had been lucky enough to be transferred into a new one with clear and luxurious water.

Buyer Beware

I hope that I've said nothing here to inspire you to run out and find a teacher if you don't have one. There's a good chance this would be catastrophic. The possibility of ending up in the company of a genuine spiritual teacher is less likely than locating the proverbial needle in a haystack. All that glitters isn't gold, and the spiritual teaching field is littered with scary Pied Piper-like "teachers" that abuse their power and lead their students into rat holes. Maybe they all start out as nice guys, guys who woke up and saw the dream for what it was. But enlightenment isn't the be-all and end-all, as it turns out. Knowing the truth doesn't give someone a license to pass it on to others. (Werner Erhard's well-quoted remark, "Understanding is the booby prize," should have laid this myth to rest.)

Before Jesus came back from the desert with the good news, he was tested by Satan and invited to fling himself down from a mountaintop in order to demonstrate his new superpowers. This was the moment of truth: would he fall prey to the biggest hurdle of all (spiritual pride) or not? When I think of this story I say to myself, "Satan wouldn't have bothered trying to seduce Jesus unless he thought he had a shot ... *and this was Jesus.*"

Genuine spiritual teachers are like a group of mountain climbers that are tied to each other throughout time and space in order to avoid any mishaps. Any trustworthy teacher (one that won't take you to hell with him when he falls off the mountain) is connected to a lineage that's devoted to serving and blessing humanity. What keeps you and your teacher safe is the blessing force that this lineage is. Your teacher's focus on *his* teacher must be unwavering in order for him to have the protection of his lineage. So any old teacher won't

do. If you should find yourself searching for a spiritual guide, be sure to check their pedigree.

Never Trust Anyone Who Works Alone

Teachers that "work alone," that don't acknowledge the beneficent help that they've received in order to find themselves where they are, are dangerous. Any teacher that's not sharing the stage can get you into serious trouble. The more capable they are of seeing the truth of things and relaying it to the rest of us the more dangerous they are. Knowing the truth and disseminating it with the blessing of a lineage are two different things.

The work that they're doing may have the appearance of being beneficial when it's not: what may be happening is that they're inspiring us to become more conscious so that we will be a better meal for forces that are less than human. When a goose is given lots of food to eat, it doesn't suspect it's been targeted by the pâté industry. I don't know for sure, but all of this new "now, now, now" work may be an example of information that could make us a more gourmet meal than we would have been if we were sound asleep. And by the way, I'm not saying these people are in league with the devil, with something that can't serve you; they may be unconscious of who or what is actually sourcing the transmission.

If I'm wrong about this, then my sincere apologies to them. If I'm right, then this may be just the heads up that's required. "Beware of false prophets" is better advice now than ever before. Some days, for all of us, it really is hard to tell who's in charge. We're usually the last to know. Saying the Name of God is the only thing that can guarantee our safety.

How to Get into Big Trouble

Just because you heard it on "Oprah" doesn't make it trustworthy. It's a great temptation to find someone who appears to have it all together and follow them. If only there were someone who could lead us in the right direction that we could give over our power to, and if only we could make it home safely without making our own efforts to remain vigilant. But in this world, as in many others, we get what we pay for, and there really is no "free lunch."

If we believe that we have a problem and we're lost, then we will be tempted to reach for a solution that may have a hidden down side. Since Madison Avenue's job is to point out that we've got a problem in order to sell us dangerous solutions, we need something that can exorcise all of the "uh-oh's!" inside of us. Saying the Name of God is that thing.

Welcome to Alice's World

Spiritual or mystery schools are unusual environments: they're places where you go to learn how to get out of step with the way the rest of the world—and your psyche—are moving. A perfect analogy for how different the climate of one of these places is is the experience that Alice had when she went down the rabbit hole. Everything was upside down: rabbits were wearing vests and talking to her, playing cards were painting roses different colors, and none of her experiences were predictable or reasonable.

The people that have been in one of these schools for a while appear to be playing from a different playbook than the one you were given. The emphasis seems to be on interrupting the structure of the habits that we've formed over a lifetime, not on protecting them. It can be really disorienting as all the layers that are superimposed upon our true identities are

becoming unraveled. The usual coping methods are useless in a place like this.

These schools function in the same way that large families do: the older students pitch in and lend a hand to help the newer ones. For the most part, a new student will go though a period where, instead of being grateful, they'll misinterpret the help they're receiving. Again, one of the most accurate analogies is the process that a caterpillar goes through when transforming into a butterfly. How could the caterpillar *not* be saying, "What the f**k?!" when they're in the process of dying to everything they've ever been?

Switching Teams

Spiritual students are in the process of picking up some new skills. Rather than remaining good at protecting their pretend identities, they are becoming adept at dismantling them. They are beginning to see that the skill of twisting the truth into a lie is overrated, and that the skill set that they've developed to maintain their fictional identities has outlived its usefulness. When someone enters a spiritual school, it becomes apparent that holding these fictional identities together isn't that highly regarded, and that learning to tell the truth about what's going on with them is the way to go.

It's ideal for a new student to look to the team's more skilled players and ask them for help. If we were learning to play tennis, it would be smart to ask for help with our backhand. Also, if we're here to learn how to play tennis, so what if our game is ping pong—we're here to learn tennis. Sometimes a student will stubbornly hold on to his Ping-Pong paddle, hoping someone will play with him. There's a period of adjustment until we figure out that this isn't going to happen, because everyone else is playing tennis.

144

The thing to do is to transfer the excellence we've developed at proffering the lie to the skill of exposing it. Another way to put it is that we've been putting all our efforts into supporting one team and we must decide to support another one. This involves switching uniforms, and going to bat for *clarity* instead of pretense.

Who Will Buy My Beautiful Illusions?

My initial experience of being in a school was unsettling to say the least. All of the brilliant and highly-stylized adaptations that I had developed to obscure my real self—the ones that had been a grand success out in the world—were met with skepticism in this new environment. Whatever I was selling, my teacher Lee wasn't buying. No matter how clever I was at obscuring the truth from myself and all these other people (and I was, if I do say so myself, pretty clever) I wasn't clever enough to avoid some mysterious bullshit detector inside of him. It was like he had X-ray vision or something.

Lee was busily dismantling all of the places inside of me that were pretending to be something that I wasn't in order to avoid serving something other than my own imagined needs. Lee seems to be fond of reminding us of Satan's proclamation: "I will not serve." Who has time to be useful and to serve when they've got their hands full justifying their words and actions, and proving irrefutably that they're right and everyone else is wrong?

Here's a story, one of many, that illustrates just how out of my league I was when I found myself in his company: A number of years ago I threw a dinner party for him. I made this fabulous lasagna with a garlic béchamel sauce that included handmade pasta (not the kind that comes in a box, but the

kind that's pliable and dusted with flour). He was standing in the kitchen when one of his students saw these gourmet lasagna noodles and exclaimed, "Oh, they're handmade!" indicating that she was impressed that I had rolled these noodles out myself. Not wanting to deny her her illusions about my culinary skills, I simply said, "Yes." I didn't say, "Yes, but not handmade by me." Lee—never one to be taken in by his students' truth-distorting inclinations—chuckled and said, "Yeah, my Mom used to serve Entenmann's cakes to her guests, hide the box, and pretend she had made the cake herself." I had met my match. Finally—someone who could see beneath my act! This was a relief, because after all, keeping up the pretense of an assumed identity is exhausting.

God's Not Messing with Us, Our Heads Are

At some point, we'll all come to the realization that since our egos are only interested in looking good and not in doing good, it's best to cut our losses and walk away from them. Eventually, Lee's work with me cleared the way for it to occur to me that I could take the same energy that I was expending pretending to be good and use this to actually be of benefit. It was silly to keep dressing up in costumes that hid the fact that I cared only for myself when I could apply myself to serving others instead. God's not messing with us, our heads are. So instead of resenting whatever situation we've been placed in, a better use of our time would be to separate from every deluded, bat-shit crazy thought that appears in our heads.

Mirror, Mirror on the Wall

There's a tried and true design that's been handed down to us from every trustworthy spiritual tradition. These

146

traditions recommend placing ourselves in a climate that's conducive to learning to fly in the face of our preferences and our opinions. This climate is designed to help us to say yes to God and to say no to self-absorption. In this climate, every time we do get what we want, we're able to see that what we're *really* doing is degrading an organism that was fashioned to worship God instead of ourselves.

In order to prepare ourselves for this act, we can begin to form a picture of just how insatiable our personal selves are. The beautiful people of Hollywood represent one of the clearest pictures of the insatiability quagmire: the grasping for eternal youth and beauty and the need to come out on top and to be the most beautiful creature that ever was or ever will be forever is so intense, that the pain and danger that accompany cosmetic procedures *appear* to be a small price to pay. Starlets never stop to ask themselves "Mirror, mirror on the wall, would it be *so* bad if I *wasn't* the most beautiful of all forever and ever?" Talk about a lose/lose situation!

We'll *never* be beautiful enough, rich enough, powerful enough or sexy enough when under the direction of an ego run amuck—and we're all running amuck, whether we know it or not. It's just that in Hollywood we get to see it on the big screen, in living color—and most recently in 3-D. Every time we sacrifice Remembrance for self-preoccupation, we're emulating the naïve young hopeful who has just stepped off a Greyhound bus, who's willing to trade everything she has and is for some old brass ring. This approach never produces a happy ending.

Is My Hair OK?

It seems like spiritual schools are designed so there's more work than can be handled by the body of students in the

school. As a result, everyone's running so fast to get it all done that some of the personality's instructions: "That cute new guy just pulled up; you'd better run and get your hairbrush"; or, "Your laundry situation is untenable" (this is especially agonizing if you have the kind of psychological twist where not having clean underwear is a crime against humanity) fall through the cracks. The beauty of the situation is that you begin to notice that your survival *doesn't* depend on how good your hair looks *or* the state of your underwear; that if you stop supporting and feeding the numerous survival strategies that you honestly believe are responsible for the fact that you're still standing, *you won't die after all.*

Get Over It

This leaves a lot of extra space and time to fill with genuine moments. The Twinkies that used to satisfy pale before the banquet of a genuine teacher. The first reaction that a student has to the me-unfriendly environment of a spiritual school may not be a happy one. A lot of gnashing of teeth ensues; a lot of "I'm not getting *my needs* met. When do *I* get what *I* want? This is *outrageous*, I can't take this! This program is *seriously* f**king with my preferences and my opinions as an individual." Get over it. Once you've been divested of all of the insatiable insistences of your psychology, the reward will more than compensate you for your losses.

We begin to realize over time that choosing what serves God over and above our own convenience works out best for all concerned, *including us.* The image that offers the starkest contrast to moving in the direction of what *we* want are the descriptions of Lee's behavior when in Yogi Ramsuratkumar's company; how he's sitting there at the ready for the least movement or indication from Yogi Ramsuratkumar. He

has been described as a runner crouched down at the ready: when the gun goes off, he charges the dais and ends up at Yogi Ramsuratkumar's feet in one fell swoop of selfless movement. This *has* to be more fun than sitting around stewing in our own self-absorbed juices, in a state of bloated paralysis.

The Efficiency Expert

A senior student in a spiritual school is like an efficiency expert that goes into the workplace to help someone save time on the job. Because he used to have your job, and he was able to make use of the wise counsel of someone who knew more about how to get it done than he did, he's worth listening to. For instance, if our job is to staple papers and the stapler is on the other side of the room, the expert may recommend moving the stapler over to our work station.

One of the inefficiencies that a senior student/efficiency expert might identify would be the habit of clinging longer than necessary to things that have already happened in the past (even three seconds ago), or making projections into the future (plotting, laying plans, figuring out what's going to happen next). From an energy management standpoint, placing our attention on the past or the future instead of this moment in time is unbearably inefficient. This is, in part, because we can only receive and give energy in the present. We actually have to show up with all of ourselves for a transaction like this. In addition, we're weakening ourselves by hanging out in the past and the future, because the forces that contour our thoughts can't avail themselves of our energy when we're in present time. And most importantly, the present is the tangent point where God is.

The irony is that we will do anything to avoid the present. This doesn't mean that it's dangerous; it just means that

the place inside of us that has a stake in denying God and remaining separate from Him finds it nerve-wracking. The fear and anxiety that drive us to numb ourselves to the present (movies, music, food, *People Magazine*, etc.) or to distract our attention into the immediate past or future feels real; it feels like *our* agenda, but it isn't. We're actually experiencing the fear these wayward forces feel.

Time Is of the Essence When It Comes to a Rendezvous with God

The experience of a new student can be compared to an inexperienced mountain climber that doesn't yet trust his footing and delays his next move because he's afraid of making a mistake. Given that our lives have been under the direction of our fear-riddled minds up until now, some trepidation is natural when we're learning to move from the part of us that's mistake-proof. Every pro tennis player has figured out that his opponent is his fear, not the other player. From the standpoint of the efficiency expert, this delay is costly. When we're standing there thinking about what might happen when we move to the next position, or about what just happened that resulted in our present position, we are delaying our next move. Time is of the essence when it comes to a rendezvous with God.

Energy Management

In addition to time management, senior students are here to help us with energy management. They can point out where the leeches are on our backs. If we're a student who's newly arrived from the swamp, chances are we have a lot of habitual ways of reacting to life that are clinging to us and sucking the life out of us. It isn't pleasant to be parted from

these underhanded expressions of our underworld, but we'll have a lot more energy and vitality once we are.

We want to become conscious because this is the only way that we'll be able to appreciate God, a rose, or anything else. When we're asleep, our efforts are linked to the work of transforming humor into anguish. When we begin to wake up, we find ourselves able to transform anguish into humor.

When we don't notice and separate from prejudicial thoughts that are connected to our habitual relationship to life, this inevitably results in a toxic emotional takeover. These thoughts that we're having are like beads, in the sense that when enough of them are strung together, we'll end up with a necklace (or in this case a choker). Problematical thoughts are the building blocks of emotional states.

The dilemma of falling into a series of moods or tantrums is that when this happens, we're hemorrhaging the life force that we came here with. This life force is our gold, or treasure. It was given to us for a specific purpose: to Remember God. When we entertain thoughts of complaint, we are degrading this precious substance and sacrificing it to a less noble purpose.

It might be helpful to realize how obsolete our thoughts in this moment are; that since they're connected to our "crib conclusions," they're in the same category as yesterday's newspaper—they're no longer relevant. When we fall prey to our psyche's version of reality, we're "cruisin' for a bruisin'," and it won't be long before we'll find ourselves parting with some of our gold. When a patch of pestilence from our past is activated by something or someone in this time frame, the trick is to walk away before it bubbles up to the surface. When we don't follow the resistance and recoil that's triggered by an opinion in our minds, we're contributing to our own vitality.

We're here to wean ourselves from having a stake in whether our worst nightmare or our best fantasy comes true, and our need to approve of our circumstances or to hate them. We'll never get life to be just the way we want it—and anyway, we have an even bigger problem than this: we're in a universe that's intent upon demonstrating to us that complaining about and manipulating reality results in serious repercussions. I think it was Werner Erhard that said, "The universe is harsh and persistent, and it will knock you on your ass every time."

Because we find ourselves in a catch-22 situation (being that we don't have enough energy to notice the thoughts that will lead us to the next energy blowout, because we've hemorrhaged too much of our life force in a previous series of emotional blowouts), the best way to get the needed rocket fuel to eject out of the next state waiting to happen is to say Yogi Ramsuratkumar's Name on a regular basis. Since the energy that's dedicated to non-remembrance is always buzzing around us, His Name could be compared to a bug spray—or better yet, a perfume—that these energies find painful, because the scent is reminding them of what they're trying to forget.

Unwillingness Is So Exhausting

And by the way, if we find ourselves overwhelmed by the idea that we're working too hard when serving someone and we conclude that we need to have a break, this may be our minds tricking us. Maybe any work that's infused with an attitude of complaint is more exhausting than it needs to be. Maybe when we stalk imperiously away from our work, exclaiming, "I need a vacation!" this means that we need a vacation from our resistance to being useful. It's possible

that we would benefit from a change of attitude more than a vacation. After all, unwillingness is so exhausting (not to mention unattractive).

And furthermore, if we notice that the people and pets around us are exhibiting signs of wear and tear and they're looking a little peaked, be sure to avoid the clutches of guilt. We can use this glimpse of the toll our recoil is taking on others to strengthen our practice instead.

Apprenticing to a Master

There's this black-and-white documentary of Yves St. Laurent working in his atelier with his assistants. There isn't much dialogue, and the film appears to be moving at a snail's pace. My initial reaction was: "My God, this is less exciting than watching paint dry." But then I began to see that it was providing a not-to-be-missed example of how a spiritual teacher works and how to assist him with his work. Yves had this group that had been with him for thirty years or so. He explained that the people who got to stay were the ones who were "unobtrusive" and had learned the knack of not pushing themselves forward.

I suppose there's a dearth of entertaining dialogue because what you're watching is a group that's working in an intensely focused way to produce something beautiful. Yves' assistants aren't making up in their heads what they think he wants; they're on the alert so they can give him what he needs. If we reject the role of apprentice (of merely being the one who runs to get a belt for an outfit when the master says quietly, "Maybe it needs a belt") because this tiny contribution can't be used to magnify the vainglorious aspect in us, then we'll spend our lives without ever adding anything of actual value to our resume. ("I see, it says here that you once provided

a belt in the moment that it was wanted and needed, and as a result you served the one who was serving Beauty.") Yves' assistants were a memorable example of a group that were standing in the present waiting for his next directive, as opposed to making things up in their heads, like what *they* thought should come next, or what *they* thought should happen with the dress.

Being useful is about being in a state of relaxed awareness, so that when something is needed we'll be able provide it without wasting energy or time. Because Yves St. Laurent's attention was intently focused on what the fashion muse was telling him, it was ideal not to distract him and slow his work down. We betray our unwillingness to serve with our lack of commitment to each moment and each task. If we're in the company of a spiritual teacher who's "all in" and in the service of something greater than himself, and we're chronically getting feedback that we didn't do what he asked for or that we're making a lot of errors in our work, then this doesn't mean that he's being picky, it means we're not moving from the place in us that's willing to be useful.

If Only I Had Moved to Phoenix (Not To Be Confused with the Song, "By the Time I Get to Phoenix")

A story about just how easy it is to move in the opposite direction of what we're told springs to mind: A long ways back, one of Lee's students implored him to tell her what her next step should be; she said that she felt that the city she was living in was no longer the right place for her. When Lee refused to give in to her request (he'd been down this road with many of his students too many times before), she stepped up her appeal by swearing that she would move to

whatever city he suggested, no matter what. He finally gave in and said, "I could use someone in Phoenix."

By the way, I've heard that we should never ask the advice of someone connected to the Will of God unless we are fully prepared to do whatever they suggest, that somehow there are strict laws in place for them and for us. If we move counter to their recommendations, then they pay a price ("Cast not your pearls before swine") and we pay a price (because we've demonstrated that we want answers but we're not willing to pay for them).

So here's what happened next: As we were all leaving the house where Lee had been giving a talk, we crowded around this woman and exclaimed, "Wow, this is great! You're moving to Phoenix; how exciting!" She responded to our enthusiasm by saying, "No, you don't understand. Lee *couldn't* have meant Phoenix because of my asthma. The air quality there is unacceptable for one such as I." (The condition that allows us to presume that a bona fide spiritual teacher must be mistaken has to do with us rather than with him. Since we have "shit for brains" we can only conclude that he does too.) Because it wasn't *me* that had been asked to do the one thing I would never be willing to do, I was appalled and flummoxed by this absurd turnaround.

Upon reflection many years later, I wonder if this person's relationship to her health, and her conviction that she knew best and that Lee didn't, might have been erroneous. Here's one possible scenario that her mind may have neglected to factor in: What if she had moved to Phoenix, gone into a life-threatening crisis due to the pollution, and as a result, had been steered by higher forces to locate an extraordinary holistic physician that healed her of her asthma once and for all, then and there? After all, this would make sense, since

Lee said, "I need someone in Phoenix." I'm basing this on the maxim that if we go to work for a cause beyond our own, we will receive everything that we need. Unfortunately, this was an unmet opportunity (a gift that was never opened). It's now twenty years later, and this woman continues to be plagued by the pain and suffering of asthma to this day.

Our minds are the masters of finding the way out, not the way through. Their mastery is never more in evidence than when they "help" us to reinterpret a spiritual teacher's words. It never occurs to us that we don't know who we're dealing with here. What's the point of having a spiritual teacher who sees three-dimensionally and can see around life's corners if we don't take his advice? This means we haven't figured out yet that the world of our minds is two-dimensional, and that these minds wouldn't recognize a good thing if they fell over it.

Can't We Just Have a Little Good Cheer Around Here?

When a teacher says, "I want you to do this," our response (founded in our desperation to minimize the inevitable blow of our deaths) is always reliably and predictably the same: "Yes, I'll do what you say—but I'm going to have to make it safe by giving your words my own special flavor and twist." When we're substantiating a program that's connected to "I must run for my life" over and over, then the "bad thing" that we're protecting ourselves from becomes unreasonably powerful. If we *knew* that all of our resistance to life and to help was connected to this single irrational and hidden terror, then we might have an easier time separating from it. We might see that saying no is ludicrous if we remember that who we really are is eternal.

When we hit a brick wall (discovered that we're finite) we began to bruise and batter ourselves, and we took ourselves out

of the game by refusing to accept the way things are. Instead, we can graciously give way to the rules, to the way things are, and say with good cheer, "OK!" I wonder if my teacher ever said to himself, "Jeez! Can't we just have a *little* good cheer around here?!" If you're the one prone to cheerlessness, and you've figured out that this is your particular survival strategy, (the expression that your personality inevitably and reliably produces in order to avoid death), then all that's left to do is to notice when you've been cheerless or churlish, and say Yogi Ramsuratkumar's Name.

"So Long, Suckers"

When we're lucky enough to have a spiritual teacher to point out where the shovel is (because we're as blind as moles), it's best to pick it up and begin preparing the garden. We don't pick up the shovel because of some crazy idea in our heads: "We've gotten along fine without doing any real work so far"; "This is working for me"; or, "It's not *my* job to deal with this hard ground." This is the strategy where we treat our teacher or God like an underling and pile all of our chores on top of him, while sitting on the veranda drinking mint juleps. Whose garden *is* this any way?

This analogy has something in common with the image of Christ carrying the burden of the giant cross through the streets on his way to the crucifixion. Every time we refuse to bring integrity to what life asks of us, we're loading the Divine up with more burdens; we're relegating it to a lowly beast of burden in order to get out of doing our job. Well, the joke's on us—because when we don't pick up the shovel, we're exiling ourselves from paradise.

Maybe this is what my teacher meant the day he announced: "I've got what I need!" Maybe there's some

immediate gratification to be gained from pitting ourselves against him and watching him struggle with our burdens. But in the end, he will have the last laugh, as he sails away to that great glory in the sky, leaving us struggling up to our necks in the quicksand of our imperious folly. He'll call out merrily (this would be if there's any justice in the world), "So long, suckers!"

Chapter Six

How the Game Is Played

The Mouse and the Mountain

I have a friend who asked God and her lineage one day to show her who she was pretending to be. Her answer was the image of a mouse. Next, she asked to see who she really was. This time she saw a mountain. A dharmic explanation for this experience would go like this: Mice are terrified little creatures that are here for a day, while mountains are strong and have withstood the test of time. Since for the most part, most of us haven't seen that we are something other than our psyches, we are spending an enormous amount of energy and time propping up and plumping up the mice that we believe ourselves to be. We're treating them to catered affairs and behaving as though it's appropriate to lavish all of our attention upon them.

If we left off substantiating these mice and taking care of them, then this would free us up to remember that we're not mice. At this point the clouds would part, the mist would evaporate, and we would see ourselves as the mountain that we are. It's somewhat rare for this to happen, because we seriously believe that it's in our best interest to continue to support a stranded, isolated little mouse that's been set adrift in the middle of an ocean all by itself, and that this shabby little identity is better than none. We can't quite see (from the mouse's perspective) that there could be anything better than this.

That's How the Game Is Played

All of the qualities that our personalities contain (good, bad, and indifferent) are made-up; they're merely plastic

veneer calculated to look like real wood. It's completely irrelevant to try to improve upon our act—to substitute generosity for selfishness, for instance. This reminds me of a dream I had where a friend of mine said, "It's not that we have to *become* a better person, we're here to remember that we already *are* a good person. That's how the game is played."

What we do has no significance when motivated by our adaptive personalities. The only thing that counts is who is *behind* our actions—any action that's inspired by our true selves will always be exactly what's wanted and needed. Conversely, everything that we do to imitate the real thing will be useless—after all, you can't get blood from a turnip (or you can dress a pig up in a ball gown, but he'll still be a pig). We can try to do the right thing all we want, but at some point we'll need to get wise to the situation and see that whenever these efforts are connected to the place in us that's dedicated to serving ourselves, the result will be unsatisfactory. The trick is to stop following the self-concerned part of us around, in order to create space for the part of us that is here to serve.

The Windmills of Our Minds

We believe we must revise our personalities and clean up our wicked thoughts and become a better version of ourselves. This would be a great plan if this was possible, but since it's not, why continue to beat a dead horse? (*As if* a leopard could change his spots!)

The thing we *can* do is a lot simpler, and actually doable. It's not that we want to wrestle with our demons—this merely enhances their status as worthy opponents. The simplest and least taxing solution is to step aside, cross to the other side of the street, and cut our losses. Whoever said, "Lie down with

dogs and you'll get up with fleas" must have had a mind. All we're really being asked to do is to avoid the mud puddles instead of wallowing in them. Why pile on the extra work of doing laundry, when we could have avoided the whole sullying episode to begin with? Cavorting in the mud will not a silk purse make. If I have only one life to live, let me live it as a blond silk purse, rather than as a mud-bedraggled pig. Remember: a swine in the mind is worth two in the bush—or, give a man a pea and he'll end up with a pea coat. We *do* get to choose. The windmills of our minds are weird enough—let's not exacerbate an already bizarre situation by frolicking in the mud puddles of these minds.

We don't have *a problem with life*. We have a problem with our *relationship to life*. The most spectacular trick is mind over imagination, not mind over matter. Since we're imagining all of this any way, why *not* exercise some creativity and flexibility?

The Bullfighter's Art

Bullfighting is an example of skillful means. The bullfighter doesn't run up to the bull when he's charging and engage him in hand-to-hoof battle; he uses his cape in order to distract and to sidestep the bull. Yogi Ramsuratkumar's Name is our cape. We can say Yogi Ramsuratkumar's Name at the first sign that our panties are in a twist and that the mood of getting what we want has entered our being. This is the moment to pull out Yogi Ramsuratkumar's Name in order to diffuse and sidestep a situation that's fated to bring us and others harm.

Without this Name, our gooses are cooked and they can't get out of the oven. Every time we create pain for another human being—when we crash and burn into a child for

instance—it may hurt to see the wreckage, but if we keep doing this again and again, (if we keep believing the mind's subtle, but oh-so-effective message: "Oh dear, what a mess this is. It's a pity, and it's too bad that you just can't help it") instead of admitting that we actually *do* have an alternative to participating in an endless panoply of carnage (not to put too fine a point on it...the Name, the Name, the Name) then we get to deal with karma.

I Was Just Trying to be Helpful

When we're having difficulty separating ourselves from the out-of-date agenda of a two-year-old, say Yogi Ramsuratkumar's Name and the place inside of us that *does* know how to do this will take over. As Shakespeare put it: "The fault, dear Brutus, is not in our stars, but in ourselves ... " The un-famous part of the quote that follows is: "... that we are underlings." Yes, we are. We're under the influence of a domineering subtext. In and of ourselves, there's not a damn thing we can do about "fixing" this wayward and domineering influence in our lives ("Gosh darn it, I'll show *you* whose boss). This would be like putting a deathly-ill person in charge of his own healing.

Our only hope is to free-up our physician self so it can separate us from our illusions. If we're feeling frustrated because we keep caving in emotionally to our pissed-off two-year-old, we need to give ourselves a break. We're not bad, merely uneducated about how to go about the project of reclaiming our lives.

Putting a two-year-old in charge of balancing all of the forces and domains inside of us is the equivalent of giving over the control of our car to him. This part of us (the one with an immature relationship to life) has a stake in making

us believe that it has the power to affect change inside of us. Every time we hit a brick wall because we've taken its advice, it gets to reinforce its thesis that it's the boss of us. It's sneaky, and likes to pretend that it was just trying to be helpful, but I wouldn't bet on it. Spiritual practice inspires us to reach the conclusion that we're going to have to get help from something outside of this closed, untrustworthy and churlish system if we're to move in a new direction.

We're The Boss

Managing the forces that are running around in us is like running a company: we have to keep on top of what's going on with our employees. If our mailroom guy is on crack and he's stealing supplies, we want to know about it so we can fire him. Since we're the boss, we get to choose to support the participants that are benefiting our company, not running it into the ground. If we discover that a part of us is dissonant with the Will of God, then we have to call this part on the carpet and remind it about company policy. We'd have no problem doing this if we knew that the survival of our company and/or our souls were at stake, but since we're in our offices taking a nap a lot of the time, we'd be hard-pressed to say what's really going on if asked. Saying the Name of God will help us to tell an asset from a liability, and give us the gumption to part with the people and internal influences that are detrimental to our vitality and sanity.

Who's in the Driver's Seat?

We only want someone driving our car that has skills and is able to move in accordance with the Will of God. Saying Yogi Ramsuratkumar's Name makes it possible to notice who's in the driver's seat. This way, we can choose to be driven

around by a maniac or a good driver. Once we notice the telltale signs that a drunk driver (one that's drunk on power, anxiety, irritation, or vanity) has taken over our cars, because the mind starts to repetitively and obsessively state its case about a particular person or circumstance (yatta, yatta, yatta …) then we can disengage and cut our ties with this energy. We become inclined to do this when we've begun to see that bad driving leads to traffic accidents. If we "just say no" to the bad driver in order to create space for the good driver to take the wheel, then the bad driver will jump in the back seat where he belongs.

Learning to move at God's pace rather than in our own good time is one way to encourage the good driver to take the wheel. We think nothing of drawing boundaries around higher forces when they intervene (or of "hitting the brakes," if you prefer). Strangely, we're reluctant to put the brakes on when forces that are less than human take over our lives.

Are We Blenders or Men?

We can exhibit the same lack of trust and faith all by ourselves as we do in the company of a teacher. This is the beauty of the situation: we can generate a fear-ridden relationship to whatever we're doing, wherever we are (whether we're in his company, driving him crazy with our distortions, or milling around in some faraway cesspool of our own creation). Either way, it's actually *our* job to notice when we're in a pointless dither. It's just a little easier in his company because our mind's opinions are no match for the perpetual evidence that he's always right. ("Damn! He's right again!")

The thing we want to see is that we have more important things to do with our time than following our mechanical

promptings around all day long. Believing the mind's input, trusting it, assuming it's true and being guided by it, makes as much sense as elevating our blenders to the position of the ultimate authority in our lives—it's nuts. We need to begin to see the mind's idea of its contribution (that its input is in the life-or-death category) for what it actually is: irrelevant and destructive.

We need to look at each thought and see what's behind it. We need to begin to call a spade a spade and to ask, "What is the thought that I'm having right now connected to?" We're not here to be led around by the nose by every passing terror. We're here to turn to Praise and Remembrance in each moment and to give up lamenting about how we didn't get what we wanted, how and when we wanted it.

How to Avoid God

The best way to do this is to be attached to whatever mission your mind is on and engage its suggestions full-throttle. This enables us to be immune to the random and the miraculous. If our disposition towards things we've decided to do was a little more relaxed (if the urgency and the insistence were less), then we would run a greater risk of encountering the Divine.

I'll Show You

Living from the part of us that's a petulant two-year-old will only take us so far. We're headed for trouble if we're listening (unconsciously) to the one that says, "I'll show *you*, you mother f****rs!" We're actually driving another nail into our *own* coffins, not somebody else's.

We have a job to do here, and dismissing every moment as not good enough makes us too dumb and numb to pick

up a shovel and start working. Reinforcing the lie we've been telling ourselves all our lives ("I don't have what I need") and turning a blind eye to the shovel because we've been too busy proving that life is insensitive to our needs, ends in stagnation and death. If we don't take care of our garden—if we don't water, weed, and nourish it—it will become worm food.

We've Been Had

Developing the ability to not create suffering for others and ourselves is a full-time job, not a part-time job. Full-time looks like being attentive in every instant in time; inserting our awareness into each moment in order to build the momentum necessary to sustain a face-to-face encounter with the Divine. Noticing ourselves being carried off over and over again by the forces of pride, greed and sloth; watching ourselves self-destruct and not projecting the destruction that lives in us on top of countless hapless bystanders, is a full-time job.

When we're attentive to this work, the desire to discover a way that results in less carnage will begin to take shape. Once we've figured out that we're automatons, blithely romping through our lives at the mercy of every unfounded nutty idea that pops into our heads, we can begin to take measures to create a more spacious relationship with life. What if everything we've ever thought or done was actually fake and false? What if the problem lived inside of us rather than outside of us? What if there was no one to take the rap, the fall, or the blame—with the exception of ourselves? What if every time we're given feedback that irritates us and catapults us into a state of "righteous" indignation, we saw this mood as our first clue that *we'd been had* instead of incontrovertible proof that we were right, as usual?

166

"Righteous" Indignation

Don't be fooled by righteous indignation. A definition of righteous anger: a hammer that exists for the sole purpose of hitting us on the head (thus rendering us unconscious) and hitting anyone else on the head (our teacher or anyone else who gets in our way by messing with our impoverished reality). There are no exceptions. If we're indignant and have the forces of fairness on our side, we've been screwed—and whoever has the bad fortune to be in our proximity will meet the same fate. Welcome to the madhouse.

These soap operas that we keep flinging ourselves into are always about one thing: our precious reputations. When our ego gets pissed-off, this is always—not sometimes—connected to a threat that's been posed to its authority. Therefore, there's actually no such thing as righteous indignation. In every instant in time, we're either Remembering that there is only God or we're being taken for a ride. Discomfort, irritation and a preference for things to be other than they are, are the precursors of further karmic enmeshment—there's a price that we pay when we pick up that hammer. This being the case, it's in our own best interest to learn the early warning signs that predate states of righteous indignation and anger.

Miss Manners Would Be Appalled

This is God's pool party and at this stage we're obnoxious guests. It isn't our house or our pool. We need to get over ourselves. We need to stop throwing the paper umbrellas from our drinks and the Swedish meatball hors d'oeuvres into the pool, and we especially need to stop peeing in it. Drinking too much and throwing up in the pool does not a good guest make. It's time to show a little decorum. Miss Manners would be appalled.

Take Me, I'm Yours

Indulging our pessimism and lack of faith—in a real teacher and in God—is a crime. Allowing pejorative thoughts and conclusions to poison our relationship with a spiritual teacher is regrettable, in every sense of the word. Making him the target of our dementia is a criminal activity. It's costly for him and it's costly for us. Even if we can't "see the light," this is no excuse for rude and bad behavior. We are privileged guests at his table and we need to act accordingly, even though we're blind at the banquet. It's *our* job to monitor and diffuse every petulant thought that arises in us and to say the Name of God constantly, in order to bathe the craziness and idiocy in our heads in the waters of His holy Name. When pejorative thoughts come up, it's not OK to walk around like beaten dogs while saying, "Take me, I'm yours." It's our job to shield ourselves and everyone around us from this toxic energy.

If were having difficulty with this, it's OK to ask for help. When we've forgotten our intrinsic nobility and we've fallen prey to Self-forgetfulness, things don't have to stay this way. We have the option in every moment of maintaining a civilized distance from *the insistence* that's moving us. Yogi Ramsuratkumar's Name will create a new preference inside of us. Perhaps the only thing worth doing is to catch the thoughts we have that represent a problem, and transform them into the Name of God.

If Pavlov's Dogs Can Do It, We Can Too

The typical reaction when we go on an emotional bender and lash out at someone is to waste a lot of time feeling hopeless and terrible, instead of re-directing ourselves to the repetition of Yogi Ramsuratkumar's Name with increased dedication. The alligator is seducing us when he says, "See,

you just can't help yourself!" This is because our psychology/alligator is problem-oriented, not solution-oriented.

Pavlov's dogs were trained to recognize that when a bell went off it was time to eat. When resistance begins to flood our minds and our emotions, we can train ourselves to see this resistance as a bell that's designed to trigger practice, instead of, "Oh, wow, I'm feeling pissed; it must be time to go have an argument with someone." Moods of discontent, anger or despair can be used as a reminder that it's time to practice, and not a cue to run off and party with these moods. Instead, we could decide to condition ourselves to respond to them as the wake-up call that they are. The way to learn that skipping the party in favor of Remembrance is in our best interest is to notice that crashing, burning, and waking up with a hangover isn't as much fun as when we sidestep the ordeal in the first place; that we're happier when we limit our attendance at these little soirees staged by the discontent in our psyches. If we keep tripping over the same end table repeatedly, let this be an indication that its time to rearrange the furniture.

Here's the connection that we need to make: when we separate from the input of our minds and feelings, life is fun; and when we don't, life is a series of boring, tedious and exhausting train wrecks.

The Holy Grail

If I were going to paint a symbolic picture of each of our "inner children," it would be of a child crying in front of a glass of water because it thinks it's half empty. The thing that characterizes a saint is that their hearts are brimming with compassion and love because they know their Father. They're not a half-empty glass of water; they're a glass brimming and

overflowing with life-giving water. Therefore, the way to counteract our inner child's misunderstanding about life is to introduce the evidence of a full glass of water by repeating the Name of God.

When we begin to take up some form of spiritual practice, discomfort may arise as we begin to move in the opposite direction of our psychology. This isn't an indication that God has bad news for you. I used to think that spiritual teachers handed out spiritual practices (including the repetition of the Name of God) just to make our lives less fun. Somewhere along the line I caught a glimpse of reality. Spiritual practices, including the repetition of the Name of God, aren't a hardship—they're a gift that's been given to us to make our transition from pretend life to real life smoother. If we're thrown into breakdown along the way as we begin to separate from the false self, we're not supposed to use this mood as a reason to slink off and say "I'm done!" This mood is merely an alarm clock going off, to tell us that it's time to step up our practice in order to smooth out the bumps along the way.

It's Not Our Job

One thing we never see from our vantage point is the faith or blessing factor. We think we can't change our assumptions about life (this part is true), and that there's no way we can put an end to our life-negative condition. But this is a half-truth. ("We're in a pickle and *we* can't do anything about it; ergo, the situation is hopeless.") We don't factor in that it's not *our job* to intervene and transform ourselves, that God does the transforming. We're living under the weight of this presumption that change isn't possible just because *we* can't accomplish it. That's quite a presumption.

As we begin to experiment and unravel our presumptions about how much toilet paper we *really* need, we begin to suspect that the "big presumption" (that there's anything other than God) may also be false. This is a revelation. Just because we've been on a train that's going back and forth between Cincinnati and Pittsburgh all our lives, doesn't mean that we couldn't wake up one morning and find ourselves on the Orient Express in the Alps. We somehow believe if *we* can't switch trains, it can't be done. If this is true, then whoever said, "With God all things are possible" is in for a rude awakening. We need to engage the process of Remembering who we already are in order to see that this is a far cry from what we're pretending to be.

My-T-Fine Instant Pudding Versus Crème Brulée

Every consideration of the truth seems to end up at the same place: the necessity of shifting our identification away from our present priorities and the importance of identifying with a new one. It's possible that we're here to learn that there's a whole other way to go than we imagined. Maybe, since crème brulée is an option, there are better things we can do than stocking our cupboards with My-T-Fine instant pudding. (If you've ever had really good crème brulée, then you know what I mean.) Saying Yogi Ramsuratkumar's Name wakes up our slumbering taste buds when they've been numbed by a surfeit of instant pudding servings. This makes it possible for us to enjoy the good stuff.

What About Me?

The Indian sage Swami Prajnanpad says that when we embark upon a spiritual path, our viewpoint is "self." At some point, this transforms into "self/others." (It's pretty

miraculous the first time you find yourself actually including someone else's point of view. This is not to be confused with our story line that we're "considerate.") He says that further on down the line, we find that our context has become "others/ self," and when we've reached our destination, all that's left is "others." This is a radical and gratifying shift. The fact that this has actually happened here and there speaks well of the human race at large.

For the most part, our responses are dictated by a place inside of us that's consumed by self-interest. The questions inside of us: ("What about me?"; "What can this situation/ person do for me?" or, "How can life hurt me?") are pretty pressing.

The Treasure Hunt

There are at least a hundred little ways to become informed about our relationship to life throughout the course of a day, provided we're paying attention. Suppose there's a bee hanging out in a cup next to us. Is our first thought, "I hope he's safe and that he isn't stuck in there," or is it, "I hope he doesn't sting me." If our first thought isn't about the well-being of others, this doesn't make us a bad person—it means that our pretend self was running the show at this moment, not our real self. All this means is that it's time to begin to create some space inside of us for the "others first" part of us. This is a unique and fun treasure hunt, where we're searching for moments in time when the part of us that's out of relationship with creation has the upper hand. No need to tell ourselves stories about how much we care, since the point of the treasure hunt is to notice the part of us that doesn't care, in order to make room for the part of us that does.

The reason that we don't work to create a new relationship to life is because our pretend selves have us bamboozled with inappropriate guilt. Since we're here to develop a sane and loving relationship with life, sweeping loveless responses under the carpet because we're worried about our reputation won't do. (Considering that the bee population is near extinction, we may want to learn how to refrain on occasion from sending them into the next world.)

If I Had a Time Machine, I'd Head to Connecticut

Years ago, when Martha Stewart was running a catering business out of her home, I would have liked to have been there in the no-cash-flow days in case she offered me a percentage of her future empire in lieu of a paycheck. This reminds me of when Jesus told his disciples: "Your reward will be great in heaven." (I guess they were getting nervous about when they were going to get their paychecks.) If we're just looking for a paycheck and we're not "all in," and we're watching the clock thinking about corn muffins when we're typing, this is a sign that we're hooked on immediate gratification. We may look back one day and say, "What was I thinking?!" I've asked myself this so often that I'd like to have it on my tombstone. Seriously—on the off-chance that someone might come across it and laugh.

The Hooker with the Heart of Gold

Speaking of being "hooked" on immediate gratification— this leads me to the idea that there are two kinds of people on our planet: hookers and heroes. Since heroes seem to be in the minority and far and few between (the Nelson Mandelas and the Mother Teresas of this world would seem to be the exception, not the rule), maybe we need a

plan to turn all of us hookers into heroes. It might be more ecologically correct to recycle, rather than scrap the majority of the human race. What if those of us who are just in it for the paycheck (spiritual dilettantes that have nothing more on their minds than looking out for number one) could be magically transformed into heroes?

There's this thing about the hooker with the heart of gold that we have as a reference point for our potential. This reminds me of the discovery I made about what was living inside of me...that God had written His Name inside of my inner heart. Since our alligator/egos are analogous to a pimp that's holding us back from transformation, we have to remove ourselves from this influence in order to realize our transcendent possibilities.

If you've ever had any doubts about whether you're rising to the occasion of your life, then the practice of saying the Name of God is for you. Here are just a few of the things that the Name of God can do for us: it can turn sloth to diligence, self-interest to devotion, cruelty to kindness, persecution to remorse, gluttony to generosity, and vanity to reverence. If you take up this practice, a day will come when you won't even know yourself.

Blowing the Doors Off the Barbie Dream House

There are two models we can follow. One is to be consumed by the perceived danger around us while constantly changing and manipulating everything and everyone in sight in order to ensure our safety. Then there's the second model, where we assume the best and we respond to the vicissitudes of life like an enthusiastic child.

A child doesn't have to have the perfect Barbie Dream House to play with; they can take a shoebox and turn it into a

house. Children bring imagination to their lives. They can turn water into wine, or at least lemonade. Instead of complaining about the water because it's not Evian or something, they're glad to have the water and they joyously proceed to make something of it. Maybe they find a tattered lemon in the road. As they walk along, they think: "I'll squeeze some of this fabulous lemon into my water." They're not immune to the unexpected gifts that are all around them, because no one's told them yet that life sucks.

Model one is a complete waste of time and energy, because God has already given us everything we could ever need or want. It's not until a tornado lifts our house up and flings it a mile away that we figure out that the second model is more productive. It's not until life comes at us hard that we can see the folly of pretending to be in control. We're caught in a double bind, because we're pretending we're in charge of everything and everyone (even when we're exercising subtlety), while simultaneously rejecting and neglecting the arena (our thoughts) that we are responsible for. How do we relax our grip and stop thinking we know better? By Remembering God. Remembering Him is the purchase price of our souls.

Our Cupboard Runneth Over

The question becomes: "What can we do with *this* moment? What's a better use of my attention and time than carrying on about how f****d up everything is?" We need to apply this question to every moment in time. It's like we open the cupboard to see what we have on hand while asking the question "What can I make for dinner with *these* ingredients?" This is a much more creative approach than looking in and saying, "I'm out of olive oil, so I guess I'll starve." We're here to participate. We've been given so much ... our cupboards runneth over.

The Truth Can Only Set Us Free
If We Stop Listening to the Lie

When my son was six, he said, "Mom, does anyone really know what love is?" He followed up with, "No, I don't think anyone *does* know what love is." The phrase "God is Love" is something a lot of us respond to intuitively; it rings a faint and far-off bell somewhere inside of us. If we haven't experienced *God* or *Love* or that *God is Love*, then why not admit that our minds don't have the whole truth—that they really *are* two sandwiches short of a picnic—and open ourselves up to something inside of us that *does* know the truth.

I've been noticing lately that the truth is all-pervasive in the dimension that we're in. You don't have to go to a monastery to find it; it's encoded into the fabric of everything around us. Perhaps we're assuming that the truth is nowhere to be found outside of us because the source of these thoughts in our heads has a vested interest in our being deaf and blind to what's happening around us. But the truth will win out.

I don't want to be put to this test, but I'm pretty sure that if I were locked in a room with only reruns of *90210*, I could experience dozens and dozens of epiphanies. Even though there are a lot of people that don't feel that this show represents a high watermark in our culture, maybe what we want to do is begin to exercise discrimination about the thoughts in our heads that are blinding us to the Sacred, instead of exercising our critical faculties about whatever is in front of us.

Self-Honesty

Telling the truth to ourselves is an incantation that we can use to undo the enchantment of our fake identities. We secretly suspect that we're screwed up, but we're not telling

ourselves the truth about this; we're white-washing ourselves and making things up as we go along in an effort to obscure "the awful truth." The process of becoming more honest, telling it like it is, and not hiding our thoughts and states from ourselves is worthwhile, because we can't begin to approach the Throne of God without a *little* self-honesty. And as they say, "Confession is good for the soul."

I had an unusual experience once where I was able to track the progression of a communication I was making to someone. The idea I wanted to express began as something clear and straightforward, but as I watched it make its way towards my mouth I noticed it going through a number of metamorphoses that were designed to make it unrecognizable from the initial impulse. It seemed to me that there was a washing machine in my head that kept cleaning up any true thoughts, in order to keep me safe from any unfortunate honesty episodes. Somehow, somewhere, I had gone off track and given myself over to a censor whose job was to manipulate and distort anything real before it could come out of me.

Because the activity that produces all of our self-dishonesty is unconscious and we have no idea how deceptive and distorted our words are, it's difficult to grasp just how much we are having ourselves and others on. Just because the part of us whose job it is to adjust the truth is doing such a good job, doesn't mean that we shouldn't be skeptical about our capacity at this stage to fearlessly tell ourselves and others the unvarnished truth.

The times when my teacher pointed out that I was lying my ass off were exhilarating, because even though the experience was embarrassing, it was also a huge relief to realize (after the pain subsided) that I was still alive. The part

of me that was convinced that I'd die if I didn't layer the truth with a lie took a few steps back each time I had one of these "deadly encounters." In this way, I began to grasp that the truth wasn't going to kill me.

It felt so good to come clean that I began to take a few risks with the truth on my own over the years. Because my teacher got the ball rolling by showing me that there was an upside to this new trick, I became a little willing to experiment. Because of this gift, I began to see that when I didn't cater to my fear by lying my head off, this enabled me to hold my head up.

The Games We Play

The sickest part of the games we play isn't so much that we're conning ourselves about the quality of our participation and how responsible we are, it's that we are forcing every person we come across to donate their energy to our games. Maybe these people have better things to do with their lives. We are pretending we want to be straight and clean, while we're simultaneously infecting them with our unwholesome relationship to life. If we can get ourselves to tell the truth about one thought going through our crazy heads, then this is the beginning of the end of our make-believe world, as well as a good day for everyone who knows us.

Guilt and Remorse

A long time ago my teacher drew a distinction between guilt and remorse. I think he told us that guilt is the only emotion that can't be transformed into something useful, that it has no redeeming qualities, and that it's a waste of time and energy. I was having a hard time understanding the difference between guilt and remorse (possibly because

my guilt and crazy cover-ups were so all-consuming that I'd never had the time to experience remorse). When I asked someone about this distinction, they said that guilt is about *us* and remorse is where we feel badly for the suffering we've created for someone else.

I don't think it's all that common to notice what another person is feeling—how bad could it be as long as it's not our problem? We may be having a hard time noticing our insensitivity to the suffering of others because none of us wants to believe that we're insensitive. In order to notice what someone else is feeling, we would have to make room inside of ourselves for this new experience by detaching from guilt. This would create some space for remorse to arise inside of us, and when this happens, the experience of remorse would magically transform our self-absorption into God-absorption. This is because remorse is a kind of fuel or motivation that helps us not to obsess over our own needs and desires. When we say, "I can continue to indulge myself with this attitude, but others will have to suffer and pay the price for my indulgence," we are beginning to abstain from thoughts that feed the self-centered self for the sake of others.

Remorse encourages us to put our minds on a diet. (When bathing suit season is approaching, we find it easier to push ourselves away from the table.) The purpose of this is to discover the "purity of intention" place inside of us. This way we can begin to connect our words and our actions to this new and exciting place.

When Our Chickens Come Home to Roost

The place that life and all agencies of blessing will always take us is the one where we can see clearly that our actions

(when moved from fear and self-hatred) are creating agony for others. In Yogi Ramsuratkumar's case, all it took for him to walk away from his killer side was an experience where he accidentally, not maliciously or on purpose, ended the life of a bird when he was a boy. For most of us, we're not at the point where we're willing to stop feeding our fear and self-hatred over the life of a single bird. If we saw that we unconsciously had brought harm and pain to everyone that we've ever known (if we saw what our control issues and our insistence upon doing everything our way and the hell with everybody else has produced), this would be a sorrowful yet wonderful viewing place. It's no longer possible, once we've done a body count, to keep consorting with the forces of destruction. If we're asleep and we're turning a blind eye to the negative impact of our words and our behavior, then life takes a hand, wakes us up out of our self-satisfied slumber, and shows us something that we *can't* ignore. Luckily, someone's keeping track of the body count, even though we're not.

My friend and I—suspecting that the chickens of our unconscious cruelty were beginning to come home to roost—used to joke with each other whenever we began to feel some pressure from reality by saying, "There goes another mangy chicken flying over my roof." I don't think we liked those mangy chickens (nobody ever does). But if we allow them to make their point then we can regard them as the blessing that they are. In the best of all possible worlds, we would regard any glimpse of the darkness we are condoning inside of us as a gift from God.

Do We Know What We're Capable Of?
Albert Camus told the story of a man who was walking through Paris one winter's night when he heard a woman

jump from a bridge into the freezing waters of the Seine. He thought about what it would cost him in terms of physical discomfort to jump into the ice-cold water, and elected to walk away. This moment—where he got to see where he *really* lived—could be the "gift that keeps on giving" for us, his readers, and for his comfort-preferring character.

This story was particularly significant for me, because when I read it I had just had a collision with my own lack of conscience. I was standing for half an hour at a bus stop in the middle of a snow storm in New York City, across the street from my piano teacher's apartment building. I saw her come outside and slip and fall. This event coincided with the arrival (finally!) of my bus. The decision I made that day—to get on the warm bus instead of coming to her aid—was a "no brainer," since it came from a playbook inside of me that clearly stated: "Me first."

Unfortunately, the shame I felt at the lack of humanity inside of me was used to prop up my already low opinion of myself and to distance me further from compassion. I didn't know at the time how to go about transforming the evil that lurked inside of me. I still don't. The thing I do know now, that I couldn't see then, is that there's hope (amazing grace) for me and for all of you other wretches out there if we say the Name of God; that this is the way to grow a conscience. Those little sponge dinosaurs that grow bigger when you put them in water could be considered a reference point for this particular miracle.

The Heart/Mind Disconnect

When we're facing our self-absorbed selves, we can't give and receive. This represents a disconnection between our hearts and our minds. In the fairy tale *Pinocchio*, the central

character needs to acquire a conscience (according to his mentor, Jiminy Cricket) in order to make the leap from a wooden puppet to a real boy. He has a series of adventures that enable him to see that pretending he has one isn't going to do the trick (every time he resorts to this, his nose grows longer). A moment of seeing where we live (one that demonstrates our *actual* priorities) is the helpful feedback mechanism (the expanding nose) that we need in order to make efforts to leave off posturing in favor of becoming real.

This disconnection between our heart/conscience and our mind is evidenced by a series of slow, toxic leaks throughout our lives. The discontent and self-hatred lodged inside of us will continue to find expression here and there until we establish a connection between our hearts and our minds. If we're lucky (this is when our number is up) we get to see ourselves do something so grievous (this is more like a toxic oil spill) that we can't pretend it never happened.

Because making this connection is the work of our true selves, the trick is to call to them (surprise, surprise, once again using the Name of God) so that we can connect to our real selves. The repetition of the Name of God is an invitation to our real selves to take an active and salvatory role. Because these selves aren't well-mannered, they are going to show up where they're not wanted.

Because our minds are connected to a core of unresolved resentment and discontent, this explains the destructiveness of the human race at large (the careless and uncaring treatment of ourselves, of others, and of our planet). Once we know that we're not hopeless because we have a plan (saying the Name of God) to separate us from "behaving badly," it's time to put it into action. After all, if crying over spilled milk was going to work, it would have by now.

The Rose

Just because we've figured out that there's something creepy inside us that *will* throw a baby under a bus in order to look good or to avoid looking bad, we shouldn't be tempted to waste our time crying over the situation. This plays into the hands of the creepy part. After all, isn't this the point: to distract us and to delay us from finding out who we are? The most useful thing we can do once we see what this thing is capable of is to extricate ourselves.

Each one of us came here on a mission: to cultivate and plant a rose. We're here to do something beautiful for God. In order to do this, we're going to have to counter the "crib decision" that we made. ("It's best to hide this rose; showing it and planting it is too dangerous.") This decision was a good one based on our circumstance as children, but when we find ourselves in the presence of a spiritual teacher, or if we have the practice of saying the Name of God, it's no longer appropriate or necessary to carry on with this strategy.

Sainthood Is for Other People

We believe we are fixed in time and space and can never evolve into anything else. "Sainthood is for other people; there's no way in hell *I* could realize who I am." Self-observation is about noticing just how prevalent and chronic the lies are that we're telling ourselves, so that we can begin to question the *big lie* (that we're being useful). This way the agenda of our secret position ("That'll never happen!") will become more transparent. This is the way to enter the land of possibility and begin to ask, "If all these other things in my mind have turned out to not be true, then what else has it been lying to me about?"

Suddenly, all bets are off. It's as though we were wandering for many years in a desert wasteland and we had assumed there were no signs of life. As the landscape begins to change and we notice flowers and fruit trees appearing, our initial response is to continue to second-guess the changes in the landscape, to assume the new vegetation is a mirage. Out of habit, we keep maintaining that the landscape is barren and we fly in the face of the evidence.

There's a well-known phenomenon that illustrates the steel-trap quality of the mind: When European ships first appeared on the coastline of the New World, the natives actually blocked them out of their minds because they'd never seen anything like this before. Their minds had the stunning ability to scramble what their eyes were seeing. Objectively, we would have to say in this case that just because the natives couldn't see the ships didn't mean they didn't exist. Self-observation is the activity of taking every conclusion the mind makes with a grain of salt, while continually reminding ourselves we're missing the point in each and every moment and that we don't know best.

Who are *we* to set parameters and limits around who we are and what we can and can't give voice to? Waking up can happen in an instant—just because it's always been one way doesn't mean it has to remain this way. This could be another one of the mind's ideas that don't pan out; yet another example of its fabulous capacity to take reality and twist it to its own end. The personality will never volunteer that for decades we've been buying faulty information that supports the fiction that we're an alligator, and that we could just as easily stop buying. The mind will always tell us this is the way it is and there's not a damn thing we can do about it.

It's like we're driving a car and we have this passenger—they're insisting that the light is red, when in truth it's green. Just because a person says the light is red doesn't make it so. That's why the phrase "We need to break faith with the mind" was invented.

It Doesn't Get Any Better Than This

Complaint strengthens the spell we're under (our misbegotten relationship to life), and gratitude loosens the grip of the spell. The weird thing about our situation is that anyone that's in a real school is sitting on top of the world. We have *no* idea that we're the luckiest ducks ever. I came to this conclusion based on the following evidence: in the Bible, it says, "Beware of false prophets." Maybe these are the people who woke up, but when they passed Shams-e Tabrizi in the marketplace and met his gaze, they kept going, reasoning to themselves: "I've just managed to neatly sidestep the humiliation of giving it up to someone else."

Each one of us in a real school came here with an unerring desire for God, for the *real thing*. This is something that we all have in common. It would be impossible to be attracted to a school where facsimiles of the real thing were being handed out if we weren't yearning for God. So if we have "the goods," (the thing inside of us that will make it possible for us to know God and to serve Him), and we have the "means" (the Name of God), then it doesn't get much better than this. If our minds are telling us differently and riddling us with complaint, then the only thing we have to do to capitalize on a brilliant, best-case scenario opportunity is to meet the deceptive mirage of lamentation coming at us with Yogi Ramsuratkumar's Name. It doesn't get any easier than this.

We've been pretending to be an ugly duckling and ignoring the swan that we are. Reminding ourselves that we're the most fortunate of swans—when the mind tries to sell us on the "fact" that we're a moth-eaten, sorry-assed duck—is the way we close up the "I'm just a schmuck" gap. We just have to continue to remind ourselves of how lucky we are. Any time I find myself not liking what's going on, all this means is that I have amnesia and I've lost sight of the big picture.

Ways of Worldly People

Q: Even when the path you show is so easy, why don't people follow it?

Ramdas: Just because it is easy! If a difficult path is taught, then too, they will say, "It is a difficult path, which I cannot walk." They do not like to follow the path any way. If you ask them to repeat *Ram Nam* [the Name of God], they say, "What can Ram Nam give you? Simply repeating the Name! What is the use?" If they are asked to do other *Sadhana* like contemplation, prayer, fasts, etc., their answer is "How difficult it is! We must have an easier path." When they fail to follow any of the paths, they console themselves by quoting the *Bhagavad Gita*. "God's *Maya* is great and it is hard to overcome it!" This is the excuse they offer and they sink more and more in worldliness, being intensely attached to the objects of the senses.[1]

When We Bleed, He Bleeds

Life doesn't rain on our parade because it's a pain in the ass. It does it because it wants us to know love. It doesn't place us in the middle of a freezing winter in South Boston

1 Swami Ramdas, *Swami Ramdas' Talks* (Kerala, India: Anandashram, 1995), 87.

just to mess with us—life wants to help us appreciate just how fabulous a roaring fire and a glass of brandy really are. If we're angry at God (and who isn't?), then we've missed the point. Separating ourselves out from and in opposition to God and not cultivating a relationship with Him because we feel our problems are His fault would be impossible if we knew just how connected to Him we are. When we bleed, He bleeds.

Once I suggested to someone, who was suffering physically and emotionally, that she apply the Name of God to the avalanche of paranoid thoughts that were streaming through her mind. She burst out crying and said, "I'm very angry at God for all this suffering!" I said, "Here's something you may not have thought about: God is right in there suffering with us, and much more intensely than we ever could. What did you think—that he's up there this whole time wearing a party hat, playing pin the tail on the donkey with your ass?" Anger at God—or at anyone else for that matter—can only exist in the twilight world of half-truths and faulty information.

When we see just how intertwined and indivisible we and God really are, then we'll have an Emily Litella moment in relationship to all of our resentment and grievances— we'll say, "Never mind!" This consideration applies to us even if we've never dreamt of saying "f**k you" to God, but are secretly holding things against him. Here's something that might help to uncover our unconscious feelings about God: The chances are high that if we haven't made our peace with our parents, we may have it in for God as well.

As always, the best way to get out of a tight and inappropriate corner like this is to say Yogi Ramsuratkumar's Name, because it will dissolve all the traces of anger and resentment that we're hiding from ourselves. Once this

happens, then *everyone* gets to put on party hats and have a really good time.

Chapter Seven

There Is Only God

The Secret of Unhappiness

I know that I promised you the secret of happiness right up front at the beginning of this book, but sometimes it's necessary to move in the opposite direction of what we want in order to get it. I'm not sure why this is so, but it does seem clear that anything we pin our hopes on and that we desire is bound to disappoint.

In this case, being OK with not being happy would guarantee us something even better than happiness: joy. I've often had an image floating through my mind of God standing around with some fabulous gift for me, but because I have my hands full of things that are less valuable (a bunch of stuff from the ninety-nine-cents store), I can't receive the gift (from Tiffany's) that He's trying to give me. If we were to decide that whatever we have right now was fine by us—and be OK with depression, for example—then this would create some receptivity on our part to receive something else.

Patience is a virtue, as well as a pre-condition for receiving a gift from God. Accepting whatever our lot in life is, instead of struggling against it, is the good-faith gesture that indicates that we're open to receiving something more extraordinary and mind-blowing than anything we could have imagined or pictured for ourselves. This is where we lean into all of our suffering (physical and emotional) and we say, "I don't have a problem with my condition, and I trust You." Embracing unhappiness would appear, at first glance, to be an odd way to get to happiness, but we must begin

to see that eternal solutions always appear to be paradoxical from the standpoint of our linear perspective.

Our minds are masters at convincing us that we deserve better, and they will never encourage us to get down on our knees and say, "Yes, my Lord, whatever you say." When the mind expresses its opinion about how crappy your life is, it's best to respond with: "Thank you for sharing, but I've decided that enjoying my life isn't such a big deal." If we do this enough times (if we back off from where our minds are taking us), this will create an opening inside of us to receive a gift from God.

Fear Not

We're here to increase our capacity to not faint at the sight of God. In the Bible, the first thing an angel says when he appears before a mortal is "Fear not," because the sacred is weird compared to where we live.

The best way that we can develop our capacity to connect with the Divine is by separating from all of our notions about what we have and what we wish we had. Until we do this, we remain a closed system and immune to God's charms. A good way to understand the trade-off that we're making, day after day, when we cling to our idea of happiness, would be to get a stuffed rabbit and a real rabbit and compare the two.

Saying yes to our experiences on earth would prepare us for the inevitable and predestined moment when we find ourselves standing before God. We're here to practice saying yes come hell or high water, and to banish every holdout and every no that got stuck in us. When it comes to an encounter with God, it's all these no's inside of us that might lead us to the preposterous conclusion that He's scary. Responding to life by putting our little feet down and

putting our hands on our hips, while saying imperiously, "No!" would make it impossible for us to see the Divine as a good thing, since it wouldn't match up with all the no's that are running us. We'd take one look at Him and say, "A yes *that* big must be terribly wrong!"

Moving towards an idea that we have of what would make us happy is based on the presumption that God doesn't love us and that He doesn't wish us well. We need to stop substantiating this notion and disconnect from it. Being unhappy isn't the worst thing that could happen to us; remaining exiled from God's company is. Developing an interest in the opinion of the small, still voice inside of us that says, "Be of good cheer, all is well no matter what things look like, and don't give up hope, this too shall pass" is our best bet. Saying the Name of God amplifies this true voice and diminishes the volume of the voice that is always saying, "You poor little dear, you shouldn't have to put up with the paucity of your life." In the tradition of G. I. Gurdjieff, the maxim that if you have roses in your outer life, then you have thorns in your inner life; and if you have thorns in your outer life, then you have roses in your inner life, should slow us down when we find ourselves chasing after roses and running from thorns.

The Cost/Benefit Analysis

We approach all the moments of our lives like accountants: we're not free to produce a response that isn't calculated and connected to a cost/benefit analysis. We're approaching our lives with the deadly earnestness of an accountant—and we all know just how much fun accountants are. We're never told that doing things just for the hell of it, without counting the cost, is more fun. Maybe the activity of "watching our asses"

is pointless. Maybe if we relaxed our ferocious grip on life, things would turn out better than expected. Maybe God isn't as mean or inept as we think He is. Maybe God wants us to have every single thing that would make us happy—it's just that He can't give us stuff if we're fixated on what *we* want and who *we think* we're supposed to be.

Beware of Alligators Wearing Babushkas

Here's a famous Sufi story (stop me if you've heard this one) that illustrates how limiting our opinions are: There once was a wise elder somewhere in Russia (picture all the women wearing babushkas) who had a fabulous horse. One day, this horse ran away and all the villagers were swept up in a mood of despair. "Oh, no!" they cried, "Curses upon the miserable fates that took your horse away from you! This is a really bad thing!" "Well," said the wise elder, "maybe it's a bad thing, but maybe it's a good thing—we'll just have to wait and see." A few days later, the beloved horse returned with a lovely mare. This turn of events delighted the villagers, and they came to celebrate the happy occasion by exclaiming, "This is truly a stroke of good fortune—now you have two horses!" Once again the elder replied, "This may be a good thing, or it may be a bad thing." The next morning the wise elder's son broke his leg while he was out in the corral training the new horse. Once again, the villagers appeared to prefer their opinion about the latest turn of events: "This *really* sucks!" The next afternoon, Cossacks arrived in the village and demanded that every young man ride away with them to fight in a war. None of the men in the village returned because they were all killed—with the exception of the young man ineligible for service due to his broken leg.

We can begin to cooperate with a spiritual teacher's more expansive vision by playing the devil's advocate in relationship to any viewpoint that appears in our minds. We can entertain additional possibilities. We can ask ourselves if there might be something that we're not seeing: "Could the particular version of reality that's just floated into my mind possibly be flawed and untrustworthy?" It's necessary for us to do a little spade work and to practice not being taken in by every fly-by-night thought in our heads.

Questioning our thoughts creates the space inside of us to receive the gift of Faith. This is also a way to demonstrate our sincerity and our good will and our desire for God before everything else. Maybe Faith is the reward that we receive for a job well done, rather than something to run after and to wish and hope for. Anything we contribute to and work for can only be rewarded.

Blind Faith

Until Faith arrives, we can proceed with blind faith by engaging selective memory; we can cling to the words of someone who *has* been to the mountain, and banish the lies in our heads by remembering their words. Speaking of blind faith, I guess it's no big deal to trudge on once we've seen the Emerald City. The fortitude, guts, and determination it takes to move *without* seeing the prize probably produces a rare and beautiful rose. Here's to all of us, blind little moles that we are, down here in the trenches.

How to Get What We Need

Jesus told us: "Seek ye first the kingdom of God, and all these things shall be added unto you." This is the same truth that all spiritual traditions point to. There appears to

be consensus around the idea that if we turn our attention and our service to something grander than ourselves, and go to work for something that exists outside of our limited and limiting sphere of attention, we'll be taken care of and we'll get what we need.

The following incident might be an example of what can happen when we put ourselves out in order to do something that doesn't *appear* to be in our best interest, and when we disobey the "wise" counsel of our minds about where our bread is buttered: I was working on a three-dimensional interactive diorama for a children's hospital with a group of high school students once. We all felt that we were doing something that might serve to uplift the spirits of the children who were going to see it. One day, one of the young artists told me that he had come into work that morning with the flu. He decided not to stay in bed because a dream broke through his fevered sleep to tell him that the way to get well—the medicine for his sickness—was to come in and work on the children's art project. Even though this seemed improbable since he was feeling sick as a dog, he did it anyway. At the end of the day, he was happy to report that his illness had passed and he was feeling fine again. In this case, walking in the opposite direction of the "What about me?" refrain turned out to be surprisingly beneficial for all concerned, including him.

The Eyes Have It

If people have gone through enough non-neurotic suffering, they're more reliable. They're willing to help out in a tough situation. You can see this in their eyes. They've seen the majesty, the breadth and depth of life, and this enabled them to make a decision to function in relationship to the whole instead of from a fragmented perspective. You can

count on these people to do the right thing when push comes to shove.

It's very important to work with the mind and unravel its craziness, so that we can see what's really going on. We don't just "see through a glass darkly"; more than this, we have bandages covering our eyes. We can't just keep pretending that our mind's viewpoint is actually real. The eyes of a person who has made the noble decision to see will look different because the bandages have been ripped away, and there's more light in their eyes. So when Lee told his students: "It's always in the eyes; you can tell what's going on with people by looking at their eyes," maybe this is what he was talking about. Maybe we've met people in our lives who have seen the awful and the glorious truth, and they're not hiding from it. If we have, this might inspire us to begin to unravel our own bandages.

In Defense of Suffering

The primary thing that humans are connected to is the avoidance of suffering. Every action and every thought we have can be traced back to this one primal motive. But what if we found out that avoiding suffering wasn't in our best interest? That suffering is the grandest thing there is? That we've been running away from the thing that has the most to offer us? Here's an analogy that popped into my head recently that indicates our relationship to suffering is upside down. This analogy actually makes suffering look good and even desirable. (I know you must be thinking: "That must be one *hell* of an analogy!") How ironic that we've spent our lives running away from the thing that's most precious. All of us that enter the company of a real teacher begin as skinny, twisted, anorexic little plants that refuse to feel anything

and to shed any tears. As a result, we've developed shallow and sickly root systems. To get to be a tree, like a saint (I'm thinking specifically here of Yogi Ramsuratkumar), we would have to shed some tears in order to nourish our root system. In this analogy, the root system—the part that's under the ground that sustains and nourishes the beautiful tree—is suffering.

A tree whose branches have moved away from itself, and have fanned out and moved upwards towards heaven, is a living reminder of what we *could* grow up to be as we begin to pay the price. Initially, we pay with pennies—small sacrifices of personal preference and comfort—as we move in the opposite direction of our desires and dedicate these small discomforts to the development of our being, to something grand and noble that can stretch out beyond itself and sing God's Praises and Worship Him. Plants are here for a season or for a few years because they have much shallower root systems than trees do. Wouldn't we rather be a tree? If we would, then we may have to shift our concept of suffering from "bad" to "good."

The first step to becoming a tree is to prepare the soil by removing the weeds. This is analogous to saying Yogi Ramsuratkumar's Name to the thoughts that appear in our minds that strengthen our connection to our neurotic suffering. Refusing to feed the unhealthy plant (the perpetually whining personality) and exercising patience and faith as it begins to wither and die (because we're not really sure if and when something else will arise) is a critical stage. Being willing to hold on and wait for the real life to take root in us can be a stretch. Every time we deny the sickly plant (the personal self that provides nothing for no one) nourishment, we are moving in the direction of what we've come here to do.

Strange as it seems, we're not here to stuff our faces with our grand illusions about what and who we imagine ourselves to be. Maybe living every moment in a self-absorbed swoon, as though all of creation was about us, is something that's in our best interest to give up.

When we first meet a spiritual teacher, we think we're an angry little plant, and we blame him for trying to kill it in order to make way for the glorious tree we're destined to be. If we're identified with the sickly and angry little plant, then we're going to think his activity is annoying and we're going to resent it. But if we make a spiritual teacher's objective our objective (choking the life out of the no-fun plant we thought we were), then the desirable outcome proceeds with ease and speed; we get on his side, instead of siding with the plant that isn't serving more than itself. We say to God, "I'm ready to stop living just for myself and to be who I am. I'd like to provide shade, and branches for birds to rest in and for children to climb."

Hava Nagila

We can remind ourselves that we're meant for more than just milling around resenting the hell out of everything and everyone. We can remind ourselves that we would rather provide something instead of spending our days kvetching about what we don't have or what we do have. This means becoming adept with our pruning shears, so that every time we have a thought connected to dissatisfaction we can nip it in the bud. In every given moment, we are either singing "Hava Nagila" or we're kvetching. It's up to us to recognize which song we're singing and to choose the song of Yes.

A spiritual teacher's job is to show us a more beautiful song, and he does this at great cost. It's our job to do the work

that's necessary to create the space for this beautiful new song. It seems like for the most part, we heap abuses on him for his trouble. The little plants that we think we are bring deadly determination to their activities—they will stop at nothing to remain alive. When a spiritual teacher enters the situation and tries to help us root the plant out, it'll do its best to kill him. These plants are vicious and poisonous—they don't only have thorns, they have teeth.

Life Isn't a Bowl of Cherries

We're defending what we're not and silencing what we are—go figure! We came here to grow a tree or a rose. We became disconnected from our mission and got sucked into the fantasy that we came for a bowl of cherries; when we didn't get the cherries, we got pissed off. Even on the occasions when we got the cherries, we became dismayed and distracted by the unfortunate pits.

Our point of view is a complete misunderstanding. If we *did* see that we came here to engage in a sacred and noble enterprise, and that the cherries were beside the point, this would eliminate a lot of pointless suffering. Feeding our personal suffering gives us nothing in return. Suffering that's connected to the honest work of digging a hole for our tree is the way to go. In this case, we get to step back from our labors and bask in the sun of a job well done.

Who Do You Want To Be When You Grow Up?

On the bright side (Remembering God isn't *all* sacrifice and deprivation), all we have to do is look at the examples of spiritual teachers past and present, at how profoundly creative, alive and beloved they are. They're the ones that are walking through the Sahara, inspired in every moment by the

Will of God. They're the ones saying, "Yes, my Lord." They're not distracted by the camels of the past and future; they're not taking even one precious moment away from praising God. So when your mind tells you the path sucks because you have to give up everything, think of our radiant spiritual forerunners.

Who do *you* want to be when you grow up? It might just be worth it to walk away from our conditioned relationship to life in order to express and delight in who we *really* are. When doubts and fears enter the mind about connecting with God, and all we can see is the hole because we've lost sight of the donut, this is just our minds tricking us. This reminds me of a poem that enjoyed some popularity when I was in elementary school:

As you wander through life
Let this be your goal
Keep your eye on the donut
Not upon the hole

Humility

It's actually possible to see that we're missing the point when it comes to what we avoid and what we embrace. If we knew, for example, that humiliation leads to humility, we wouldn't avoid it like the plague that it isn't. It's possible to adjust our sights, and to remember that there's something valuable hidden inside the experiences that we hate the most. When our attention is trained on a ferocious avoidance of humiliation rather than on its value, it's easy to miss the obvious. When our self-image begins to unravel as a true teacher holds up a mirror to show us the objective reality of our machinations, the recoil is so strenuous that it eclipses and

obscures any and all transcendent possibilities. All we can see in these moments is the horror of watching our reputation being torn to shreds, and all we can hear is "Nooo!"

There may be more going on than we can imagine in these moments. Up may be down, and down may be up. The importance of beginning to take our minds' opinions with a grain of salt can't be overstated. We may actually be mistaken about every evaluation we've ever made. If we don't know who we are, where we're going next, or where we came from, we may also be blind to the purpose behind our most dreaded experiences. It might not occur to us that humiliating experiences are paving the way for humility.

The Road to Hell Is Paved with Being Right

Not pulling out arguments, defenses, or excuses when we're given feedback creates space for a beautiful flower to grow in our garden. If we continue to be the one who's always right, we end up with a garden of weeds. If, on the other hand, we experience the discomfort of humiliation and forego lashing out at the person trying to help us, our reward for this sacrifice is the flower of humility. Because anyone who's a saint and loved by all has the quality of humility, we can begin to make decisions about what we want in our garden and to cultivate it accordingly.

A Tidy Garden

We can infuse flexibility and permeability into our mechanical selves by going in the opposite direction of what our personalities prefer (after all, every little sacrifice counts). But we shouldn't take our efforts so seriously that we become confused about the truth of our situation: we're nothing until the spark of possibility in us is ignited through

benediction. *We* don't achieve anything. It's easy, once we've become proficient in self-observation, to get tangled up in the weeds of pride that grow with "our achievements" and to believe we've accomplished something. We could be creating more weeds if we don't recognize that spiritual practice gives us the possibility of clearing the landscape inside ourselves so that our true selves can arise. As always, just to be on the safe side, it's best to be perpetually giving up all the glory to God. If we've managed to clean out the weeds of self-reference but we've replaced them with the weeds of pride, then we haven't accomplished very much. It seems to me that my teacher Lee lives in a perpetual state of giving it up to his teacher Yogi Ramsuratkumar. This makes for a tidy garden.

We've been pretending to be the one who's less than dirt because of our "crib conclusion." Finding out we actually *are* dirt, glorious dirt—and that God is going to plant an amazing garden in us—is a tremendous relief! We can identify with the fate of Sisyphus—the god in Greek mythology that was sentenced to push a rock up a mountain for eternity that kept rolling back down again. Finding out that we don't have to keep up the never-ending struggle of pretending we're something is great news. All we have to do is turn the garden over to God and say, "I've prepared this garden for You." If the realization that the garden doesn't belong to us is tough to take, then we can just keep rolling our rock up the mountain, only to see it roll back down over and over again. "Misery, misery, misery, misery … life is but a dream."

Reverence

Maybe one of the reasons that we've been created is to move from irreverence to Reverence; to pay our respect to

something—*anything*, or someone—*anyone*, other than ourselves. Maybe we're in the process of learning to leave off *pretending* to be something in order to be filled with Reverence. Unfortunately for most of us, we don't know how to make it out of these self-involved trances and to put an end to all of this endless milling around inside of ourselves. Until this happens, we're the "hollow men …" that are living "lives of quiet desperation," "… measuring out our lives with coffee spoons." When we begin to turn our attention away from our imaginings, this creates the opening we need to be able to revere, worship and praise God. We're here to come out of whatever comfy little cubbyhole we're in so that we can pay our respects to life.

Attachment Is the Fly in the Ointment

My teacher's days are unusually efficient; everything seems to happen in him and through him and around him in the right way, at the right time. His relationship to life reminds me of the ideal way to approach a chicken. This is where every scrap has been taken from the bones, and the bones themselves have been used to create soup. How could his day be otherwise, given that he's moving in concert with the Will of God?

One thing I can think of that would account for this alignment is that he doesn't wake up in the morning attached to one thing or one outcome or another. He doesn't begin each day saying, "I want" or, "I don't want." When the Buddha woke up, he asked himself, "What's the holdup here? How come these people are moving counterclockwise against life, instead of clockwise and in sync with life?" One of the answers he came up with was that our attachment was the fly in the ointment.

My Precious, My Precious

My teacher hit his students with some horrifying news a number of years ago: "You know, don't you, that the work you're doing to Remember God may require a couple of sacrifices. You may even be required to give up your favorite belt!" This announcement continues to send chills up my spine every time I think about it.

I've always had a schizophrenic relationship to jewelry. The artist in me loves it, and has come up with a slew of designs that would probably stun the marketplace if they saw the light of day. On the other hand, my personal self is quite immune to its charms. My mother and my grandmother had jewelry boxes, but I made sure to stay clear of them— especially the ones with the dancing ballerinas. Just when I thought I had made it out of this particular bardo without falling into its clutches, my waterloo fell into my lap in the form of an unusually beautiful necklace. It was a series of delicate and perfectly crafted strands of silver and turquoise. It was love at first sight. This was the only piece of jewelry that I had ever had a "vested interest" in. So far so good.

But a few years later, I was innocently sitting in front of my teacher when the bizarre and unwelcome notion that I should take it off my neck and give it to him entered my mind. Another part of me was quick to oppose this weird idea, and I found myself lost in a duel (as in the depictions of a devil sitting on one shoulder and an angel sitting on the other) between two very different points of view. I was in a state of deadlock and paralysis as this ping-pong match raged on.

The thing that catapulted me out of this state was the point of view of yet another part of me. This part said something to the effect of, "For crying out loud, this is silly! You can't just sit here forever, so just get on with

it!" Recognizing that this part had made a valid point, I finally handed it over. Maybe what I might have learned from this is that it's never a question of whether we will surrender everything to God or not. The real question is: how much time do we want to spend screwing around, since it's inevitable? Come on, do you really think you've got some big decision to make here, given the fact that everything belongs to God anyway?

In the "Lord of the Rings" trilogy, the emaciated and pitiful Gollum—who has been reduced to spending his days in a sunless cave, muttering, "My precious, my precious," due to his obsession with the ring—shouldn't be lost on us. Whatever you can't quite get yourself to give up owns *you*, not the other way around.

The Fisherman and His Wife

Every time we have the slightest preference for things to be one way or another, we become incapable of allowing ourselves the "luxury" of complying with the Will of God. Our egos really *won't* stop until they're the undisputed ruler of the entire universe. The fairy tale *The Fisherman and His Wife*, like most fairy tales, points to something that we're all in the process of figuring out. Here's my version:

> Once upon a time, there was a fisherman who lived in a slovenly hut with his wife. Their standard of living was unbelievably low. One day, the fisherman caught a glorious fish with golden scales and emerald fins. The fish said to him: "If you don't eat me, I'll grant you a wish." The fisherman said that he didn't need anything for himself, but he knew that his wife would be happier if she had a new dress and a nice house.

204

As he made his way home, the fisherman was surprised to note that a very nice house had replaced their shack. When he arrived at the new house, his wife was wearing a sleeveless Evan Picone original, and she was sitting in her Barcalounger, sipping a glass of Grand Marnier. She turned to her husband and said, "Now *this* is more like it!" As she looked around, she was particularly pleased to note that the furnishings were from Ralph Lauren Home.

The next day, a familiar feeling of dis-ease crept over her, as she spotted an offending throw pillow. She couldn't be sure, but she thought she might have seen it in one of the other huts along the beach. This catapulted her into a tirade about how stupid her husband was for not asking for a mansion with a closet full of clothes and a bunch of servants. She ordered her husband to go back to the fish and make her demands known.

While her husband was loathe to bother the fish again, he did want to make his wife happy (as if *this* was ever gonna happen!). When he asked for these upgrades, the fish replied, "No problem."

The fisherman returned home to discover that his wife was delighted with her new and improved situation. Unfortunately, after a few days she started getting twitchy again. She couldn't help noticing that the servants weren't deferring to her every whim with as much enthusiasm as she might have liked. So she explained to her husband that their lack of respect could be easily remedied if he went back to the fish and requested that she be made queen of all the land.

This new request was fulfilled with equal alacrity. In the twinkle of an eye, a majestic castle appeared where the mansion had stood. The fisherman found his wife in all her glory: peacocks roamed the throne room, along with hundreds of courtiers and courtesans. Initially, she was quite pleased with the new turn of events (she found the peacocks especially amusing), but then, in a moment, she became outraged when one of them pooped on her foot.

When she regained her composure, she reasoned to herself that if she were *God* she wouldn't have to put up with this crap. She ordered her husband back to the fish, with instructions to change her status from queen to God. The fish replied, "I regret to inform you that this time your wife has gone too far." In a flash, the humble fisherman's shack now stood in place of the magnificent palace.

What's the moral of this tale of woe and loss? Some possibilities come to mind. Maybe when it comes down to it (to our death), it doesn't much matter if we're lying in Egyptian-cotton sheets or in a gutter; maybe we can count ourselves lucky if we've come to the end with a gleam in our eye and a song in our heart. Or, while we can't dethrone God, we *can* pray to develop good manners, in order to bow before Him while saying please and thank you.

Resistance Is Futile

I had a dream where I saw that someone very dear would be taken away from me in the end—kind of like the coming attractions to a really bad movie. So I threw myself on the ground and began sobbing uncontrollably. But then I had a

moment of clarity. Strangely, I was able to see what I'd never seen when awake: *any* path that I took because *I* wanted to would *always* end in misery. On the other hand, any time I followed the Will of God, what He wanted, things would work out well. Even though the dharma clearly states "Thy Will be done," this was the first time I *knew*, beyond an idea in my mind, that surrender is the only *viable* and *practical* choice. The way that we live is in opposition to the truth of things, in hundreds of minor and major ways. All day long we're asserting "our will," "our preferences," and "our opinions" over and above the Will of God, while never suspecting that we're screwing ourselves.

Step Away from That Bag of Garbage

A friend of mind was innocently walking down Fifth Avenue one day in New York, when she was catapulted into a bizarre visionary state. Out of nowhere, all the people on the street appeared to be clutching bags of garbage to their breasts. What she could see in this moment was that the contents of these bags, while they appeared to be really precious, were garbage when compared with all that God had in store for them. Nothing—not their charge cards, not even their beloved children—could hold a candle to the glory of God.

She reported that this was one of the truest moments of her life. It was a moment when an angel took the trouble to place bags of garbage in the arms of all of the people in the street, in order to impress upon her the relative importance of the things we hold dear in this world. Establishing a more neutral position inside of us by separating from our preferences has always been the tried-and-true remedy for our misery.

God Loves Beauty

Since we're all too busy to Remember God, maybe we can begin our approach by admiring His creation and celebrating His work through an act of creativity. Maybe it's not for nothing that the phrase "God loves beauty" appears in the Koran. Perhaps we can learn the art of sidestepping our fabrications by throwing ourselves into the service of creating something beautiful.

Perhaps we *can* achieve an instant of self-forgetfulness, an instant where we're moved by something other than the presumption that we need to *get* something rather than to *give* something. What if it turned out that it's *not* all about us? What if it turned out that our survival was dependant upon serving rather than "pretending" to serve? Oddly, it's this rush to get "our due," and "our just deserts," that interferes with our getting what *we* need. If we're not providing anything, then what is it exactly that we feel we're entitled to? The universe doesn't suffer lay-abouts and pretenders lightly.

Service Is Everything and the Rest Is Bullshit

I once woke up in the middle of the night to find myself saying out loud: "Service is everything and the rest is bullshit!" When we're identified with the part of us that feels that it has to fend for itself—because it knows that its days are numbered and that none of us are going to get out of here alive—we're barking up the wrong tree. The right tree (in terms of getting what *we* need) is to stop ruminating about our *own* needs and to separate from the relentless insistence that's driving us hither and thither. What works is to become quiet inside for a moment and ask, "What does so-and-so need right now?" This new and different approach is even more effective if this person is the one who's done us wrong, or the one who is beneath us.

This reminds me of a musical answer I got when I asked myself the question "Why *are* we here?" I was caught by surprise when a song from the forties took over, and I found myself belting out enthusiastically, "*Make* someone happy, *just one* someone happy!" If the answer I got was true, then why *not* make a cup of tea for someone else—nemesis or not—after checking in with the place in us that wishes to serve, and separating from the run-of-the-mill ulterior motives that are usually running our psyches. After all, until we begin to separate from our paranoid program, all we are is a one-note, one-trick pony.

Good Luck with That

Sartre was wrong when he said, "Hell is other people." Others aren't hell, we are. We're addicted to our righteousness, and our conclusion that we're right and everybody else is f***ing us over. I don't care how convincing our minds are, how adept they are at pleading the case that we're a hapless victim—this point of view will never be supported by the Sacred. When we do this, we're on our own in a hell-realm of our own making. Good luck with that.

The Bar and the Barfly

There's a Carson McCullers story where a kid walks into a bar early one morning to deliver cream, and an old-timer sitting at the bar collars him and says something like, "Kid, si' down. You wanna know about love? I'll tell you about love ... You wanna start small. You get yourself a goldfish, and when you figure out how to love it, you get a little white mouse. You keep trading up, until you're ready to love a person." According to this story, if someone out there is pining to be in a relationship and they're getting nervous because it's

beginning to look like their prince or princess isn't coming, it's never too late to light a candle instead of cursing the darkness. It's never too late to go out and get a fish, a fish bowl, and some fish food, and to spend some quality time watching, appreciating, and adoring your fish.

Speaking of Men and Women

Our egos are wired differently than our true selves: they have the destructive chip, not the creativity chip. Their passion is scanning our environment for any possibility that can be downgraded; they have no interest in upgrading the possibilities that present themselves to us. They're here to make the worst of a bad or a good situation, not to make the best of whatever is in front of us. They have the opposite agenda of the one that turns water into wine. Their *forte*, their special talent, is turning wine into poison. Whatever you give this part of you to work with, it will set about fashioning a bomb to blow up you and as many others as possible. The thing that fuels these feats of madness is fear.

The destructive possibilities of following our egos are never more in evidence than when a man and a woman attempt to create a relationship. For a thorough understanding of what we're up against in this arena, the best textbook that I know of is *The Alchemy of Love and Sex*[1], by Lee Lozowick. It contains a series of secrets that we need to know in order to make love with our partners instead of war. Right off the bat, secret number one ("The Imprint of God Is Women"), lets us know what we're up against. The author posits that the tension between the sexes is the result of something that we experience when we're babies: Girl babies are overwhelmed and frightened by their contractual obligation, when they

1 Lee Lozowick, *The Alchemy of Love and Sex*, (Prescott, Arizona: Hohm Press, 1996).

recognize that they contain the same imprint that their mothers do (obviously, their mothers are God because they are keeping them alive). Boy babies, on the other hand, intuitively recognize that their imprint is different from their mothers and that they aren't God. This sets them up for life for an unconscious and antagonistic relationship with women. There's a lot of support for this thesis when we factor in the perpetual demonstrations that we've seen of the "fragile male ego."

This anger about not being God has led to a number of regrettable and painful repercussions for women. At some level, the trace memories of being burned at the stake (or worse) by men are influencing their responses in this day and age to men. Marion Woodman once gave an example of her own fear in action. She said that there comes a time in every marriage when your husband walks into the kitchen one night, wearing this ratty old bathrobe that his hairy, spindly little legs are sticking out of, and you look over at him and you say to yourself, "He's just not good enough!" I'm not sure what happened next, but I can imagine that her husband's response to her ungenerous appraisal of him was perceived by him at some level, and this produced some unpleasant and angry repercussions. Had she not been listening to the part of her that contains "the destructive chip," things might have turned out differently. The thing that we have to realize here is that none of us are innocent, and that the smartest thing that we can do is to give each other a break, since we're all really scared.

Love Lost

I think the reason that our memories of the past are unreliable is because we aren't standing in a place of neutrality

and objectivity in the moment when something is happening to us. Our selective memories are the product of selective experiencing; we are filtering out so much of our lives that we'd all be hard-pressed to come to the end of them and know what really happened to us while we were here.

The only thing we can know with certainty is that, for the most part, we didn't give ourselves or these other people an even break; that we superimposed a loveless unreality on top of our lives and we died without knowing that we were loved. If we knew we were spending our time here lost in lovelessness, we would lose interest in tallying up the "who did what to whom" score and spare some time to mourn all of the love that was lost on us.

Pretending Won't Make It So

We've been driving around in a car with a flat tire for decades, pretending it's not flat—when all we needed to do was *see* that it was flat in order to get out and change it. The reason we haven't been aware of our situation is because we've been listening to our minds for so long. The job of our minds is to keep us stuck in a morass of paralyzing and problematical energy by convincing us that we're helpless. We're trapped in the habit of ignoring the flat tire because we're clinging to a belief (that we've constructed over many years) that we lack the power to change it. We were convinced somewhere along the line that our best bet was to pretend it's not flat: "Hell, we've gotten along well enough so far … let's just not rock the boat." Never mind that it's leaking.

The problem with this decision is that as we get older, we no longer have enough vitality to lull us into a false sense of security. This is when the shit hits the fan, because we don't have a place to stand on to deal with the situation.

Sticking our heads in the sand works for only so long—it's not a winning formula, let alone one that's aligned with the perspective of eternity.

How to Limit Our Options

The best way to stagnate and compromise the possibility of spiraling upwards to freedom is to get attached to a particular strategy—a winning formula that we think will take us to freedom—when it can't, because we're still connected up to survival rather than love. Health nuts spring to mind: even though they're on the right track—maintaining a body that has enough energy to accomplish spiritual transformation (after all, if our goal is to become more real and full of life, it makes sense to eat real and alive food)—the right track could turn into the wrong track if it became the main track. What I'm referring to are the lost souls who haunt health food stores because they've become addicted to wheat grass.

The opportunity we have is to work creatively with what's available here in this world, while not getting attached to or fixated by any one accoutrement. If we've become enthralled by the magnificence of wheat grass, then this will stop us from expanding in order to find something even better. This comes down to using what's available here to benefit the emergence of our true selves, without allowing any one thing to get its hooks into us and to distract us from our quest.

If your particular winning formula is your therapist, your yoga practice, pumpkin seeds, decorating, positive thinking, or conspiracy theories (this is where we distract ourselves from uncovering the lies inside our heads by focusing on the lies of the world), you'll end up at a standstill. Whatever our trip is, if it becomes the main thing—the thing we have to have—then it will end up standing in the

way and anesthetizing us to the one thing that won't use us up and leave us for dead. Anything we need to keep us going (even when we're kidding ourselves that what we're doing is "spiritual") will eventually come back to haunt us. The attitude that's the most hazardous to our unfolding awareness of God is the one that presumes that we know what we're doing, and that we need look no further than our yoga mats for salvation. Just because our particular winning formula is helping us "keep the edge off" doesn't mean that it isn't blocking our evolution.

Step Away from That Rice Cake

Thinking that you've found the winning formula—the way and the truth—is less likely than not. Here's an example of how easily we can be led astray. (If you're eating a rice cake while you're reading this, you may want to put it down.) Researchers at the University of Michigan determined that their rats died with alarming rapidity when fed a diet of rice cakes. Autopsies revealed dysfunction of the pancreas, liver, kidneys, and degeneration of the nerves in the spine. It turns out that the process of creating a rice cake (the use of a machine that subjects the rice to high temperatures and pressures) makes them extremely toxic, particularly to the nervous system. In another study, half of the rats were fed corn flakes and the other half were fed the cardboard from the box. The group on the cardboard diet outlived the ones living on corn flakes. This goes for Cheerios, Rice Krispies, Puffed Wheat, and too many other breakfast treats to mention.

This reminds me of the case of a dear friend who came to visit me years ago, with several suitcases stocked with Perrier water (a few years later we would discover that Perrier contained harmful amounts of benzene) and rice cakes. She

had begun gaining a lot of weight and this was her attempt to "do the right thing." Every time she wanted to have something "fattening," she would heroically have a rice cake instead.

There's a lot of bad information out there dressed up (wolf-in-sheep's-clothing style) to look good. When it comes to our approach to God, it's healthy to begin to question the winning formula we've been giving our support to all of our lives, just in case we may have missed or misunderstood something along the way. This is where keeping an open mind comes in handy.

A New Playing Field

When a spiritual teacher's help moves into our neighborhood (by the way, newly discovered scriptures have confirmed that Jesus wasn't the most popular guy in *his* hood; that he was regarded with fear, animosity, and mistrust by his neighbors) this means that the alligator/Mafia that's in charge of hiding who and what we are from us wasn't entirely successful and we're still connected to the place inside of us that's yearning for the truth to will out. Yet still, we can't help responding unconsciously to every piece of the truth that the teacher's interjecting into an ironclad system of lies as though we were still babies, and the only way to survive these "truth assaults" is to war against them.

It takes awhile to begin to give it up to whatever spiritual teacher has appeared to save us from ourselves, and to begin to admire his fortitude, compassion, patience, and all-around good sportsmanship. It takes time to figure out that the playing field has changed and the situation is no longer the same as it was when we were a baby. What distinguishes this playing field from the crib is that we now have benevolent and trustworthy backup. Now that we have sanctuary, all

we have to do is move in the opposite direction of our "crib conclusion." This would be the ideal time to open our ears to the information our teacher or life is always giving us in order to connect to the truth.

A Springboard for Remembrance

The more we're grateful for a spiritual teacher's presence and for the sanctuary and protection we've been given, the more we will override the old voices in our mind that say, "You don't have what you need, you poor sucker … How can you be expected to do *anything* useful?" His benediction is here to eclipse and drown out these lying voices. If we actually *do* the things a teacher recommends, the baby killer in us (the ways in which we perpetuate what was done to us) will become "de trop." The lynchpin of our sleep will mysteriously transform into a springboard for Remembrance.

The Crossroads

At some point we begin to see that the Sacred *does* exist, and the part of us that's been dictating our life experience digs in its heels and sends us thoughts and moods in order to assert its authority over and above the Divine. In its terror, this part of us creates a smokescreen of negativity and projected anger into our environment to obscure any hazardous reminders of the truth. Get a clue—our minds aren't our friends. They never have been.

It's at this point, when the dictator within is really riled up (because we've caught the scent of freedom) that we have come to a critical juncture in the efforts that we've been making to Remember ourselves. We've come to a crossroads, where we're either going to cave in to the pressure of the pretend self and identify with all of its complaints—dressed

up to look like they belong to us—or we're going to work with increased dedication to undermine their version of reality for the sake and safety of our souls.

Trusting the information from our minds—when we've hit the point where the alligator has seen that its days are numbered and we're getting too close to connecting with the Divine—is a mistake. We've come to the place on the path where feeding our neuroses and colluding with the enemy has more painful repercussions. The war has begun and we're going to have to choose sides: feed the alligator, or feed the Divine.

There's No Substitute for the Real Thing

Waking up to who we are is challenging enough for our children without compromising the integrity of their brains with drugs and video games. I know it's hard to take life straight—without a shot of bourbon, a new hat, or a video game—but separating from our drug of choice is the only viable option that's open to us. This is the option where we all face the music ... and dance. As tempting as it may be to recoil from our pain, disconnect from it, and fend-off reality, avoidance is the hard road, not the easy road. God doesn't accept substitutions, and we're in a diner where the menu clearly states, "No substitutions." This is good news, because there aren't any substitutes that are as good as the real thing.

The fate of a heroin addict is a more graphic depiction than most of just how workable it is to disconnect from reality, but it does give us a picture of the road to rack and ruin that leads away from life. But just because we've chosen to kill our possibilities off discretely and slowly doesn't mean that we won't end up malnourished and depleted when all is said and done.

Is it Real or Is It Memorex?

In the best of all possible worlds, we would all refrain from hobbling and crippling our children before they hit the crossroads—the place where they get to vote for a real life or an imaginary one. The thing is, they're being exposed to a lot of replicas of real things, and the parts of their brains that were designed to have revelations and to Remember God (to have objective rather than subjective experiences) are being systematically compromised.

Here's an interesting experiment that was done a few years ago involving imaging children's brains: When the subjects were shown computer-generated/video-game images, only very superficial areas of the brain lit up—the impact wasn't integrated throughout the system (kind of like getting a hit of speed). Images taken from real life not only lit up areas in the brain designed for higher thinking, but the information was absorbed and integrated throughout.

We could conclude from this that distancing ourselves from reality has a price, and that there's no substitute for the real thing. Moving in the opposite direction and away from the gifts we were given would appear to put us at the risk of devolution. Disconnecting from reality is only a good idea if you want your brain to atrophy. Carbon copies and facsimiles of people and places don't carry the nourishment that our children need.

A Clear and Present Danger

Oprah produced a show recently that focused on children that had become addicted to video games. The heartbreaking thing was watching a four-year-old go through acute withdrawal when his games were taken away; his distress was identical to that of someone withdrawing from crystal

meth or heroin. Here's a letter that expresses the plight of the children who are at the mercy of our technologically advanced culture:

> The computer technology virus is so deeply embedded in the cells and minds of our children at this point, and is spreading at such an alarming rate, that what the spiritual elders warned us of is directly upon us, which is: that it's too late. Can I please just say that I am heartbroken about this?
>
> I watch my step-children spend entire weekends doing nothing but downloading TV programs from the internet, e-mailing their friends, playing video games, and completely absorbed in the computer software that is of current interest to them. Most of their friends do the same thing. They don't know whether it is warm or cold outside, whether it is cloudy or sunny, and for the most part, they don't care. They can barely take fifteen minutes to finish a meal before they race back over to the computer to resume what it is they were doing that's of such paramount importance to them. Sometimes after hours of staring at that damn screen, they get so disassociated from their bodies that they don't realize that they are hungry or thirsty or tired. Their skin is pale from lack of being outside in the sun, and I cringe as I notice their posture when sitting at the computer—it's the same kind of posture that leads adults straight into my office thirty years later to be treated for back and neck pain.
>
> In order to "relate" to my step-daughters, I have sat with them for an entire evening while they

watched some of these TV programs to get a sense of what it is that drives them to such a state where they are impervious to nature and all human life forms around them. And truthfully, I was horrified by what I saw. Across the board, these TV shows (as do the fashion magazines, which they also like to read) portray women as petty and superficial, vain, bitchy, competitive, devious, overly-skinny, upper-middle class and blond. This is what my step-daughters race to their room to watch every weekend when they come over and what they talk to their friends about during the week. To me, it's entertainment at the expense of human dignity. I've been making an effort to go along with the whole thing, be relaxed and good natured about this obsession with and addiction to computers, cell phones, and i-pods, but I cannot ignore the voice in the depths of my conscience that is screaming, "Something is terribly wrong here!" Little by little, these ravenous, insatiable and insidious viruses are squeezing and sucking and draining all the humanity and soul out of this planet.

... [I]t is plain to see that the cost we are paying and that our children, grandchildren and great-grandchildren will be paying in the energetic spiritual and human domains for this grandiose, mind-boggling deification of the sleek, brazen technology god is exorbitant. Is this really an evolutionary process or is it a devolutionary one? Concomitant with this obsession with technology is the rise, to epidemic proportions, in the use of antidepressants ...

... There has been an extreme disconnect from the rhythms of the natural world in our time. There is

more loneliness, misery and isolation on the planet now than ever. We stand alone, out of sync and out of touch with the intrinsic, graceful holiness of Life itself. Revelation of the Sacred can be found, as indigenous people and visionaries have always known, through relationship with the simple magic and profound mystery of nature. The Heart of the Sacred is discovered through the cultivation of compassion for all life forms. But the eyes of the world are caked shut with the dust of deception, and we as a species have inexorably desecrated and banished the Sacred through this incessant worshipping of false gods and idols. We have lost the way, and it is too late. The veils of darkness have turned to heavy, molten lead ... [2]

Get Them While They're Young

The devastation of our children at the hands of the pharmaceutical industry is a more obscene threat. Did you know that our children are the pharmaceutical industry's largest target market, and that liquid Prozac (for babies) and peppermint Prozac (for toddlers) are two of their most promising products? You know the expression "Get them while they're young"? Disabling a child's brain while it's still developing is an excellent way to turn the next generation into mindless and malleable shoppers.

From my experience, drugging children at a young age has a downside: when they reach puberty, all hell breaks loose. A psychiatrist called me a few years ago with a little problem he was having. He had been rather too free with his prescription pad with his own children, a boy and a girl,

2 "Letters and Fragments," *Tawagoto*, 20, no. 2 (Summer/Fall 2007), (Prescott, Arizona: Hohm Press), 172-73.

and began giving them antidepressants and Ritalin when they were two. The problem was that when his son entered puberty, his parents had to lock their bedroom doors so that he couldn't kill them with a baseball bat in the middle of the night. Their daughter expressed her dissatisfaction with what had been done to her (before the age of consent) by repeatedly trying to kill herself.

The good news is that the damage to our children's neurotransmitters is repairable. There are programs that have been developed to slowly wean these children away (never ever withdraw them abruptly) from these drugs safely, while supplying them with foods and supplements that target physiological and emotional repair.[3]

Peter Breggin is a psychiatrist who's written a slew of books (*Talking Back to Prozac; Reclaiming Our Children: A Healing Plan for a Nation in Crisis; Talking Back to Ritalin*) about just how dangerous these drugs are for our children and for the rest of us. It seems to me that the drug/technology crusade to dismantle our children's creative intelligence takes the cake when it comes to the multitude of fronts that need our attention. Fifty percent of our children in this country are currently on "meds," and this number is climbing. This being the case, who's going to solve the problems like wars, global warming, famine, and water shortages (to name a few) that our children will be inheriting?

Every problem has a solution, but if we continue to cripple the capacity of the next generation of problem-solvers, the "brave new world" that's coming our way (that we were warned about), will continue to gain on us with ever more alarming speed. Speaking of this brave new world, see the article in *The Detroit News* (Jan. 11, 2001) called "Drug

3 Julia Ross, *The Mood Cure*. (New York: Penguin Books, 2002).

222

Evasion Now a Crime— Swallow This!" by Samuel Walker. I read it a number of years ago and I can't seem to get it out of my head.

Gratitude Before the Fact

Sooner or later, we will connect all of our efforts to Remember God to an intention that's more expansive than "OK, I'll make these efforts because I want out of pain." Before this happens, we can begin to remind ourselves that the reason we're trying to remember Him is because we want God's Will to be done in and through us, and that we want to do something for Him. Even if we don't harbor a desire yet to shift our motivation for saying His Name from us to Him, we can begin to imagine the possibility. We can precede each effort we make with a declaration that connects it to our intention. Just because we're used to doing everything from the point of view of our safety doesn't mean it has to stay this way. We could say to ourselves, "Because I've given self-absorption a shot and I have the feeling that ultimately this approach is doomed, I'm open to learning a new trick where God becomes the focus."

Ultimately, we've been given the opportunity to declare: "Because my mind is sacred, it's a crazy-thought-free zone." If you go on vacation and come back to find that your house has been taken over by a bunch of addicts and they've turned it into a crack house, you have a decision to make: Are you going to let them stay or kick them out? We need to identify ourselves with the rebel alliance, and remind ourselves that we're fighting a holy war against Darth Vader and the storm troopers. We need to dedicate all of our efforts to bringing ourselves to consciousness, and we need to remind ourselves that the point of making these efforts isn't to get out of pain

but to do something for God. At some point, we will find ourselves connecting our efforts with an objective beyond ourselves as we know them.

Checkmate

We *can* make a habit of attuning ourselves to gratitude for the help we've received, instead of complaint. The habit of complaint can be pressed into the service of a more elegant relationship to life. We can turn a liability into an asset. Every time the mind produces a thought that's about complaint, we can link it to gratitude (i.e., "Dammit! She's always interfering with my decisions; I had decided to take a shower and now I don't get to do that.") So you notice this mood of dissatisfaction for what it is and you counter it (as in your next chess move) with the thought, "Beloved God, I'm very grateful for You and for my life."

Speaking of turning liabilities into assets, spiritual masters excel at taking us (some of us are certainly in the liability category when they find us) and transforming us into assets ("And now, for my next trick!"). We need not feel any pride over our accomplishments, since this miraculous creative act is something that's done for us rather than by us.

The great thing is you don't even have to mean it. You can just be paying lip service to a gratitude phrase, while you're building this response into your habit structure. You can still be in the mode of being "on it." You can be in no mood to give up your precious complaint while pulling out this "countermove." This phrase "Beloved God, I'm very grateful for you and for my life," becomes a new habit. When you follow this phrase with saying Yogi Ramsuratkumar's Name, this is the "checkmate" option that we're all looking for. Inserting gratitude and Yogi Ramsuratkumar's Name into a

thought or a mood of discontent is an antidote to the poison contained in the malicious thoughts and moods cavorting around inside of us.

This is the perfect plan, because the forces that send these thoughts to convince us that nothing is ever good enough or right enough—in order to make our energy digestible ("downer" energy is one of their favorite foods)—will be checkmated but not overly outraged. These forces are going to be like: "Rats! Every time we try to get a meal here she brings in gratitude and Yogi Ramsuratkumar's Name and messes with our food!" The more we do this, the more automatic and ingrained it will become. The trick is to reassure the part of us that enjoys and feels safe in the downer condition that it can feel free to carry on after we've put this antidote into our system; that this is just a temporary and innocent interruption of its program: "We interrupt this programming to bring you a special announcement." No use riling it up and provoking it. If it continues to give us more alarming data about its "problem" of the moment, then simply re-apply the antidote. These forces *do not* like to be denied. It's best if they think that you're not cutting them off forever from their food source, but that you're just instituting this innocent little twist.

It has just occurred to me that it's not necessary to wait for an untoward thought … that the above remedy may be applied whimsically and haphazardly throughout the course of the day. It's actually quite pleasant to remember that it's not *all* gloom and doom from time to time.

The Main Event

As useful as it is to counter our churlishness by making gratitude lists and to remind ourselves to substitute gratitude for complaint, these activities aren't the thing itself (the

bouillabaisse). They're the prep work for the main event. A moment when we connect to what is, as it is, in the present, and we have an actual experience of gratitude, is always spectacular. This is where the lights go on in a place buried inside of us and we breathe with the mood and the essence of gratitude. All of the efforts that we make to disconnect from the places inside of us that are thwarting this experience are valiant and worthwhile, because they pave the way to experiencing mind-boggling and heart-shattering states of gratitude.

Don't Make Promises with Your Mind That Your Body Can't Keep

Lee once recommended that his students commit to very few alterations in their pattern, because making a bunch of promises "with your mouth that your body can't keep" weakens our position in relationship to the establishment. When we don't follow through with an anti-establishment activity, this lets the pattern know that we're no threat to it and it can continue to lead us in the direction *it* wants to go. What's worse is that we end up feeling hopeless and helpless and demoralized by yet another example of our failure to overturn the tables. What we want to do is to begin to establish credibility within ourselves, to begin to exhibit the qualities of dependability and consistency that will qualify us for the leadership position within our own being. Have we learned nothing from the story of the tortoise and the hare? Slow and steady wins the race.

I'll Do It Later

Every time we buy a problematical conclusion, we are betraying who we are and stealing energy from the part of us that's sacred and true. It's pretty easy for the mind to seduce

us into not getting quiet and saying Yogi Ramsuratkumar's Name. It's probably got plenty of good rationalizations and reasons for not converting our intentions into action. Here are a few: "I'm in the middle of something, I don't have time; I'll do it later." ("I'll do it later" is one of its favorite lies.) If we realize we didn't meditate today, the mind will say, "No problem, you can do it tomorrow." Our true self would tell us, "Do it now, because all you have is the present." *It* knows that the future doesn't exist and that all we have is the present moment.

We're here to learn how to connect inspiration to immediate action rather than relegating it to a future time. The one that wants to keep us out of the present is a grand seducer. Every time we have the thought: "Oh, I could be saying Yogi Ramsuratkumar's Name" and then we don't, we're breaking faith with inspiration, with what we know God would like, and we're voting for sleep. Every time a notion connected to Remembering appears and we go in the opposite direction, this is a subtle but measurable betrayal of the Divine. We're saying we know what the right thing to do is, but we're not going to do it anyway.

God Doesn't Care How Attractive Your Cart Is

In the case of the approach we take to coming to our senses, less is more. It's better to pick one small departure from our programming and be consistent with it (don't bite off more then you can chew or digest) than to be heroically deluded about our follow-through abilities. We get into trouble by imagining that we're way more capable than we are, and then crashing when we come back down to earth. Maybe this is why in *The Karate Kid*, the kid can't figure out what painting a fence has to do with becoming a martial

artist. A real teacher will always tell us to slow down and to chop wood or carry water. God doesn't care how attractive your cart is. It doesn't belong in front of your horse.

Don't Let the Bastards Get You Down

If you've ever had the feeling that your life isn't your own, that you're spinning out of control, there *is* something you can do about it. There's *always* something to be done. This is *your* life we're talking about here—don't let the bastards get you down. You know the expression: "This life was only a test. If it had been a *real* life, you would have been given an instruction manual." We *have* been given the manual—ignorance of its contents (or the law) is no excuse. [Note from typist: "I hate that!"]

Take Off My Bathrobe and Put Down That Sherry

Here's an accurate analogy of our situation: we're the master of a house and our servants have tied us up and locked us in the basement. They're upstairs pretending to be us, and they're dressing up in our silk bathrobes and drinking our sherry. We're in the unenviable position of being subservient to something that should be serving us. The only way that the servants manage to maintain control over us is by cleverly hiding the truth of who's who from us; by making us believe only what they tell us. Saying the Name of God releases us from the dream that we're having that it's OK to be subservient to forces that are less than human.

What Was That About Hats?

There are a lot of practices that have been developed over time to help reveal the truth to us. The problem isn't that these practices don't work; the problem is that our attention

is always being disrupted and we can't remember to do them. This reminds me of a Monty Python skit where a group of philosophers are sitting around a boardroom table trying to come up with answers to the human dilemma. One of them proposes that the crux of the problem is our short span of attention. Immediately following this, another one interrupts to ask, "Now what was that about hats?"

In the tradition of George I. Gurdjieff, the distinction is made that the "person" who decides to get up early the next morning isn't the same one who shuts off the alarm clock and goes back to sleep. The ability to follow through with a purpose that we're inspired by seems to be hard to come by (yo-yo dieting being one example). If we're going to escape from the basement (the established pattern that's running us), we're going to have to be more clever than our captors, and we're going to have to bring diligence and consistency to our efforts in order to replace our fragmented state with single-mindedness. Saying the Name of God is the most efficient way to do this.

Foiling the Forces of Sleep

A friend of mine determined the other day that she was going to kick off the practice of saying Yogi Ramsuratkumar's Name during two specific activities (she'd already figured out that things like typing a manuscript and nuclear physics were out), and that she needed to find non-cerebral moments to inject this practice into. She chose whenever she was walking from one place to another, and whenever she was washing dishes—the theory being that if she could just get the motor running, then the Name would take on a life of its own and seep through into all of her other activities. Everything went extremely well the first day—so much so that she was

surprised and delighted to find that when she woke up, Yogi Ramsuratkumar's Name was reverberating inside of her. But when her decision began to fade, she realized that she would have to put a measure in place to foil the forces of sleep. She wrote her commitment up ("If you're walking or you're washing dishes, you're saying the Name of God") on a Post-it and attached it to her bed frame so she could remind herself every night before sleep and every morning when she woke up to follow through on her commitment. One of the mind's favorite tricks is to convince us, when we falter, that it's impossible to get back up on the horse. It's lying, as usual.

The Case of the Lost Lamb

I came across something recently where Lee said it was easier or better or something to work with a student who had willingness instead of ability than one who had ability but lacked willingness. I guess something in the clockworks of the second type got stuck somewhere along the line—some big no jammed the clock. Maybe these people had help at one point, and some place in them was prepared to receive God—but then they got clever and ran away, saying, "Screw this, I've got this covered, I'll do it my way." Maybe these are the remedial cases (the walking wounded) that a teacher comes here to fix. But maybe it's OK to be one of these—didn't Christ talk about how everyone rejoices over the lost lamb when it returns to the fold? Maybe the people who make it back from the hell of being strung-out make the best addiction counselors. And maybe God loves us one and all.

Bathing Suit Season Is Almost upon Us

Passing on the thing that substantiates the house of cards that we believe ourselves to be is like passing on a piece of

chocolate. It may not seem like the smart thing to do at the time, but remember: bathing suit season is almost upon us. I think Irina Tweedie's teacher recommended that she think before she speak; that she cultivate the habit of assessing the quality, purpose and content of her proposed words before unleashing them and harshing her teacher's buzz; that she stop short of treating the universe to another dissonant discourse. Examining the agenda lurking beneath the words that we want to say out loud—taking a stethoscope or a microscope to them and checking to see whether the words are connected to *clarity* or to the cancer of self-reference and self-importance—couldn't hurt.

Spiritual schools are traditionally places of silence. This gives the aspirant the opportunity to notice and witness the true state of affairs inside of them. The adage "If you can't say something nice, don't say anything at all" could be extended to "If you can't say something that isn't connected to perpetuating the redundant and boring myth of who you're pretending to be, then don't say anything at all." In other words, "Put a sock in it."

Feel the Burn

It's a hell of a thing to find out that we're actually not "the one"—that we're *not* Keanu Reeves in *The Matrix*. Despite our best efforts to assert our knowledge and fabulousness over and above the whole world, the reality is we're the one who was created to worship the One.

One of the ways to find out that we're posers is to limit our posing. Denying the words that are dying to come out of our mouths, in order to safeguard our reputations and impress upon others that we're cool, is ultimately workable. The activity of observing what we so desperately want to say

and refraining from saying it is analogous to the experience you get in a gym where you "feel the burn." It's uncomfortable to stop confirming these false identities and to stop telling lies about who and what we are, but it *is* useful. It clears some space inside of us to act in a way that contributes to, rather than detracts from, whatever situation we find ourselves in.

Silence is Golden

Letting the alligator (the conclusions in your mind) say things out loud is equal to talking out of your ass, thus the expression "You're talking out of your ass." Until your alligator learns some manners and stops contributing its life-negative two cents to every conversation you're having, silence is golden.

Some Early Warning Signs
That Your Alligator Has Staged a Takeover

Some of the early warning signs that the limbic/alligator part of us is working overtime and like mad to connect us with the pissed-off energy left over from our childhoods are:

- dis-ease
- tension
- feelings of superiority
- "justifiable" anger
- irritation
- self-pity
- getting the last word in
- anxiety
- arguing
- making excuses
- emotional imbalance
- feeling insecure

He Loves Me, He Loves Me Not

Any moment in time that we bring conscious awareness to is a moment well spent. The moments when we're asleep and we're lost in thought are empty. We can't build moments

of conscious awareness when we're busy ruminating upon, categorizing, and superimposing our opinions on top of the dream we're having. And, we can't refrain from this activity because we're asleep. This is quite the situation. From where we're sitting (in a field of daisies), we think we're supposed to be picking through them in order to figure out which ones are acceptable and which ones are not good enough. It doesn't occur to us to admire the field, and love these daisies one and all (to count our blessings). This is an important point, because it's a profusion of moments of *conscious, appreciative awareness* that attracts the help we need to free us from the daisy-nitpicking world. There are better things we can do than picking apart the petals of a flower while saying, "He loves me; he loves me not." This is silly—of course God loves us.

What we *need* is a break from the routine, a vacation from the craziness in our minds, in order to free our attention. The Name of God is the all-inclusive vacation to the Bahamas that we've been looking for. Since we're not at the point where we can meet our circumstances with good cheer and grace (here we go again—why *is* it that every road leads us to saying the Name of God?) then it's time to do something that *will* make a difference, that *has* the power to transform inflexibility into fluidity. Yogi Ramsuratkumar's Name will literally, not figuratively, dissolve every trace of inflexibility and rigidity inside of us. It's more powerful than a vat of acid or a speeding bullet.

The only reason that we underestimate the effectiveness of the Name of God is because we're identified with the ineffectualness of our personalities. All we can see and believe in is the space we're living in. I guess this is where obedience comes in. Even if we can't believe (from where

we're standing) that Yogi Ramsuratkumar's Name has the ability to completely alter our landscape, we can "just do it" because our spiritual teachers are saying to. Where's our sense of adventure and fun-loving experimentation? Why not find out what will happen if we introduce this new ingredient into the mix?

"Organized" Religion

One of the unfortunate side effects of "organized" religion (as if God needed *us* to organize the revelations that His prophets and saints carry down to us—*as if!*) is that Remembering God is a part-time job; that our responsibility to this relationship can be deftly handled by Remembering Him once a week on Sundays. There have been a number of other bad side effects (too numerous and too blood-curdling to mention here) due to the human race's unfortunate tendency to not leave well enough alone.

Now and at the Moment of Our Death, Remembrance Is the Purchase Price of Our Souls

My first spiritual teacher was less organized in his viewpoint, and said that every moment of our lives must lead us to a spontaneous Remembrance of God's Name at the moment of our death. This is the big test. If we can't Remember Him when we're cleaning the wax out of our ears with a Q-tip, what are the odds that His Name will spring to mind as we're barreling towards death? I had a dream a few years ago about someone I hadn't spoken to in a good ten years. In the dream she was dying, and I said to her, "Now Audrey, when you die, you don't want to be saying 'matzo balls,' you want to be saying the Name of God." When I called her the next day and told her this

dream she said, "Now that's interesting, because I was diagnosed with inoperable cancer this morning and given six weeks to live—thanks for the tip." (Another clue I've been given is that the goal is to Remember God in New York City, standing in the middle of Times Square on New Year's Eve.)

A way to measure whether or not Remembering God has taken root inside of us is to have someone set off a smoke alarm when we're not expecting it. If our response is "Oh shit!" rather than "God" or "Allah" or Something, then this indicates that there's work to be done. The trick (the rabbit-out-of-the-hat trick) is to Remember God while we're here. Anyone can Remember God after they're dead. The prize for this unusual feat (for making efforts to reclaim our true identity while swimming in the opposite direction of all the other salmon) is one you don't want to miss out on.

The Game Is Always On

The way that we get to the place where we can Remember God's Name when we're under extreme duress, where we have unwavering and undivided attention on Him no matter what's going on, is by assuming that when it comes to the mind "the game is always on." We can't get to unwavering attention by believing that all the justifications, excuses, and opinions in our minds are so. The game is always on, even when we're siding with the one that's pretending otherwise. Our minds are the masters of finding the way out, not the way *through*. Their mastery is never more in evidence than when they "help" us to reinterpret the words of a spiritual teacher; when they jump in to edit out the most important piece in these words, the one thing that actually could make a difference.

This letter was written by Yogi Ramsuratkumar for an event held in May 1988:

My Friends !

This beggar learnt at the feet of Swami Ramdas the Divine name of Rama, and beg, beg all of you not to forget the Divine name Rama. Whatever you do, wherever you are, be like Anjaneya-Maruthi thinking of Rama and doing your actions in this world. At every stage we face problems, today one problem, tomorrow another problem, the day after tomorrow another problem. And on account of facing these problems often we get dejected, disappointed, psychologically sick, if we don't remember the name of Divine. So this beggar will beg all of you not to forget the Divine name, Rama. There are people who like to remember the name of Siva. It is equally good – there are people who like to remember the name of Ganapathi – equally good. Whatever name you choose, whatever form you choose but give to this beggar what he wants. Never forget the Divine. Live in the world and the problems will be there. If we are remembering the Divine name, we are psychologically sound. May be, we may feel a little some of the problems. Even then the intensity with which we feel if we don't have faith in God is much more than a man of faith – a man who remembers the name of Rama. So this beggar is always begging, begging for food, begging for clothes, begging that you should compose songs on this beggar, build a house for me – buy a house for me – a cottage for me – this thing – that thing – so many things. But this beggar will beg of you this also, and you are always giving what this beggar has begged. So this beggar begs please don't

forget the name of God. This Divine name has been always of great help to all in the world.

You read Kabir, Tulsi, Sur, Appar Swamy, Manickavasaga Swamy – how they emphasised Namasivaya. Don't forget it – this is your heart – this is your soul whether it be Om Namashivaya or Om Namo Narayanaya whether Rama, Siva or Krishna whatever name you choose, whatever form you choose does'nt matter. But remember the Lord with any name, with any form of your choice. Just as when there is heavy rainfall, we take an umbrella, and go on doing our work in the factory, in the field, wherever we go for marketing and catching hold of the umbrella we go though the rain is falling there. But still we work – still we work – do our work. Similarly we have got so many problems all around. This Divine name is just like an umbrella in the heavy rainfall. Catch hold of the Divine name and go on doing your work in the world. This beggar begs of you and this beggar has received all he has begged of you. So I think none of you will shirk away, when this beggar begs of you 'Don't forget the Divine name'. This beggar prays to his Father to bless you all who have come here. My Lord Rama blesses you – My Father blesses you. Arunachaleswara blesses you. It does'nt matter to me what name it is. All the blessing of my Father for all of you! well, that is the end. That is all.

Chiquita Banana and the One-Million-Dollar Prize

I've been inspired to offer a one-million-dollar cash prize, to be awarded to the first one among us to prove conclusively that whatever we're thinking right now takes precedence over and has more value than saying the Name of God.[4] When we find ourselves musing (benignly or otherwise), we can stop and say Yogi Ramsuratkumar's Name. When we're on the metro and we realize we're on the wrong train, being carried further away from our destination, it makes sense to get off at the next stop so we can correct the situation. What's to be gained by remaining on the wrong train?

Nobody Anywhere Has It Better Than You in This Moment

Nobody anywhere has it better than you in this moment.[5] This is the answer to your mind when it pulls you off course and tells you, "You don't have it so good; if only you had this or that, things would be better," or "So-and-so has it so much better than I do. If only I had *her* life." This is how we're tricked out of our inheritance: our minds will marshal their unassailable logic against the idea that *nobody anywhere has it any better than you in this moment.* "This is preposterous!" they will say. "Obviously there are people in the world having a better time and a worse time." But then eternal truth isn't subservient to and doesn't obey logic. Remember: the rational mind couldn't see the truth if it showed up in your living room dressed up in a bunny costume.

4 The only prize-worthy exception that I can think of would be if someone were to open their eyes one morning and leap out of bed, ecstatically singing, "I'm Chiquita Banana and I've come to say, 'Eat a banana every day!'"

5 I base this on the idea that God's Name is written in each of our inner hearts, and it's most likely that He doesn't play favorites and He doesn't love some of us more than others, or write with indelible ink in some of our hearts and pencil in others.

When we figure this out we won't bother arguing with the truth on the grounds that its arguments fall short and they don't meet with our linear agreement.

Just accept the fact that you're under the spell of a two-dimensional guidance system, and that the *truth* functions three-dimensionally. Accept and rejoice in the knowledge that you don't actually know what's going on. Whew! What a relief! I guess it's a good news/ bad news situation. We're going to have to admit that on the one hand our psyches don't know anything but on the other hand our real selves do. We're going to have to work our way through our resistance to our ignorance and accept our condition.

Ultimately and eventually, we'll end up admitting and making our peace with the fact that we're in the dark (and possibly even too stupid to live)—because trying to ward off the truth is like trying to put out a raging forest fire with a garden hose. The lie is no match for the truth. This being the case, why put off until tomorrow what you can do today?

Don't Forget Your Umbrella

I may have fallen short in presenting a compelling enough picture of the urgency of taking up the repetition of the Name of God. But then, there may have been nothing I could have said that could compete with the urgency of the details of your life at this time. Yet still, you may want to keep this practice close at hand in the event of a rainy day.

If all else fails—and eventually it all will—you always have the Name of God. There's only one thing I know for sure (all the rest is a crap shoot): the Name of God is all we really have because it's what's at the heart of us.

Other Titles of Interest
From Hohm Press

YOGI RAMSURATKUMAR
Under the Punnai Tree
by M. Young

Hohm Press's first full-length biography of Yogi Ramsuratkumar, the wondrous and blessed beggar of Tiruvannamalai, contains more than 80 photographs. From the lyrical to the factual, this book is filled with hundreds of stories of the much-loved saint. Personal accounts of those who knew the beggar well reveal a life story unique even in the long history of India. *Yogi Ramusuratkumar: Under the Punnai Tree* occasionally takes a larger view and explores how Ramusuratkumar's life fits into broader themes of the spiritual path. This book is a literary and pictorial feast for those who love India's rich heritage, and a must-read for spiritual seekers of all traditions. Paper, 752 pages, color photos, $39.95; ISBN: 978-1-890772-34-5

A MAN AND HIS MASTER
My Years with Yogi Ramsuratkumar
by Mani, with S. Lkasham

For six years, twenty-four hours a day, the author (Mani) lived with and served Yogi Ramsuratkumar as his closest personal attendant. This book is filled with delicate details of life with Yogi Ramsuratkumar. The narration first finds him as a homeless beggar in the streets, and moves onward through the construction of his magnificent ashram under Mani's direction. Living amidst spiritual richness and the material poverty of India, Mani tells the story of a saint who blessed the lives of tens of thousands; one who remains a unique figure in India's spiritual history. Paper, 394 pages, color photos, $21.95; ISBN: 978-1-890772-36-9

To order, visit our website at: www.hohmpress.com

ONLY GOD
A Biography of Yogi Ramsuratkumar
by Regina Sara Ryan

This book traces the life story of the hidden saint, Yogi Ramsurat-kumar – a highly-educated holy man who lived as a beggar on the streets of India (b. 1918 - d. 2001). "Only God" was the saint's creed, and his approach to everyday life. It reflected his absolute faith in the one transcendent and all-pervasive unity, which he affectionately called "My Father." His unusual innocence and radiant presence were recognized by seekers from both East and West, and visitors came to know him as "the Godchild" of Tiruvannamalai, the small southern city in which he lived for over forty years. An interesting mix of interviews, fact-finding and storytelling. Hardcover, 832 pages, color photos, $39.95; ISBN: 978-1-890772-35-2

FATHER AND SON
The Indian Beggar King Yogi Ramsuratkumar and the American Master and Bad Poet Lee Lozowick
by VJ Fedorschak

The author summarizes this book by calling it "a contemporary spiritual epic on the magic and mystery of the traditional Guru-devotee relationship." *Father and Son* chronicles the twenty-four years (1977-2001) during which Lee Lozowick visited with and participated in the life and work of his Master, Yogi Ramsuratkumar, the beggar saint of Tiruvannamalai, South India. It also traces the development of Lee Lozowick's growing community and work with students and devotees in the U.S. and Europe. Fedorschak interviewed the American master extensively, and catalogues his answers to scores of questions about this unique and transformational relationship. Hardcover, 980 pages, color photos, $85.00; ISBN: 978-1-890772-84-0

To order, visit our website at: www.hohmpress.com

THE SHADOW ON THE PATH
Clearing the Psychological Blocks to Spiritual Development
by VJ Fedorschak
Foreword by Claudio Naranjo, M.D.

Tracing the development of the human psychological shadow from Freud to the present, this readable analysis presents five contemporary approaches to spiritual psychotherapy for those who find themselves needing help on the spiritual path. Offers insight into the phenomenon of denial and projection.

Topics include: the shadow in the work of notable therapists; the principles of inner spiritual development in the major world religions; examples of the disowned shadow in contemporary religious movements; and case studies of clients in spiritual groups who have worked with their shadow issues. Paper, 324 pages, $17.95; ISBN: 978-0-934252-81-2

HALFWAY UP THE MOUNTAIN
The Error of Premature Claims to Enlightenment
by Mariana Caplan
Foreword by Fleet Maull

Dozens of first-hand interviews with students, respected spiritual teachers and masters, together with broad research are synthesized here to assist readers in avoiding the pitfalls of the spiritual path. Topics include: mistaking mystical experience for enlightenment; ego inflation, power and corruption among spiritual leaders; the question of the need for a teacher; disillusionment on the path ... and much more.

"Caplan's illuminating book ... urges seekers to pay the price of traveling the hard road to true enlightenment." —*Publisher's Weekly*

Paper, 600 pages $21.95; ISBN: 978-0-934252-91-1

To order, visit our website at: www.hohmpress.com

AS IT IS
A Year on the Road with a Tantric Teacher
by M. Young

A first-hand account of a one-year journey around the world in the company of *tantric* teacher Lee Lozowick. This book catalogues the trials and wonders of day-to-day interactions between a teacher and his students, and presents a broad range of his teachings given in seminars from San Francisco, California to Rishikesh, India. *As It Is* considers the core principles of *tantra*, including non-duality, compassion (the Bodhisattva ideal), service to others, and transformation within daily life. Written as a narrative, this captivating book will appeal to practitioners of *any* spiritual path. Readers interested in a life of clarity, genuine creativity, wisdom and harmony will find this an invaluable resource. Paper, 848 pages, 24 b&w photos, $29.95; ISBN: 978-0-934252-99-7

SELF OBSERVATION ~ THE AWAKENING OF CONSCIENCE
An Owner's Manual
by Red Hawk

This book is an in-depth examination of the much needed process of "self" study known as self observation. It offers the most direct, non-pharmaceutical means of healing the attention dysfunction which plagues contemporary culture. Self observation, the author asserts, is the most ancient, scientific, and proven means to develop conscience, this crucial inner guide to awakening and a moral life.

This book is for the lay-reader, both the beginner and the advanced student of self observation. No other book on the market examines this practice in such detail. There are hundreds of books on self-help and meditation, but almost none on self-study via self observation, and none with the depth of analysis, wealth of explication, and richness of experience that this book offers. Paper, 160 pages, $14.95; ISBN: 978-1-890772-92-5

To order, visit our website at: www.hohmpress.com

Contact Information

Sofya Smith is the current director and a cofounder of the Prihatin Institute. The Institute develops and champions bio-identical/nature-inspired antidotes to the symptoms of ADD, ADHD, and autism. See www.prihatin.org

HOHM PRESS
PO Box 2501
Prescott, Arizona 86302

www.hohmpress.com